The Truth Behind The Christ Myth:
The Redemption of the Peacock Angel

The Truth Behind the Christ Myth

Mark Amaru Pinkham

ISBN 0-931882-02-9

Printed in the United States of America
on acid free paper

Published by
Adventures Unlimited Press
One Adventure Place
Kempton, ILLINOIS 60946 USA
Phone: 815-253-6390
Fax: 815-253-6300
www.adventuresunlimitedpress.com

Write for our free catalog of
other fascinating books & videos

Other Books by Mark Amaru Pinkham
THE RETURN OF THE SERPENTS OF WISDOM
CONVERSATIONS WITH THE GODDESS

The Truth Behind the Christ Myth:

The Redemption of the Peacock Angel

Mark Amaru Pinkham

Acknowledgements

There are a few people who deserve special mention for the creation and publication of this book. Thank you Dad for your essential support and assistance. Thank you Jodi Noto for your Pagemaker expertise and patience. Thank you Kathryn Peters and Dannion Brinkley for all your help. And a special thanks to my wife, Andrea, who has always been supportive of my writing.

I am the root and the offspring of David,
and
the bright and morning star.

The Revelation of Saint John the Divine 22:16

Table of Contents

Introduction

Part I: Jesus Christ and the Peacock Angel
Chapters
I Saint Paul and the Myth of Jesus Christ..............................page 2
II The Peacock Angel: Beginning of the Christ Myth............page 17
III Jesus Christ merges with the Peacock Angel....................page 43

Part II: In Search of the King of the World
IV The World is a Giant Peacock..page 64
V The Peacock Angel and Shamballa....................................page 74
VI The Redemption of the Peacock Angel............................page 87

Part III: The Once and Future Myth of the Son of God
VII The Christ Myth of the Ancient Goddess Tradition.........page 100

VIII A Son of God Myth for the Age of the Son...................page 107

Part IV: The Symbols and Rites of the Peacock Angel and Son of God
IX The Symbols of the Peacock Angel and King of the World...... 113
X The Rites of the Peacock Angel and Son of God...............page 145

Footnotes and Bibliography..page 151

The Author Pages..page 157
The Author
The Kumara School of Wisdom
Sacred Journeys
Astrology

Introduction

As we slowly gain a solid foothold into a new millennium many of us are seeking answers as to how the human race could have arrived at its present condition. In our pursuit for answers we find ourselves scrutinizing both Darwinian theory and the legacy of **Jesus Christ**, while asking whether human beings could have truly evolved from apes and whether Jesus Christ, the supposed *One and Only Son of God*, ever even existed. A current body of evidence suggests that his legend is no more than a fabrication created by ambitious Church Fathers seeking to control the faithful. Thus, the Judeo-Christian underpinnings of our western civilization suddenly seem shaky and threatened with imminent collapse.

This work endeavors to contribute to the current interrogation of Jesus' life story by introducing the legend of the **Peacock Angel** from **India**. Through legends and historical fact the text will seek to prove that the Peacock Angel was the original Son of God, and that his legend was the foundation upon which the popular myth of Jesus Christ was built. When the myth of the Peacock Angel left India millennia ago, it was first taken to Persia, then Babylonia, and finally to the **Holy Land** by Saint Paul. **Saint Paul** was himself a life long worshipper of the Persian version of the Peacock Angel, Mithras. The Apostle traveled to the Holy Land from his native **Tarsus**, the headquarters of Mithras worship in Asia Minor, and then proceeded to graft the ancient legend of the Peacock Angel onto what has become the greatest story ever told, the legend of Jesus Christ.

And there is more... This book will also reveal through historical evidence that the same myth of the Peacock Angel which evolved into that of Mithras and Jesus was also the foundation for the legend of **Melek Taus**, a Kurdish manifestation of **Satan**. The original Son of God thus possessed the seeds of both Satan and Christ, and was, therefore, the androgynous union of Spirit and matter. Finally, the text will prove that the Peacock Angel is not a fictitious entity. In the Far East he has been worshipped by for thousands of years by monks and occultists as **The King of the World**, our planetary monarch who resides in **Shamballa** in Central Asia and who is intimately associated with the planet **Venus**. In the West he has become known as the chief **Fallen Angel** and the ever-present **Watcher**, **Lucifer**, who continually studies humanity from another dimension.

So, get ready to meet the original Son of God, the Peacock Angel, and gain a whole new understanding of the Christ Myth....

Blessings to you and yours,
Mark Amaru Pinkham

Part I
Jesus Christ
and
the
Peacock Angel

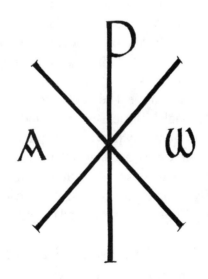

I
Saint Paul
and the
Myth of Jesus Christ

We will begin our study of the history of the Christ Myth with its latest manifestation, the legend of Jesus Christ, and then work backwards to its origin in India. We thus commence with an examination of Saint Paul, the apostle who made the legend of Jesus Christ into a marketable form which has steadfastly endured for the past two thousand years while helping steward the development of western civilization. But who was Saint Paul, *really*? What was his true relationship with Jesus Christ? What influence did he have on the legend of the *One and Only Son of God* to make it the cornerstone of a religion which now claims two billion adherents worldwide? Was Saint Paul, as we are lead to believe by most Judeo-Christian historians, born into a Jewish family and groomed to uninhibitedly embrace the philosophical tenants of the Pharisees? Or is there something hidden in the Apostle's early life which we should know about, something which would compel him to eventually accept an obscure and controversial figure as the Son of God? Could a voice speaking forth from a light be enough to make Paul, or any other person for that matter, abandon his native faith in order to endure untold hardships and persecution while spreading a radical and unpopular doctrine for the remainder of his life? These are important questions which this chapter will seek to answer by presenting Saint Paul's intriguing relationship with Mithras, a Persian version of the ancient Peacock Angel from India and the apostle's most cherished deity. Through historical evidence and references it will become clear that Mithras' legend eventually provided Saint Paul with the foundation for his Christian legend of Jesus Christ, and that both Paul and other important prophets of his time truly believed that Jesus *was* Mithras. But first we must introduce Mithras, an obscure deity to some, but a historical figure just as important as Jesus Christ himself in shaping Christian doctrine and its legend of the Son of God.

Who was Mithras?

Mithras was an ancient Son of God who emerged out of the Persian religious tradition at a time predating the prophet Zoroaster, circa 600 B.C. According to the popular myth which circulated among his worshippers, Mithras was born on December 25 from a virgin and his cradle was soon surrounded by joyful

shepherds who arrived from the adjacent fields in order to worship the new Son of God. Mithras was sent to Earth by his Father, Ahura Mazda, with the specific mission of defeating Ahriman, the Persian Satan. After fighting valiantly against Ahriman, Mithras concluded his earthly sojourn with his apostles at a Last Supper. Then, while ascending into the heavens (following a crucifiction and ressurection three days later, according to some records), Mithras assured his loyal followers that he would return at the end of time for one last battle with Ahriman. This battle would culminate in Everlasting Life for the faithful and herald a golden age upon the Earth. During his absense, Mithras' advised his followers to worship him annualy on his birthday and weekly on his holy day, Sunday, with a Holy Communion of bread and wine.

Mithras was an important deity of the Persian Mazdian religion and of Zoroastrianism, but it wasn't until missionaries took his cult westward into Asia Minor that he became the principal deity of his own religion, Mithraism. One of the primary areas where Mithraism took root was Asia Minor, especially within the country of Cilicia and its principal city of Tarsus, the birthplace of Saint Paul.

Tarsus, Seat of Mithras Worship

Certain ancient historians, including the Roman Plutarch, were explicit about Cilicia being not just one of the Asia Minor counties where Mithras worship was observed, but the true bastion of the Persian Son's religion. Plutarch contended that Roman soldiers, who were responsible for spreading Mithraism throughout the Roman Empire and making it the greatest religion of its time, were trained in the mythology and rituals of Mithraism by Cilician pirates they had captured while policing the Mediterranean Sea. In more recent years, contemporary archeologists have corroborated Plutarch's testimony and linked Cilcica to Mithraism through their extensive excavations of the land. In Tarsus and other neighboring locations they have uncovered the ceremonial tools of Mithraism, as well as the ruins of "Taurobolium," temples where candidates for initiation into Mithras' cult were bathed by the blood of a bull while it was slaughtered above them.[1]

Saint Paul, A Magi Priest of Mithras?

Saint Paul grew up with the signs and symbols of Mithraism all around him and it appears that his relationship with the cult continued during his subsequent years in Palestine. As one of Jerusalem's tentmakers, and later, as one of the Temple guards, Saint Paul was daily exposed to Mithraism through his clientele and collegues, the Roman soldiers, most of whom were initiates of the cult. But how could Paul have become an initiate of Mithras and also live and worship as a Jew? A survey of early Church history offers an impeccably clear answer to this important question.

Saint Paul was never a Jew in the true sense of the word. Epiphanius, a historian of the Fourth Century, tells us this by quoting a tradition handed down from the Ebionites, the first Jewish-Christian movement which was led by James, the brother of Jesus. According to the first Christains, Paul never completely converted to Judaism. He only converted in order to win the hand of the daughter of a Jewish priest. Unfortunately, soon after his conversion his sweetheart spurned him, making Paul enraged at his beloved, as well as at all Jews. He then proceeded to write and speak disparagingly towards certain aspects Judaism, such as circumcision, the Sabbath and the Law of Moses. [2] This testimony of the Ebionites appears corroborated in the *New Testament* wherein Paul only referred to himself as a Jew under duress, such as after he had been arrested by the Jewish authorities in Jerusalem for allowing paganistic ideas to infiltrate Judaism (Acts 21, 22).

Another intriguing notion with some historical merit asserts that Saint Paul was a Magi priest of Mithras. This rather heretical idea was championed by some of the earliest writers on Christian history, including Clement of Alexandria. Clement contended that the maligned Simon Magus (a name derived from Magi, the title of the Persian priests of Mithras) could have actually been a name for Saint Paul, and he confirms his radical notion by revealing that Paul was often referred to by his detractors as Simon. [3] In order to further corroborate his seemingly dubious theory, Clement, along with other early authorities, pointed out many glaring similarities between Paul and Simon, such as that both men lived at approximately the same time and each was separately referred to as the first paganistic "heretic" (Clement, Bishop of Rome in the 2nd Century referred to Paul as the "original heretic"). It was also noted that Paul and Simon were both acknowledged to be the principal nemesis of the Ebionites, and each offered to contribute money to the incipient Christian order for the priviledge of wielding the Holy Spirit. In addition, both men preached a theology of dualism and each was recognized as the "Great Apostle" and founder of Gnosticism. [4] At least one Gnostic sect, the Paulicians, honored Saint Paul's contribution to Gnosticism by naming their order after him and even the Gnostic school named after Simon, Simonianism, was referred to by more than one commentator as "radical Paulinism." [5] Thus, both philosophically and historically Simon Magus and Saint Paul dovetail. In the final analysis it can be said that they were both adherents of dualism and the descendants of the Magi of Babylonia and Persia. Paul's dualism can be clearly discerned in his *Epistle to the Romans* wherein he alludes to the universal polarity as Spirit trapped within the limitations of matter and waiting for "redemption." (Romans 8:19-24) [14] Thus, whether it is proved conclusively that Paul was in fact Simon Magus, it must be admitted that he was an agent of Persian dualism and, therefore, an honorary Magi priest.

Persian Dualism and the Roots of Judaism

Paul's career as a Magi priest may have commenced through his contact with Judaism, a religion which had itself been infiltrated by Persian dualism hundreds of years before the apostle set foot in Palestine, thus making Judaism a relative of Mithraism. The corruption of Judaism occurred during the exile of the Jews in Babylonia, when the Persian Magi, who entered Mesopotamia during the conquest by their renowned Persian Emperor, Cyrus the Great, indoctrinated many of the Jewish priests and prophets into their dualistic ideology of absolute light and absolute darkness. Through their contact with the Jewish Rabbi, the Magi names assigned to these two eternal principles, Ahura Mazda or Ormuzd and Ahriman, were subsequently changed to Hebrew monikers. Persian dualism was then escorted back to Palestine by the Jewish Rabbis and prophets.

The first definitive sign of Persian dualism having infiltrated Judaism is preserved both within the writings of the sect of the Essenes, as well as those of the Biblical Prophet Daniel, a talented visionary who served as a dream interpreter to the Babylonian King Nebuchadnezzar during the Jewish captivity. Nebuchadnezzar was so pleased by Daniel's interpretations of his dream symbolism that he had the prophet made chief over "all the wise men of Babylon," [6] thereby grouping him within an elite fraternity comprised of adept Chaldean astrologers and Ashipu magician-priests. When the Medes under Darius conquered Babylon, Daniel again proved the superiority of his "magic" by surviving a night alone in a lion's den. Thus, by the time Cyrus invaded the city, Daniel was considered a sage without equal and the obvious choice to serve as liaison between the Babylonian priesthood and the incoming Magi. The result of the Magi's ideology on Daniel's thinking cannot be overstated; ultimately it precipitated a series of visions within the prophet which helped define the upper echelons of the celestial hierarchy for all Jewish mystics for hundreds of years to come. During some of Daniel's most important visions he found himself in the presence of the "Great Prince"[7] and leader of all the Archangels, the Archangel Michael, whom he designated in his writings as the patron of the Jewish people and, ostensibly, as the spirit of the "Son of Man" who would descend from the clouds at the end of time and rescue the righteous on Earth. Saint Michael was clearly the Hebrew name for Ormuzd or Ahura Mazda, the greatest of the seven Ameshspentas or archangels which Daniel had learned about from his Persian teachers. Like Ahura Mazda, Michael became known by the Jews as the leader of seven Archangels and, like his counterpart, was worshipped as a reflection or embodiment of the highest lord of creation. The name Michael or "Mikael" means "Who is as God."

Daniel of course also learned from his Persian preceptors about the dark god, Ahriman, and this knowledge was eventually passed down through successive

orders of Jewish mystics until reaching the Essenes, who knew him as Belial. The Essenes, whose texts have been compiled into the *Dead Sea Scrolls,* referred to Archangel Michael as the "Lord of Light" and to his eternal polarity, Belial, as the "Lord of Evil." The Essenes also called Michael and Belial "The spirits of truth and falsehood (who) struggle within the human heart."[8] Belial's derogatory title, the "Spirit of Falsehood," is an obvious reference and link to his Persian counterpart, Ahriman, whose name means "Lord of Lies." Thus, with the advent of the Essenes into history, the Persian deities, Ormuzd and Ahriman, the Lords of Light and Darkness, became transformed into Michael and Belial.

Mithraism and the Essenes, Close Cousins

While the Babylonian Magi were infusing Judaism with dualism, they were also synthesizing the new religion of Mithraism, which promised the arrival of a Messiah who would completely eradicate and defeat the dark lord. Judaism, especially its secret sect of Essenes, may have adopted both their dualistic theology and a belief in a coming Messiah from the Persian Magi of Babylon, thus making the religion a close cousin to the emerging Mithraism.

Striking similarities between Mithraism and the Essenes seem to suggest a parallel development for both faiths and the adoption of shared of rites and beliefs. As mentioned, each religion embraced a dualistic theology which mirrored the other. Moreover, each observed daily and weekly Sun worship (both Mithras and Michael were Sun Gods) and both clung to prophecies of a solar savior or messiah who would arrive at the end of the world and expunge all evil from the Earth, thus ushering in a New Age of Righteousness. The Essene notion that the world was going to end during their era was probably adopted from the Magi priests of Mithras in Babylon, who predicted many earthly events through their adept astrological calculations.

Another interesting link between Mithraism and the Essenes is the spirit of the incoming Messiah. The Essenes anticipated the incarnation of Archangel Michael, while the savior of Mithraism was destined to be the heavenly light, Ahura Mazda, who would incarnate physically as Mithras. Since Michael was a Hebrew version of Ahura Mazda, both the Essenes and the initiates of Mithraism apparently awaited the incarnation of the same spirit.

Mithraism's most orthodox and zealous initiates, the Roman soldiers, were also related to the Essenes through their militant attitudes and their prophesies regarding the incarnation of a heavenly warrior. The Essenes savior was to be the heavenly commander, Michael, who as their eternal guardian was destined to stand shoulder to shoulder with them at the end of time for one last battle against Belial and his evil legions. Similarly, the Roman soldiers pledged to fight alongside

Mithras during his prophesied return, and prepared for their savior's earthly return by continuously battling the forces of unrighteousness, the envoys of Ahriman. Once their savior's rout was complete, stated the prophets of both militant traditions, the commander of God's holy army would sound his battle trumpet and initiate the creation of a new world and a New Age of Righteousness.

Michael Incarnates as Jesus

But before the incoming saviors of the Essenes and Mithraism were to fight shoulder to shoulder with their earthly flocks, they needed to first take up a physical body. It was thus prophesied by the sages of Mithras that Ahura Mazda would incarnate into a form manufactured by the contracting darkness of Ahriman, and then live physically on Earth as Mithras. Similarly, the Essenes expected Michael to incarnate into a body synthesized by the contracting forces of Belial before assuming his earthly role as the prophesied Messiah. According to the "sleeping prophet," Edgar Cayce, creating a body for the incarnating spirit of the Messiah was the Essene *raison d'etre*, a truth he claimed was implicit within their name, which he asserted means "expectancy."[9] Cayce's visions have been recently validated by the discovery of *The Dead Sea Scrolls*, Essene texts anciently hidden at Qumran on the shores of the Dead Sea. Such texts clearly reveal that the Essene prophets were indeed fixated on the Messiah taking a physical form among them.

But, paradoxically, *The Dead Sea Scrolls* predict not just one, but two messiahs. One of the prophesied messiahs was to be the Messiah of Aaron, a priestly messiah, and the other would be the Messiah of David, a secular messiah who would eventually rule all the Jews as their king. According to Laurence Gardner, this does not reflect a contradiction in Essene prophesy. In his *Bloodline of the Holy Grail* Gardner reveals that the Essenes expected one Messiah to be born who would unite both offices. He would be the kingly Messiah, as well as the priestly Messiah, and he would unite both as the "Michael."[10]

Both Gardner, as well as the apocryphal Jewish text *The Talmud of Immanuel*,[11] maintain that at the top of the Essene priestly hierarchy was the "Michael," and right below him were offices named after the two other principal archangels, Gabriel and Raphael. The proper and complete name for the highest office of Michael was "Michael Zadok," a title that unites Michael with Zadok, the name of King David's righteous high priest whose lineage the Essenes sought to revive. Apparently, the priest holding the office of the Michael Zadok was the highest and purist of the Essene clergy. He was one who had conquered his worldly passions and could thus incarnate the power and wisdom of Michael (a name for both the archangel and the universal Higher Self) upon the Earth plane. Ultimately, the Essenes would pass the office of the Michael Zadok to the Messiah, Jesus

Christ, thus acknowledging him to be the full incarnation of Archangel Michael. When Jesus was born the office was in the possession of his Essene teacher, John the Baptist, who had inherited it from his father, Zacharias. After John was decapitated, however, the office was passed to Jesus, John's chief disciple.

An interesting link between Jesus and Saint Michael, the spirit he incarnated, is revealed through a comparison of quotations ascribed to them. The following admonitions of Saint Michael (1) and Jesus (2) are nearly identical.

(1) "And Abraham saw two roads. The first road was strait and narrow and the other broad and spacious. Michael then explained to Abraham "This strait gate is the gate of the righteous, which leads to life, and those who enter through it come into Paradise. The broad gate is the gate of the sinners which leads to destruction and eternal punishment."

From: *The Testament of Abraham*

(2) "Enter by the narrow gate; for the gate is wide and the way is easy that leads to destruction, and those who enter it are many. For the gate is narrow and the way is hard that leads to life, and those who find it are few."

From: *The Gospel of Matthew*

Michael Is Melchizedek

The Essenes also referred to the incarnated spirit of the Messiah as Melchizedek. According to Gardner, the Essene title of Zadok was also expressed as Zedek, meaning "righteousness," and the title of Michael Zadok was alternately rendered as Michael Zedek, or as the synthesized Melchi-zedek. The name Melchizedek truly embodies the qualities and angelic rank of Archangel Michael and is a descriptive epithet for the greatest of angels. Melchizedek, which unites Michael, Melek or Malak with Zedek, is translated variously as the "Righteous Michael," the "Angel of Righteous," and as the "King of Righteousness.

Although Melchizedek is often portrayed as an entity separate from Michael, the Essenes apparently knew they were synonymous, a truth revealed in their *Prince Melchizedek Document.* The essential oneness of the two deities is also discerned through a comparison of their legendary characteristics and responsibilities. Throughout time both have been accorded the title "King" or "Angel of Righteousness," and both have been jointly referred to in Judaic writings as the "Prince of the Heavenly Temple." On separate occasions Jewish mystics have envisioned both Michael and Melchizedek sitting upon a regal throne and resembling the Ancient of Days, and the prophets were also known to call both figures

Malak Yahweh, the "Angel Yahweh," a name for the angelic form assumed by Lord Yahweh during his visits to Earth as recorded in the *Holy Bible*. During one of these special planetary visitations Malak Yahweh was the first "person" or "Father" of a trinity of angels which visited Abraham at Mamre.[12] Michael's at-one-ment with Yahweh and Malak Yahweh is also implicit within his name, which translates as "Who is (as) God."

The Nestorian Heresy

Historically, the Essene knowledge that Jesus was an incarnation of Michael/Melchizedek appears to have passed from the reclusive Jewish sect to the Order of Ebionites, the "Poor Ones," the earliest group of "Christians," which was headed by Jesus' brother James. The Ebionites, many of whom were also Essenes, gained adherents outside of Palestine and eventually spread to Syrian Damascus and Antioch where their doctrines were promulgated for generations to come, even at the risk of heresy and excommunication.

One native of Antioch who later martyred himself in order to spread the truth regarding Michael-Melchizedek's incarnation as Jesus Christ was Nestorius, a clergyman who became Patriarch of the Eastern Roman Church during the Fourth Century A.D. While defending the beliefs of a friend before a church council, Nestorius sent heretical reverberations throughout the Christian world by openly declaring that since his mother Mary was human, Jesus must have himself been born human and only later become divine by incarnating his higher self. Nestorius' radical pronouncement eventually succeeded in getting him excommunicated, but it also triggered the formation of a new church, the Eastern Syrian or Nestorian Church, wherein Jesus' higher self became recognized as the highest of angels, Michael-Melchizedek.

On the Road to Synthesis

The Apostle Paul's greatest contribution to the Christ Myth was to unite (or reunite) the two Messiahs of Mithraism and the Essenes. Paul concluded that Jesus was the incarnation of Mithras and then synthesized the symbols and rites of Judaism and Mithraism into a form of "Pagan" Christianity.

The evolution of Paul's unified understanding of the Messiah began one fateful day on the long road between Jerusalem and Damascus. According to the story as it is recounted in the *Holy Bible*, as Paul (or Saul, as he was originally known) rode horseback to Damascus in hopes of bringing some of Jesus' followers back to Jerusalem for certain torture and possibly death, he was suddenly blinded by a "great light" from heaven and thrown from his horse to the ground. As a lifelong devotee of Mithras, Paul would probably have instinctively recog-

nized the light to be a manifestation of the Persian Son, whom he associated both with the spiritual light of the world, as well as the luminescence of the physical Sun. Then, when a voice spoke from within the light calling itself "Jesus of Nazareth," Paul's belief system would have been instantly shattered, thus causing him to become "blind," both literally and figuratively. With the urgency of a man whose entire belief structure was suddenly immersed in a confusing, mental fog, Paul would have groped inwardly while asking: "How could the light of Mithras call itself Jesus…unless…unless Jesus is Mithras?!" Paul's consuming inquiry would have precipitated his eventual unified revelation, but the temple guard would remain in darkness for days to come before a new understanding could fully blossom.

Paul eventually regained his "sight" with the help of a Christian by the name of Ananias, whose proselytizing work on the convalescing Paul no doubt helped the future missionary in recognizing the Light, and thus Mithras, as Jesus. Considering his eclectic background, such a revelation would have been both intoxicating and liberating for Paul because now he would be free to honor both his Jewish and Cilician heritages. He would also be able to revel in the wisdom that Mithras was not just a mythical figure, but a physically incarnated Son of God. Renewed and strengthened by this new knowledge, Paul resolved to spend the remainder of his life spreading the teachings of the Christ Messiah.

Throughout the last two thousand years many people have asked why, if Saint Paul had never even met Jesus, would he spend most of his life converting Gentiles to the Messiah's Christian doctrines? The most obvious answer appears to be that Paul believed he was converting Gentiles to the ancient path of Mithras, whose most recent incarnation had been Jesus the Christ.

Jesus Merges with Mithras

Following his revelation, Paul distinguished himself as the greatest of Christian missionaries, even risking his life to spread the Gospel of Jesus the Christ. As he traveled among the Gentiles he also authored the first life story of Jesus Christ. Gradually, through the process of amalgamation begun on the road to Damascus, Paul united the archetypal pagan Son of God, Mithras, with Jesus Christ, until the two Sons of God merged into the *One and Only begotten Son of God*. Because of Paul's adept work of synthesizing the Christ Myth, it was eventually nearly impossible to distinguish the Persian Son of God from the Jewish Messiah.

The following comparison reveals how the trend begun with Saint Paul eventually culminated in Jesus and his path merging with Mithras and his ancient religion. The similarities between the two saviors and their traditions are both manifold and unmistakable.

1. Jesus was born in a manger surrounded by farm animals and shepherds. Later Jesus was himself depicted as the "Good Shepherd."

The myth of Mithras maintains that the birth of the Persian Son occurred in nature and, afterwards, Mithras was soon surrounded by shepherds from the local area. When the legend of Mithras was eventually taken west from Persia to Phrygia, the Persian Son of God easily merged with his counterpart, the shepherd Attis, and from that time onwards Mithras was always depicted wearing his characteristic shepherd's hat.

2. Jesus was born to a virgin.

According to one western Asian school of Mithraism, Mithras was born to the virgin goddess Anahita. One of Mithras' largest temples in western Persia was dedicated to "Anahita, the Immaculate Virgin Mother of the Lord Mithras."

3. Jesus' birth had been predicted by the Three Wise Men who arrived at the manger to give the Son of God their blessings.

According to one legend that became popular in Medieval Europe, many hundreds of years before Jesus' time the Persian prophet Zoroaster predicted the future birth of Mithras and the journey of three Magi who would follow a star to his birthplace.[13]

4. Jesus, the "Light of the World,' was born December 25th.

Mithras, the solar "Lord of Light," was reputed to have been born on December 25, a traditional birthday assigned to many Sun Gods. Originally Jesus' birth was celebrated in the spring, but it was later changed to its current date in order to coincide with the birthday of Mithras and other Sun Gods.

5. Jesus came to battle the Devil and his legions of demons.

Mithras' *raison d'être* was to defeat Ahriman, the Persian "Devil," and his denizens. Ahriman was an ancestor of the Christian Devil. As confirmation of this truth, one of the Devil's monikers, "Oh Henry," is reputedly derived from the name Ahriman.

6. Jesus came in his "Father's name;" Jesus said that he and his Father were One.

Mithras came to Earth in order to serve his "Father," known as both Ormuzd or Ahura Mazda, by defeating his eternal nemesis, Ahriman. Mithras was said to be both the Son of Ormuzd, as well as synonymous with him. Ahura Mazda was the Divine Light and Mithras was the embodiment of that Divine Light on Earth.

7. Following his crucifixion, Jesus emerged, reborn, from a cave which had been covered over with a huge rock.

Legends contend that at his birth Mithras emerged from a large rock. Later, one of Mithras' esteemed symbols were rocks.

8. Jesus brought together his 12 apostles for a Last Supper during which he served them bread and wine, symbolic manifestations of his body and blood respectively.

Mithras is reputed to have gathered 12 devotees for a Last Supper in the waning moments of his life on Earth. During his Last Supper Mithras shared bread and wine which symbolized his blood and body.

9. After three days Jesus arose from the dead on Easter.

In certain branches of Mithras' cult the Persian Son of God was asserted to have undergone a death and arose from the dead after three days. His devotees celebrated his resurrection on or near what later became the Christians' Easter.

10. Jesus ascended into Heaven in the springtime.

Mithras also ascended back to the kingdom of his Father in the springtime.

11. Jesus is prophesied to return at the end of time and oversee the "Rapture," the raising of the righteous from their graves and tombs and their ascension into Heaven.

Mithras guaranteed his devotees that he would return at the final hour of the world's existence to raise the righteous from their graves and bless them with eternal life.

12. Jesus will return for the Armageddon, the final battle with the Devil and the forces of evil. It is predicted that the Devil will be defeated, bound and gagged, and then tossed into the "bottomless pit."

Mithras, the god of contracts, is scheduled to return for one last battle with Ahriman, when the dark lord's earthly contract has expired. At that time Ahriman and his denizens will be slain, removed from the surface of the Earth, and tossed into an underworld "pit."

Christianity versus Mithraism

1. To become initiated into the path and teachings of Jesus Christ, a liquid baptism was required to wash away past sins.

To become a devotee of Mithras a person was required to wash away accumulated impurities through a baptismal bath consisting of a bull's blood. On occasion water was substituted for bull's blood.

2. The early rites of Christianity were observed in the underground catacombs of Rome.

Mithras' rites were observed in dark, underground temples designed to simulate the clandestine caves found in nature, which were the original habitats of Mithras' rites.

3. The holy day of the week in Christianity became Sunday.

Mithras' holy day was Sunday because he was a solar god and Sunday is the day of the week dedicated to the worship of the Sun.

4. The Holy Communion of Christianity became the sacrament of bread and wine symbolizing the body of Christ.

The followers of Mithras were instructed by their esteemed Son of God to worship him with a communion of bread and wine while he was away. This communion was to take place on Sunday, Mithras' sacred day.

5. Seven Sacraments, loosely regarded to be rungs up the spiritual ladder, were implemented in the Catholic Church.

In Mithraism an initiate gradually advanced through seven degrees of attainment.

6. Christianity promulgated a belief in Heaven and Hell and Eternal Life. Such beliefs were a departure from traditional Jewish theology.

The followers or Mithras believed in the heaven of Ormuzd and the hell fire of Ahriman. With Mithras' grace they could achieve eternal existence in heaven.

The Three Wise Men, devotees of Mithras?

According to historical fact, not only Saint Paul but the Three Wise Men who visited Jesus' nativity in Bethlehem were devotees of Mithras. Like the apostle, they also apparently believed that the newborn Messiah was the incarnated Mithras. The Three Wise Men of legend were Magi, Zoroastrian priests from Persia who oversaw the temple rites of Mithras within their Asian homeland. Their appear-

ance at the Messiah's bedside was the fulfillment of a prophesy made by the great sage Zoroaster, which stipulated that the Magi would be present at the bedside of the incarnated Mithras. According to Marco Polo, the Three Wise Men were indeed Magi from Persia, a truth the Venetian merchant discovered during his famous journey across Persia to China. In the book of his travels Marco Polo states:

"In Persia there is a city which is called Saba, from whence were the Three Magi who came to adore Christ in Bethlehem; and the three are buried in that city in a fair sepulcher, and they are all three entire with their beards and hair. One was called Baldasar, the second Gaspar, and the third Melchior."[13]

When visiting the Persian tombs of the Three Wise Men Marco Polo was told a curious legend by the village historians which revealed that the Magi fully believed that the baby Jesus was the incarnated Mithras. According to the ancient legend, after the Magi had arrived in Bethlehem and bestowed their prayers and blessings upon the newborn Messiah, the baby Jesus gifted them with a magical stone while somehow communicating to them, perhaps telepathically, that they were to return home with it and forever worship the rock as sacred. But soon after leaving the bedside of the Messiah the disbelieving Magi disregarded the explicit instructions of the Son of God and carelessly tossed the stone into a pit, at which instant the rock combusted and flames of fire arose in its place. The repentant Magi, realizing their oversight in not treating the stone as holy, captured a portion of the stone's fire and sadly completed their journey to Persia with it in tow. Following their return to their Persian homeland they placed the fire in one of the Zoroastrian temples of Mithras and gave the presiding Magi priests instructions to keep it burning indefinitely.

Marco Polo's myth of the Three Wise Men reveals unequivocally that the Magi recognized the newborn Jesus as Mithras. This can be concluded because rock and fire were both definitive symbols of Mithras, the Persian Son of God whom had been born from a rock and was traditionally worshipped as an eternal flame kept burning within the Magis' temples, which were known as Dar-i Mihr, the "Court of Mihr"[15] (Mihr was a name for Mithras).

The Chi-Rho, Symbol of Jesus or Mithras?

Another seemingly indisputable link between Jesus and Mithras is Jesus Christ's monogram, the Chi-Rho or Labarum, which is derived from the first two letters of the Greek word for Christ. The Chi-Rho, which unite as the word "Christ," was adopted from Mithras, the Sun God who for thousands of years had shared the symbol with other solar deities.[16] The symbol had been inscribed by solar

worshippers on rock faces as early as 2500 B.C., and it was known to have been engraved upon coins minted by the Alexandrian Ptolemies, the Greek monarchs who were recognized by their subjects to be Egyptian pharaohs and human incarnations of the Sun. The Chi-Rho's solar affiliations can also be gleaned from its alternate designation, that of "Labarum," meaning "Everlasting Father Sun."

The Chi-Rho is first mentioned in Christian history in association with the Holy Roman Emperor Constantine, the ancient ruler reputed to have adopted Christianity as the faith of his empire. According to the church historian Eusibius, the king first saw the symbol blazing in the sky just before winning the pivotal battle of Milvan Bridge, and soon afterwards he accepted Jesus as his savior and Christianity as the new religion of the empire. What this Church Father neglected to tell us is that while Constantine may have accepted the fundamentals of Christianity, the emperor did not convert to the faith until he was on his deathbed. In truth, Constantine remained a lifelong worshipper and priest of the solar god Sol Invictus-Mithras and proved his devotion to Mithras by making the national holy day of the Roman Empire Mithras' holy day, Sunday, which he called Dies Solis, the "Day of the Sun," in honor of his solar deity. In actuality, Constantine was no stranger to the Chi-Rho symbol, and when he envisioned it in the heavens he no doubt felt compelled to honor it as the ancient symbol of his beloved Mithras, his guiding light and the principal deity of most Roman emperors who had preceded him to the throne. Certain Roman emperors, including Nero, Diocletian, and Aurelion even recognized themselves as incarnations or descendants of Mithras. Thus, when he eventually won his battle, Constantine would have attributed his success to the Sun God of the Roman Empire and not to Jesus. It must also be acknowledged that Constantine must have associated the Chi-Rho with Mithras because he commanded his soldiers to engrave the symbol on their shields before going into battle. Constantine's soldiers, like nearly all soldiers of the Roman Empire, were devotees and initiates of Mithras and only entered battle with the confidence that the Persian savior was at their side. They would never have thought to fight in the name of an unknown savior or god, because by doing so they would not only risk their lives, but the eternal life promised by Mithras. Constantine was aware of this, and being a brilliant strategist he knew that the only way his soldiers would consent to have the Chi-Rho adorning their shields was if they believed it was the symbol of their beloved Mithras.

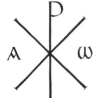

The Chi-Rho or Labaram

Paul, Author of the Q Gospel?

Paul's revisions of Jesus' legend and his amalgamation of Mithras' life to it apparently influenced the content of the Synoptic Gospels, the four Biblical texts which are the definitive authority regarding the Christain Messiah's life. Contemporary scholars theorize that the Biblical Gospels were probably based upon a standardized gospel, the hypothetical "Q Gospel," which may have been composed by Paul or one or more of his students. One current theory asserts that the Q Gospel was synonymous with the first gospel to be authored, *The Gospel of Mark,* but since Mark was a student of Saint Peter and not himself one of the 12 Apostles, the question of where Mark gathered the information for his gospel remains speculative and dubious. A plausible explanation is that not Mark, but Paul, is the author of the obscure Q Gospel and that Mark used Paul's narration as the model for his own version of the story. This seems probable considering the numerous "pagan" references to Jesus accorded to Paul which became part of not only Mark's Gospel, but the other three Gospels as well. Such paganistic references include "the Only begotten Son," as well as the "Logos," which is a Greek term for the "Divine Mind" and "Word of God."

But whether or not one accepts Mark's version of Jesus' life story as an evolution of Paul's, it must be accepted that *The Gospel of Mark* is full of secondhand and biased information and therefore cannot be trusted as an accurate account of the Messiah's lifetime. It has been proven that some of the information used by Mark was borrowed directly from the Jewish historian Flavius Josephus' and his *Antiquities*, and that other sources in his Gospel were distorted by the apostle in order to gain a more favored and widespread following for his ministry. This, at least, is the testimony of Clement of Alexandria, one of the earliest Church Fathers, who claimed that Saint Mark incorporated into his gospel only that information which would best accommodate his students. In a letter to a confidant named Theodore, Clement laments:

"(As for) Mark, then, during Peter's stay in Rome he wrote (an account of) the Lord's doings, not, however, declaring all, nor yet hinting at the secret (ones), but selecting those he thought most useful for increasing the faith of those who were being instructed."[17]

II
The Peacock Angel:
The Beginning of The Christ Myth

The previous chapter was dedicated to scrutinizing Jesus' myth and revealing it to be, in many ways, a spurious rendition of Mithras' legend. In this chapter we will take another step backwards in time and show that Mithras' myth was itself based upon a more ancient legend, the myth of Murrugan, the Peacock Angel, from India. Thus, like so many religious traditions worldwide which are rooted in India, in order to discover the origins of The Christ Myth we must turn to the Asian subcontinent.

The Myth of Murrugan, The Peacock Angel

Many thousands of years ago in Bharata Varsha (India's ancient name) there emerged the legend of a Son of God known as Murrugan or Mitra (or Skanda, Karttikeya, and Subramuniya, he had many titles), who was the Son of Shiva and Shakti, the primal God and Goddess. Murrugan or Murruga, a name derived from Mayura, Sanscrit for Peacock, was also known in other parts of the East as the Peacock Angel and recognized to be the first and greatest Son of God.

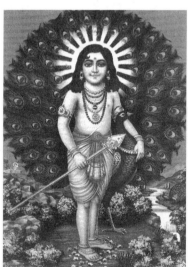

Historians acknowledge Murrugan to be a very ancient deity. As Mitra, he is mentioned in the *Rig Veda*, a scripture authored at least five thousand years ago and quite possibly the oldest surviving scripture in the

world. Murrugan or Skanda (another of his names) is recognized by the Tamils and the Adavasis, the "First People" of India, to be one of the oldest deities of the Indian subcontinent. In some of their scriptures of these early Indians Murrugan is linked with Agastyar, an ancient sage of the semi-mythical Pandyan Kingdom, an empire that the Tamils of south India claim existed thousands of years ago upon a land mass connecting India to Sri Lanka and Mu or Lemuria, a fabled Pacific continent that the *Sillapadakaram* (a Tamil text) refers to as Kumari Nadu, the "Land of the Kumara."[1] In his ancient homeland Agastyar promulgated the wisdom of Shiva (he is know traditionally as the first teacher of Shaivism) and a version of the Christ Myth, wherein Murrugan was referred to as Kumara, meaning "Androgynous and Forever-young boy." When the Pandyan Kingdom eventually sunk to the bottom of the Indian Ocean, Agastyar took the legend of Murrugan north into south India and established an ashram for its propagation. From Agastyar's retreat in the Pothigai Hills, the myth was taken by his students to all parts of ancient Bharata Varsha. Today, in reference to Agastyar's link to Murrugan, the *Puranas*, the ancient legends of India, refer to him as the "Son of Mitra." Some of these same texts also link Agastyar and Murrugan with Lemuria and the Pandyan Kingdom. They maintain that Murrugan's principal centers of worship, as well as the places associated with his birth and marriage, include Palni in south India and Katirgama in Sri Lanka, two locations which were anciently nearby or connected to the legendary Pandyan Kingdom.

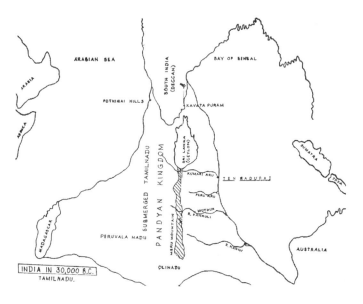

The Pandyan Kingdom

The Contemporary Myth of Murrugan

Considering the extreme antiquity of Murrugan's legend and the vicissitudes of the Indian subcontinent it has thrived within, it would be presumptuous to claim that it has not undergone numerous changes over time, especially considering that patriarchal theologians worldwide have been known to rewrite many indigenous legends of the more ancient matriarchal traditions with their own ideological slant, such as the myth of the Egyptian Seth, who was once the greatest of Egyptian deities and later became a demon. Murrugan's legend emerged out of the matriarchal Tantric traditions of the south Indian Adavasis before being adopted by the Vedic, patriarchal theologians of north India. The Adavasis' nature and Goddess worshipping proclivities, which perceived one homogenous principal manifesting throughout the Earth, designated Murrugan a god of nature. They and the other Tamils worshipped him as the androgynous life force from which crystallized all physical form, especially the vegetative forms which are renewed annually. As the life force and Son of Shiva and Shakti, Murrugan was also recognized to be the embodiment of the universal polarity in all its myriad manifestations, including hot and cold, light and dark, and good and evil. This ancient Son of God was, therefore, androgynous.

It has been speculated that the Adavasis may have adopted their conception of androgynous Murrugan from Agastyar, since the ancient missionary and his students coexisted with the early southern Tamil population. Like the Tamils, Agastyar and many of his students, including Babaji and Bogarnath, the founders of Kriya Yoga and Rasayana, or Hindu Alchemy, are known to have conceived of Murrugan as the androgynous life force. But in contrast to the Adavsis, their goal was alchemical transformation. The focus of their worship was directed at awakening Murrugan in his manifestation as the Kundalini, the life force coiled at the base of the human spine. All the practices of Agastyar's disciples, who are known historically as the Maheshvara or "Shiva" Siddhas, were designed to awaken the inner Kundalini or the Serpent Power, which would then alchemically transform them into immortals like their beloved Murrugan.

Thus, we may never know the content of Murrugan's's original myth unless, perhaps, we examine manifestations of other Son of God legends around the world which have survived the Patriarchy's treatment of the ancient Goddess culture (we will do this in Chapter VII). But for now it is enough to discern elements within the various Son of God myths of the East and West which link them together and reveal their common roots. We can certainly do that with the current version of Murrugan's myth, which as you will see shares many common elements with the legend of Jesus Christ.

Murrugan's "Christ Myth"

According to the current, popular "Christ Myth" of Murrugan, the Hindu Son of God was born from Shiva and Shakti, and was thus the Son of a Holy Trinity. Shiva, his "Heavenly Father," sent Murrugan to Earth to rid the planet of the evil Asuras, the "Fallen Angels," who were threatening to destroy humanity. With the help of his golden spear or lance, Murrugan decimated the king of the Asuras, the Hindu "Devil," and then proceeded to exterminate many of the dangerous animals which roamed Earth's surface. Once righteousness had been restored and humans were again safe and protected from evil, Murrugan commenced his role of Savior of Humanity and taught the path of yoga which would assist those humans ready for rapid spiritual growth. Then, once he had completed his earthly mission, Murrugan transcended into other dimensional realms where he continues to protect his devotees while monitoring the spiritual evolution of all humanity.

Since his departure, Murrugan, like his Christian counterpart, Jesus Christ, has been worshipped daily by his followers as the savior and immortal protector of all humanity. Similar to Jesus, Murrugan is also recognized as the "Way" which leads to redemption and immortal life. As such, Murrugan is specifically the patron of the various paths leading to enlightenment and immortality which utilize the disciplines of yoga and meditation. By following these practices and invoking Murrugan's unseen guidance, disciplined practitioners of yoga currently believe they can achieve moksha, spiritual liberation, and become immortal like their forever-young savior. And, if the Kumara is sufficiently pleased with the devotion and progress of his devotee, he might show his grace by manifesting physically in front of them as he did for Agastyar and his students Babaji and Bogarnath.

In regards to his ongoing role of humanity's protector, Murrugan is, like Jesus, often referred to as the Commander in Chief of God's Heavenly Host. In this capacity he is called Karttikeya, as well as Seyon, the "Red One," the warrior who dresses in vibrant, red robes and wields both a spear and a fiery temperament. Commander Murrugan often stands in proximity to a bright red cock, a symbol of his fiery commitment to righteousness and spiritual wisdom. Just as his symbolic red cock crows when the first rays of the morning Sun begin to pierce the darkness of night, Lord Murrugan similarly dispels the darkness of ignorance with his spiritual light.

A contemporary visitor in India will today find images of Murrugan scattered throughout the subcontinent, abundant testimonials to the prolific missionary work of Agastyar and his students. Murrugan is traditionally depicted as a forever-young boy of about eight to twelve years of age. His

religiously installed images either stand alone inside or outside of his ornate temples, and sometimes they are accompanied by images of his mythical parents, Shiva and Shakti, along with his elephant-headed brother, Ganesh. Like Murrugan, Ganesh emerged from the earliest tribes of India, which were known as "Gans."

One characteristic feature of Murrugan's temple compounds' are statues of his symbolic bird, the peacock. Often, the image of a peacock will be found standing guard outside of Murrugan's temple while facing the Son of God's indwelling, forever-young image. The peacock is Murrugan's sacred animal because through its form, character and bodily adornments it exemplifies the attributes of the Son of God. The way that the peacock feeds upon the "evil" snakes which threaten the safety of humans, for example, symbolizes the Hindu Christ's commitment to protection and righteousness. And the peacock's notorious, cantankerous temperament reflects the fiery nature of Murrugan, while the "eyes" adorning the bird's prolific feathers reflect the omniscient nature of the Son of God who sees and knows all. The colors of red and blue that cover the peacock's exotic plumage reflect Murrugan's androgynous nature, as does the bird's predominant color, green, the "middle" color, which is the preeminent color of polarity union. The prevalence of blue and green on the bird's body also denote the polarity union of Heaven (blue) and Earth (green), or Spirit and matter (Shiva and Shakti) united.

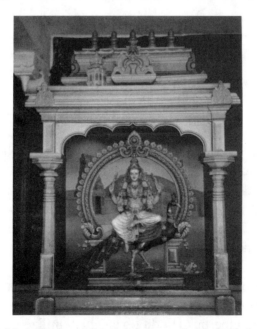

Lord Murrugan at his main temple in Palni, India

Murrugan's androgyny is also revealed by his form of a prepubescent, genderless boy, and it is intrinsic to his nickname, "Kumara." This appellation for Murrugan unites Ma and Ra, the primal syllables associated with the universal male and female principles, Shiva and Shakti, with Ku, the sound syllable of the immortal Son of God.[2] The three syllabled Kumara also denotes the Holy Trinity and the three of powers of Cosmic Fire (see below).

Rudra: Murrugan as the Word and Life Force

Like Jesus Christ, Murrugan's theologians have associated the Hindu Christ with the "Word" of God. This primal Word is, according to the Apostle John, the form taken by Christ when he created the physical universe. This Word is the Judeo-Christian "Amen," a version of the AUM of the Hindus. Both syllables are signature sounds or names for the Son of God in his primal manifestation. From a sacred-scientific perspective, AUM or Amen is the vibration that created life by precipitating the creation of a super-refined form of the life force, known as "Cosmic Fire." As this Cosmic Fire condensed, it initially manifested as physical fire before additional cooling and coalescing shaped it into the various forms which now populate the physical cosmos. Not surprisingly, when the symbol of AUM is turned on its side, it becomes a trident, the ancient symbol of fire and fire gods.

In his form of Cosmic Fire Murrugan is known as Rudra, meaning "red," "fiery" and "the Howler." Hindu scriptures depict Rudra as an unclean and grotesque wildman with volatile and unruly behavior, thus making his personna reflect capricious, uncontrolled fire. Rudra's legendary weapon, the trident with its three prongs, symbolizes the three powers intrinsic to the AUM and Cosmic Fire: creation, preservation and destruction. Cosmic Fire is an alternate name for prana or chi, the life force which creates, preserves, and destroys the cosmos. From a cosmological perspective, Rudra is the personification of the primeval, fiery soup of volatile atoms that violently smashed against each other during the first moments following the Big Bang.

There are numerous Hindu texts which utilize symbology and allegory to designate Rudra as the primal "Word" and Cosmic Fire it radiates.

For example, one of the eighteen *Puranas*, the *Shrimad Bhagavatam,* states that at the beginning of the creative process Rudra as a forever-young Kumara emerged out of Shiva's Third Eye of Wisdom, the universal seat of the cosmic AUM. In addition, the *Bhagavatam* states that Rudra's complexion was a vibrant red, the color of Cosmic Fire. Rudra, the AUM and Cosmic Fire are, therefore, synonymous. The *Bhagavatan* also links Rudra with the polar opposite colors of yellow and blue, the male and female colors which unite philosophically as the "androgynous" red of Cosmic Fire. Rudra's three associated colors of blue, yellow and red correspond to the three prongs of his trident, the Holy Trinity, and the three powers intrinsic to Cosmic Fire. In this regard, blue is associated with creation, yellow with preservation, and red with destruction.

According to the *Vishnu Purana,* after Rudra as Cosmic Fire created the universe he divided his Cosmic Fire body into its blue and yellow component parts, his "Sons," thus giving order and stability to the new cosmos. Lord Rudra is also reputed to have insured cosmic harmony by giving birth to angels known as Rudras and Maruts, who were assigned the roles of controlling the weather and policing the universe for unrighteousness.

In Egyptian cosmology Rudra is known as Ptah, the fire god and creator of the universe, who divided himself into his polarity, his twin boys, the Kaberoi, and thus established order in the cosmos. In Judaism he is the red-colored Samael, the destructive and unruly Spirit of Fire, which the Aramaic *Targums* refer to as the first and greatest of the angels, and in Roman mythology he is Vulcan, the smith god. Rudra is also closely associated with the Jewish Cain, the first son of the primal couple, Adam and Eve. Cain, meaning "Smith," is closely associated with both Vulcan and Cosmic Fire.

Murrugan is also the Eye or Fish

Another symbol of Murrugan which links him with Jesus is the vesica pisces, which is known popularly as the "Eye" or "Fish" symbol of the Son of God. The vesica pisces, which is the intersection of two joined circles, symbolizes the union of the male and female principles, is an archetypal symbol of the Son of God. Like the Word, the vesica pisces is also related to Cosmic Fire, because the union of the polarity (as Shiva and Shakti or the male/female genders) produces life and the life force. Sacred scientists concur that the vesica pisces has been around since the beginning of time and claim it is the first geometrical form from out of which all others have emerged.

According to one metaphysical perspective, it because of the vesica pisces "eye" that the Son's presence and consciousness currently pervades

the entire universe. Following the creation of the first, primal vesica pisces by the divine union during the initial moments of Creation, the fish or eye rapidly multiplied until it filled the cosmos. When the Son's eyes had filled the universe, he became completely omniscient. The classical symbol of the rapid multiplication of the vesica pisces is the "Flower of Life," a symbol of Osiris, which is composed of innumerable vesica pisces (see Chapter IX).

The Vesica Pisces: it becomes both an Eye and a Fish

Murrugan's special version of the vesica pisces worshipped by his followers is the "eye" of a peacock feather, which is a "tear drop" version of the vesica pisces "eye." Collectively, all the eyes adorning a peacock's fanned-out plumes represent Murrugan's myriad eyes which pervade the entire universe. The popular "fish" symbol of Jesus Christ is a more traditional and symmetrical version of the vesica pisces, but it is also intimately related to the peacock "eye." The fish or eye manifestations of the vesica pisces preexisted and foreshadowed its adoption by Christian theologians by many thousands of years.

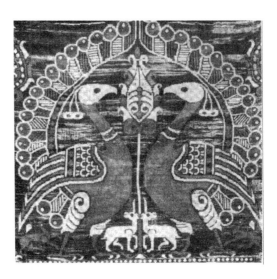

In this Moslem motif the vesica pisces "fish" unites with peacocks.
The symbols of Jesus Christ and the Peacock Angel are here united.

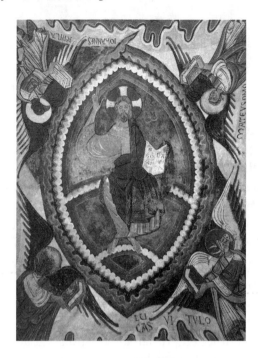

Jesus in a Vesica Pisces motif. From"Christ in Glory"

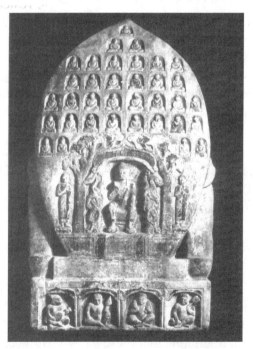

All Sons of God, including Jesus and the enlightened Buddhas, have been depicted within Vesica Pisces motifs,

Sanat Kumara:
Murrugan as King and
Guru of the World

After the Son of God's vesica pisces eyes had filled the universe, he began to watch over and protect his creation while governing it as its ruler. It is because of the governing role of the Son that Murrugan, Jesus Christ, and Osiris have all been worshipped by the mystics and gnostics of their respective traditions as the Lord and King of the Cosmos.

But besides being King of the Universe, both Murrugan and Jesus have additionally been referred to as King and Guru of our Earth. Murrugan's overlordship of our planet is symbolized by his solid gold peacock throne which greets visitors to his principal temple at Palni, in south India. In his function of King and Guru of the World, Murrugan is known by an additional moniker, that of Sanat Kumara.

Sanat Kumara is a very interesting character. Besides playing a major role in Hindu mythology, he is also distinguished by having an actual (sometimes physical, sometimes etheric) manifestation on Earth. Monks and yogis of the East, for example, claim to have visited him at his palace in the Gobi Desert of Central Asia, one of the first locations Sanat Kumara supposedly gravitated to after arriving from the planet Venus six million years ago. Confirmation for Sanat's existence can be also found in the writings of numerous western adventurers and researchers who have traveled across central Asia over the last two hundred years and either met the King of the World or heard of him from natives who had. This group of intrepid adventurers includes the German archaeologist Max Muller, Ferdinand Ossendowski of Russia, the French Consulate Louis Jacolliot, and distinguished members of the Theosophical Society (which once had its principal headquarters near Madras, India). Each has, in his own way, steadfastly maintained that Sanat Kumara was (and is) the Lord of Lords and Priest King over the entire Earth.

Some of the Asian legends gathered by the western explorers in Asia, include those compiled by the Sungma Red Lama (a.k.a. Robert Dickhoff), a western seeker who studied with the Buddhist Lamas of the East and contends that Earth's first Guru arrived from Venus with a large entourage. Sanat and his entourage ruled over the Pacific continent of Lemuria, says another westerner, the enlightened Master Satguru Sivaya Subramuniyaswami of Hawaii, who claims to be able to read directly from the Akashic Records. Subramuniyaswami maintains that these early visitors came to Earth during the Satya Yuga, the Golden Age of Wisdom, and their leader, Sanat Kumara, then assumed the role of "Celestial King of Lemuria." [3]

According to Ossendowski, a man who studied directly with Buddhist monks in Mongolia, upon his arrival Sanat Kumara announced that his name was AUM,[4] the vibrational sound or signature of Cosmic Fire whose three letters denote the three aspects of the dynamic life force.

Sanat Kumara's role as World Guru is introduced near the end of the *Chandogya Upanishad,* wherein the First Born can be found in conversation with the great sage Narada. At the outset of their profound dialogue the distraught Narada laments that even with his mastery of scriptural knowledge he has not been able to find true inner peace. But when Sanat Kumara reveals to him the wisdom of the Self that transcends all book learning and leads to eternal joy, Narada gains renewed hope and enrolls in the service of the forever-young boy as his devoted disciple. In a similar fashion Sanat Kumara has assumed the role of guru to many other important sages on Earth, thus meriting the title of first and greatest teacher of the Siddha Marga, the "Path of the Perfected Ones."

One esoteric legend maintains that the wisdom which Sanat propagated eventually became the foundation of the worldwide Goddess or Tantric spiritual tradition. The wisdom of alchemy and yoga which he taught was brought by him from Venus, the planetary seat of the Goddess in our Solar System, and designed to culminate in the awakening of the Goddess in Her manifestation as Kundalini at the base of the human spine. Sanat Kumara, the master of Cosmic Fire and wielder of its three powers, was a Master of this fire and well qualified to establish schools of yoga on Lemuria for those ready to awaken it and undergo rapid spiritual evolution. Eventually, Sanat Kumara founded the Great White Brotherhood in order to preserve the Goddess' alchemical teachings and spread them around the globe.

Having originated from Venus, the planet of love, Sanat Kumara was also the master of the power of love. Love is a form of Kundalini fire; it is the passionate fire generated by the union of the polarity. Tradition links Sanat Kumara with the *Bhakti Sutras*, the "Aphorisms of Love," which he is reputed to have dictated to his principal disciple, the sage Narada. Sanat also taught Narada and his other students to use the name "Kumara" as a mantra for love. He taught that it can be used as a powerful alchemical tool for uniting the internal polarity and opening the heart chakra.

One final but very important note. With his manifestation as Sanat Kumara, Murrugan takes a step closer to being not only an ancestor of Jesus Christ, but synonymous with him. Legend states that when Sanat Kumara came to Earth from Venus he arrived with his Kumara brothers, one of whom was named Sananda Kumara, which is the esoteric name for Jesus Christ. But more than just being Sanat's brother, Sananda was also a part of Sanat. He

was a personification of Sanat's higher self, thus making Sanat and Sananda one united entity. The notion of Sananda/Jesus being synonymous with Sanat Kumara will be further explored in Chapter III.

The Myth of the Son of God migrates West

Eventually, the myth of Murrugan moved westward from India. It became part of the Persian spiritual tradition, as well as a component of certain Middle Eastern religions, including the Judeo-Christian religion of Palestine. Within these faiths Murrugan became known by many names. He was worshipped as Mithras, the Lord of Time, Jesus Christ, and Melek Taus. Melek Taus, a deity worshipped by the Yezidhi Kurds of Iraq, has been called a manifestation of Satan of the Devil. Thus, via his western migration, androgynous Murrugan divided into his polarity, Christ and Satan, the Lords of Light and Darkness.

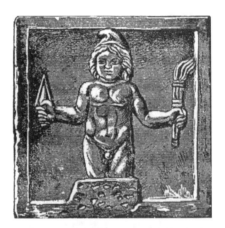

The Peacock Angel as Mithras
with his fiery torch and dagger

Mitra, Mithra and Mithras

Murrugan's march across Asia begins in India with androgynous Mitra, a manifestation of Murrugan alluded to in the *Rig Veda*. In ancient times Mitra, whose name means "contract" and "friendship," ruled over contracts and interpersonal relationships. He was the lord of balance responsible for overseeing all vows, contracts, and friendships between people and he was called upon by both merchants and marriage partners alike to protect and monitor their contracts. Righteous Mitra rewarded those who abided by their contractual responsibilities and punished those who were remiss in their agreed-upon duties. As the preeminent deity of balance and fairness, Mitra was wor-

shipped by his devotees as an androgynous god.

Mitra formed a partnership with Varuna, the sky god who oversaw man's relationship with the Creator. Varuna's role was to determine the karmic consequences of those who did not live in alignment with divine law and thus transgressed their earthly contracts with Spirit. Both Mitra and Varuna were associated with the Sun and its daily passage through the heavens. Mitra ruled the time of day associated with the balance of light and dark, i.e., sunrise and sunset, and Varuna oversaw the rest of the day, when the Sun slowly ascended and descended from its highest point in the sky.

During the Aryan expansion westward into Persia, Murrugan as Mitra became Mithra or Mithras, meaning "contract." Some academics might argue that the Aryans settled in India and Persia simultaneously, and therefore neither nation could claim to have preceded the other. However, no settlement has been found in Persia as ancient as the Aryan settlements of Harrapa and Mohenjo-daro in the Indus Valley, and no Persian scripture has been discovered as old the *Rig Veda*, which is possibly the most ancient surviving spiritual text in the entire world. This ostensibly points to the Aryans having arrived in India first before initiating their westward movement of Indo-European culture into Persia. But even if one argues that neither Mitra or Mithra preceded the other, their ancestor Murrugan most definitely preceded them both. Murrugan emerged out of the Dravidian or Tamil civilization of south India, a culture which thrived thousands of years before the Aryans entered either north India or Persia. Therefore, history appears explicit in maintaining that the Christ Myth began with Murrugan in India and then spread westward as the legend of Mitra or Mithra.

In Persia, Mitra became Mithra, the androgynous savior adored within the faith of Zoroastrianism. Like his Hindu counterpart, Mithra was worshipped as the mediating god of balance and his sacred "element" was that of fire. The keepers of his temples, known as "fire temples," made sure to keep the indwelling flame lit; otherwise the guidance and protection arriving from Mithra might also be extinguished. In his temples, Mithra was traditionally portrayed standing between or in conjunction with the "Dadophori," the twin torch bearers. Later, when Magi priests of the Persian empire took Mithra to Asia Minor and built a religion around him, Mithraism, Mithra became known as Mithras and acquired legions of devotees from both Asia and Europe.

The primary functions of Mithra or Mithras was to mediate between Ahura Mazda or Ormuzd, the Lord of Light, and Ahriman, the Lord of Darkness. To accomplish this important task he occasionally incarnated physically on Earth, the middle realm between Heaven and the underworld, where the two gods fought for supremacy. As a reflection of the Hindu Murrugan,

Mithra's functions included subduing the forces of darkness when they became ascendant on the Earth plane, even if it meant confronting them in physical combat. For the purpose of fighting off the darkness, which was recognized as Ahriman in Persia, Mithra, like Murrugan, always carried a sword or dagger.

Mithra was also the principal deity of the Persian monarchs, the Asian kings who wore golden-pointed crowns symbolizing Mithra's solar radiance. For these rulers, Mithra was the solar god who could bring victory in battle as well as steady prosperity to their Persian kingdoms. No Persian king ever dreamt of entering a battlefield without first making a prayer and offering to Lord Mithra.

Mithra was thus the King of Kings and the throne behind the throne of all Persian monarchs. He was the Persian version of Murrugan or Sanat Kumara and the acknowledged King of the World. Every Persian monarch was his loyal and obedient vassal.

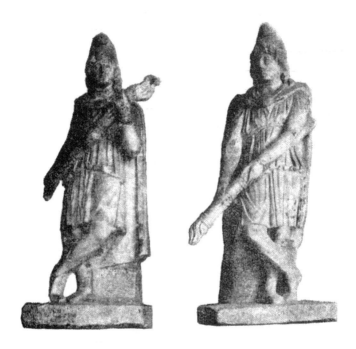

Mithras' Dadophori
Mithra's Dadophori were his Twin Flames, his polar opposite halves. They were the Persian version of fiery Rudra's polar opposite halves, and the counterparts of the Kaberoi Twins, the Twin Flames that the Egyptian fire god Ptah divided himself into when he created the cosmos.

Mithra and the Mihragan

In Persia Mithra was also known as Mihr, and the Persian fire temples were called Dar-i Mihr, the "Temples of Mihr." The most popular annual celebration of Mihr in Persia was the "Mihragan," a name which obviously links Mithra as Mihr to the Hindu Murrugan. The activities of the Mihragan, which included bloody sacrifices, prodigious consumption of wine, and joyous, unbridled dancing and feasting, reflected the raucous celebrations of Murrugan in south India.

The sacred Persian festival of the Mihragan was the most auspicious time to both honor and directly commune with Lord Mihr. It was celebrated during the androgynous Son's most sacred time of the year, the autumn equinox, the day when light and dark balance each other. Mithra's holy day was later changed by the Persian Son's reformers to the sixteenth of September, a day of balance situated in the middle of the "seventh" month of twelve months (Sept means seven), but Mihr's conservative devotees continued to celebrate it on the equinox. Today the festival is principally celebrated at the spring equinox, the time of the year when the ancient Zoroastrians once celebrated the resurrection of Mithra.

The Mihragan was initially observed over much of Persia, but because of the bloody animal sacrifices involved in the rite it has now become circumspect and only celebrated in certain remote towns of Iran, especially those located within the Yazdi plain.[5] Over the course of five days in February these towns come alive with feasting, dancing and the sacrifice of live goats in honor of Mihr. In the spirit of their ancestors, the people of these towns continue to give thanks for the bounty bestowed upon them by Mihr, their beloved savior, protector and provider.

The Yezidhi and Melek Taus, the Peacock Angel

Besides traveling to Babylonia and becoming Mithras, Persian Mithra also found a home in another part of Asia. Persian missionaries of Mithra left their city of Yazd or Yazdi and its surrounding plain before traveling to what is now northern Iraq and transmitting Mithra's doctrines and rites to the area's population of Kurds. These Persian missionaries and their descendants mated with the native Kurds, thus engendering a new people, the Yezidhi, the "People of Yazad." The term Yazad became both an identifying name for the Persian missionaries' city of origin, Yazd, as well as a name for Mihr.

For the central deity of their religion, the Yezidhi chose Melek Taus. Melek Taus was Mihr in his ancient form of Murrugan, the Peacock Angel. He was referred to as both Malak Taus, the "Peacock Angel," as well as

Melek Taus, the "Peacock King," thus acknowledging his status as both King of the World and the Universe.

With Melek Taus as their centerpiece, the Yezidhi fabricated a religious tradition composed of elements from both the East and the West. Situated as they were on the crossroads of caravan routes leading to and from Europe and Asia, the Yezidhi were continually exposed to many foreign ideologies, including that of Christianity, Gnosticism, Mithraism and Sufism. Great synthesizers that they were, the Yezidhi created a unique faith built upon such practices and ideas as circumcision, Heaven and Hell, and the seven Sufi levels of spiritual advancement. To guide them, the Yezidhi even had their own version of a "pope," the "Mihr,"[6] who was acknowledged to be a representative of Melek Taus.

As the years passed a class of prophets emerged within the Yezidhi religion who claimed to have received direct revelation and possibly a visit from Melek Taus. Some Yezidhi prophets maintained that they had received direct telepathic communication from the Peacock Angel and thus learned many secrets regarding the Son of God, including his divine birth at the beginning of time when he manifested as the first and greatest of all the angels. Such prophets eventually identified Melek Taus with the deities of other religions, thus referring to him as Sanatel, the firstborn Son of the Gnostics; Samael, the Jewish deity of Cosmic Fire; and Azzazel, the first born angel and leader of the Fallen Angels. Azzazel became the most popular of Melek Taus' names and the Yezidhi became "The People of Azzazel."

Perhaps the most important vision received by any Yezidhi prophet was reported by Sheik Adi b. Musafir, an important reformer of the Yezidhi whose tomb in Lalish, Iraq is the culture's most important shrine. According to Adi's own account of his inter-dimensional encounter, when he was merely twenty years of age the prophet was riding horseback one dark night through a desolate part of the Persian landscape when in front of him suddenly appeared "two camels with legs eight feet long, heads like water buffaloes, long bristly hair, big round ox-like eyes glowing green, and jet black skin, yet otherwise resembling a man."[7] Adi nearly fell off his horse in fright, especially when his gaze fell upon a nearby conspicuous tomb that quickly transformed into a minaret and grew straight upwards until it touched the sky. The towering minaret shook violently, along with Adi's knees and the surrounding countryside. Concluding that the end of the world was at hand, Adi feared for his life and was about to faint when his vision suddenly changed. The beneficent form of a forever-young boy with peacock feathers growing out of his hind end then appeared in front of him. With love in his eyes, the boy spoke thus:

"Fear not; the minaret may well fall and destroy the world, but you and those that hearken to you (the Yezidhi) will be unharmed and rule over the ruins. I am Melek Taus and have chosen you to proclaim the religion of truth to the world."[8]

Melek Taus took Sheik Adi to the highest levels of heaven, and then for what seemed to the Kurd like seven years or more taught him all the mysteries of the universe. When the training was finished, the Peacock Angel instructed his new prophet to return and "proclaim the religion of truth to the world."[9] Upon his return shortly afterwards, Adi found himself back in a world which was only a few minutes older than when he had left it.

During the remainder of his life Sheik Adi wrote down the life story of the Peacock Angel and codified Melek Taus' sacred rites for the Yezidhi priesthood. He amalgamated the information he had gathered in the next world to what other Yezidhi prophets had written about the Peacock Angel, and thereby helped construct the definitive Yezidhi legend of Melek Taus.

Currently, the standardized Yezidhi legend of Melek Taus, which is recorded in the *Mas'haf Rish*, "The Black Book," maintains that the Peacock Angel was born as the First Son and Creator of the Universe. He continued to retain his lofty position within the celestial hierarchy until the time of the Garden of Eden, when he was overcome by his own pride and ego and committed the cardinal sin of failing to bow down to Adam. At that moment Melek Taus became the "Fallen Angel," Lucifer or Azzazel (the name commonly used by Moslems and Jews for the fallen angel who demurred from bowing to Adam), and it was he who coerced Adam and Eve to eat of the forbidden food (although it was not fruit, but wheat, in the Yezidhi myth). The conclusion of the Yezidhi legend has the Peacock Angel assisting the

"Adam and Eve expelled from Paradise."

33

divine couple as they are escorted out of paradise for their transgression.

The wise Yezidhi prophets recognize Melek Taus to be the androgynous union of the God and Goddess. Like his ancestors Murrugan and Mithra, he is the union of higher self and lower self, light and darkness, and his legend is thus interpreted from this perspective. The Peacock Angel's fall from grace was the result of his dark polarity overwhelming his light half, thereby giving way to the darkness of egotistical pride. Adam and Eve, the divine couple who represent all early humans, were evicted after Melek's fall to symbolize that when the Peacock Angel fell from the limitations of the ego, so did all of humanity. This occurred because Melek Taus, which is a name for Sanat Kumara, the soul and King of the World, is the sum of all people on Earth. Collectively we reflect his evolutionary status and consciousness. When Melek Taus fell from grace by being overcome by his Luciferian ego, so did we. And since that fateful time Melek Taus has ruled the world as Lucifer or Azzazel, while we of Earth have remained immersed in our egotism and selfish pride.

But the Yezidhi prophets are optimistic and predict that eventually the Peacock Angel will atone for his transgression by recognizing his ego and disempowering it. As he does so all humans will also detach from the seductions of their egos and subsequently realign with the Higher Self and Divine Will. The Yezidhi claim that this process is occurring now, and soon Melek Taus will reclaim his exalted position as the greatest of all angels. His return to spiritual grace is known among the Yezidhi as "**The Redemption of the Peacock Angel,**" and understood to be the redemption of all humanity (see Chapter VI).

Because the Yezidhi refer to themselves as the "People of Azzazel," they have been intensely scrutinized by western theologians, who have dubbed them as infamous "Devil worshippers." It is true that the Yezidhi worship Satan, but not the diabolical Satan we are familiar with in the West. Their Satan is the Gnostic Satan, Satanel, whom they continue to recognize as the first and highest of the angels. By acknowledging the darkness of their deity they give power to that darkness, and thus perpetuate it. Since we in the West have heaped so many negative connotations onto the name Satan, the Yezidhi currently forbid its utterance in their company. This mandate includes not only the name Satan or Shaitan, but also any words with a "sh" prefix. Thus, the Yezidhi worship Melek Taus, not Satan, and strive to cultivate only the good qualities of Melek Taus, while also seeing them in each other. They perform good, charitable actions, seek to achieve Heaven, and aspire to cultivate an open heart. They claim that Melek Taus is always assisting them in cultivating such divine qualities and goals.

The King of the World in the Legends of the Hopi

Within the ancient Hopi tradition can be found an apparent reference and confirmation to the existence of Sanat Kumara and Melek Taus. This is the Hopi Massaw, the current King of the World. The Hopi claim that Massaw has ruled the planet at least as long as the beginning of the Third World, the Age of Atlantis, when tradition says humans made shields of hide and flew through the air upon them (interpreted by many as being flying saucers). Massaw was originally a righteous king, but during the Third World his actions began to be motivated by his self serving ego and he subsequently fell from the grace of the Great Spirit. He then became the Lord of Fire and patron deity of the Hopi Fire Clan, as well as the ruler of the underworld. But Massaw's rulership of the Earth's surface did not end with his abdication, and he later resumed his reign as King of the World at the beginning of the current Fourth World.

Massaw can also be found in other Native American traditions, thus ostensibly proving that the knowledge of Sanat Kumara was widespread throughout the Americas. The Yuma tribe of the American southwest, for example, refer to Massaw as Mastamho, a king and teacher of ancient times. The Algonquins remember him as Malsum, and the Cheyennes allude to him as an ancient teacher of their Massaum rites, the rites of the "Contraries."

The Hopi knowledge of Massaw may have been acquired from Lemuria. According to Hopi legend, the tribe arrived in North America after "island hopping" across the Pacific Ocean. After reaching the shore of their new land they turned to see many of the Pacific island stepping stones sink to the bottom of the ocean floor as the Third World ended and the Fourth World commenced.[10] Thus, while residing on the Pacific islands which were vestiges of Lemuria, the Hopi and other migrating tribes may have learned and assimilated the legend of Massaw. It is truly fascinating to compare the two names of the King of the World from opposite sides of the world, Massaw (also spelled as Massauu) and Melek or Malak Taus.

The Morrigan of Ireland

Another possible manifestation of Sanat Kumara or Murrugan is the war goddess of ancient Ireland known as Morrigan. Morrigan, whose name means, "Great Queen," appears to be a female counterpart of Murrugan, the King of the World. Morrigan is a "triple goddess," which means she is comprised of three goddesses and three powers, which may have originally corresponded to the three powers of creation, preservation and destruction. Like Sanat or Lucifer, Morrigan is also associated with death and the underworld.

The King of the World as the "Lord of Time"

During Mithras' westward migration, a belief in the ancient Son of God as the King of the World became the foundation of certain mystery school traditions. Three of these organizations, the Ishmaili, Roshaniya, and Illuminati, worshipped the King of the World as the "Lord of Time" and sought to align with him through special spiritual disciplines. Ultimately, some select members of these organizations attempted to conquer and control the world for their deity, which has lead many contemporary thinkers to conclude that all mystery schools have a hidden conspiratorial agenda to conquer the world.

The King of the World's title "Lord of Time" refers to the King's destructive or Luciferian power which manifests as both egotism and materialism. But the King's destructive power can also be transformative. Thus, the title Lord of Time is also a name for the transformative and ultimately liberating power of Kundalini. Kundalini transforms by destroying and purifying all impurities, concepts, and obstructing emotions which keep humans from realizing their inherent divinity. The aspect of the Lord of Time's destructive power which is invoked and utilized depends upon the consciousness and spiritual evolution of the summoner. Some members of the above mentioned mystery schools unwittingly chose to align with Sanat or Lucifer's materialistic and egotistical power, but there were also many in the organizations who sought to use the King of the World's power for spiritual growth.

The Ishmaili, Roshaniya, and Illuminati designed their mystery school traditions as vehicles for aligning with the Lord of Time's destructive power. The final degree of their traditions were thus known as "King," "King of the World" or "Father," and indicated that the highest initiates had achieved complete union with the Lord of Time's consciousness and power. These titles descended from ancient Mithraism, wherein the highest degree awarded was "Pater" or "Saturn." Saturn, the Planet of Time, is the king of the Solar System and a cosmic manifestation of the Lord of Time. Saturn is related to Satan, a name for Lucifer meaning "adversary." When Sanat Kumara "fell" into time and matter, Sanat became Satan.

Through their nine mystical degrees the Moslem sect of Ishmaili, the "People of Truth," committed themselves to uniting with the "Lord of Time" by accumulating Baraka, a name for Kundalini. Their main headquarters was Cairo, a city named after the planet Mars, the "Red Planet" which was sacred to the aggressive and destructive power of the Lord of Time. Mars was also sacred to the warrior aspect of Murrugan, who as "Karttikeya" is intimately linked with the planet Mars.

The Roshaniya, the "Illuminated Ones," was founded in the eleventh

century by an Ishmaili initiate, Bayezid Ansari of Afghanistan, for the express purpose of mobilizing an army of perfected men and women to govern the world in the name of the Lord of Time. In order to unite with the Earth's monarch, the Roshaniya spent many solitary hours meditating on their planetary king. As they did so, they learned numerous ways to move the destructive/transformative power of the Earth's monarch through them and thus promote the rapid expansion of either ego or spiritual consciousness. They also acquired supernatural powers which were deemed necessary for conquering the world and ruling it. Once a Roshaniya initiate had progressed through eight degrees his transformation was complete. He then acquired the title of Melek or "King," and was thus one with his lord.[11]

Like the Roshaniya, the European Illuminati also had eight degrees which culminated in the title of "King." And, similar to its Afghan cousin, the Illuminati was also founded for the explicit purpose of conquering the world for the Lord of Time. In order to accomplish its mission, the Bavarian-centered organization had its members infiltrate many of the most powerful organizations of their time which espoused goals similar to their own, such as the Freemasons and Rosicrucians. In this way they could enroll others in their nefarious plans without them knowing it.

The Knights Templar and Rex Mundi

Closely aligned with these three Asian and European mystery schools was the Order of the Knights Templar, which legends claim was formed soon after the First Crusade. Through their extensive interaction with the Ishmaili and its satellite organization, the Assassins, the Templars acquired in-depth training regarding the Lord of Time, whom they are known to have affectionately referred to as Baphomet, the "Lord of Wisdom," and Rex Mundi, the "King of the World." Androgynous images of Baphomet, a dark goat god, and three-headed black effigies of Rex Mundi signifying the three powers of the King of the World, are said to have graced the highest altars of the Templars. The fall of the Templar Order transpired when the Christian Inquisition found the Templars worshipping grotesque images of Rex Mundi, whom they naturally assumed was the Devil. They were half right. Rex Mundi *was* Lucifer, the Lord of Time and Destruction, but like the spiritually advanced members of other mystery schools, the Templars worshipped Baphomet's transformative influence, the Kundalini power, which was a concept Christian fundamentalists were never able to fully grasp. Through invoking the destructive power of Rex Mundi and Baphomet's wisdom, the Templars' sought to spiritually evolve and precipitate a golden age of enlightenment.

The Witches, Devotees of the Planetary Lord

Another controversial group that sought to unite with the Lord of Time included members of the loose-knit European network of Witches. According to records gathered by Margaret Murry and compiled within her seminal text, *The God of the Witches*, during their testimonies before the Christian Inquisition the Witches claimed to have worshipped a "Lord" in order to gain the power to heal and manifest material abundance. Their Lord would enter their covens dressed in black and perhaps wearing the mask of a goat or bull, animals which are symbolic of the dynamic life force found in nature, thus linking them to the embodiment of the life force, the Lord of Time. Some Witches would unite sexually with their Lord in order to receive some of his prodigious power directly, which could then be used for either white or black magic. Those Witches who used the power for self-serving purposes or to destroy another human united with the egotistical and materialistic aspect of the Lord of Time's power, but those who used the power for healing and spiritual evolution aligned with its uplifting aspect.

The Lord of the Witches was apparently a European manifestation of Sanat Kumara or Murrugan, a truth implied by Idres Shah in *The Sufis*. According to Shah, missionary groups of Moslem Sufis wielding doctrines and rites similar to those of the Hindu Murrugan infiltrated Europe as part of the Moorish expansion into Spain, and then grafted their rites on to those of the European Witches. One of these itinerant Sufi groups were known as the Maskara, an order which originated in India probably as roving devotees of both Shiva and his son Murrugan. The circular dance of the Maskara mimicked the orgiastic rite anciently observed within the popular cult of Murrugan, and the Maskaras consumption of the datura plant for inducing consciousness expansion was reminiscent of Shiva's devotees who ceremonially imbibed a liquid infusion of the herb in order to unite with their deity. It is interesting to note that in India both Shiva and Murrugan were worshipped as destructive, trident-wielding deities similar to the Devil, so they could have been easily transformed into the archenemy of the Church after arriving in Europe. Shah is explicit in maintaining that the rites and doctrines of the Maskara influenced the crystallization of the rites of the Spanish Witches, as well as the worship of their Lord. The Maskara legacy can be found in the Spanish word for witch, bruja, which is an evolution of Mabrush, a Maskara term meaning "intoxicated by the thorn apple (datura)."[12]

From Levi's *Transcendental Magic.*

Androgynous Baphomet of the Templars

The Nazis and the King of the World

Like the Illuminati, the German Nazis were a European organization bent on using the destructive power of the King of the World for world domination. It is a well known fact that the Nazis sent numerous clandestine missions to eastern Asia in hopes of first locating the King of the World and then enrolling his help in their nefarious schemes of world conquest. They were influenced by such popular esoteric texts as Helena Blavatsky's *The Secret Doctrine* and the Englishman Lord Bulwer Lytton's *The Coming Race,* which had convinced the Nazis that the King of the World ruled an underworld civilization populated by the descendants of their ancestors, the Aryan blond-haired and blue-eyed race which had once ruled much of central and eastern Asia. Lytton maintained that the King of the World and his subjects were the possessors of "Vril," a name for the power wielded by the Lord of Time, which could be used to manifest material objects and ultimately conquer the world. Surely, concluded the Nazi elite, the King of the World would be happy to use his occult power to help his brethren become lords of the Earth and thus restore the Aryan honor. Their long term goals included the creation of a new race of Germans who would be able to wield the Vril power themselves.

It is also historical fact that the Nazi were intimately influenced by the Austrian Theosophist Rudolph Stiener, who wrote lengthy treatises regarding the King of the World. But Stiener, as opposed to Blavatsky who acknowledged the planetary monarch to be the "Maha (Great) Guru" of "all the ‚less divine teachers and instructors of mankind…," [13] took a dim view of our planet's king. He referred to him as the embodiment of both Lucifer and Ahriman and portrayed him as the wellspring of materialism and egotism. In truth, both he and Blavatsky were right. Even though the King of the World initially ruled from his higher self, after his "fall" he had been governing the world as the egotistical Lucifer. Either by choice or inadvertently the Nazis proceeded to align themselves with Stiener's version of the planetary ruler and adopted the "left-handed" swastika - a symbol of Luciferian rule and black magic – as the emblem of their Third Reich. Their connection to Lucifer may also extend back to the continent of Atlantis where the "Sons of Lucifer" were the "Sons of Belial." [14]

Besides enrolling the King of the World in his nefarious schemes, Hitler made it his personal mission to acquire one of the planetary monarch's symbols, the Holy Spear or "Spear of Destiny." As an avid German historian, Hitler was well acquainted with the Holy Spear that had pierced the side of Christ and later accompanied each Holy Roman Emperor to the throne as his

authoritative emblem of world dominion. Hitler's singular goal was to acquire the Holy Spear and return with it to Germany, thus endowing the Third Reich with the authority to rule the world. After rising to the rank of Fuehrer, Hitler's first act of office was to march into Vienna, take the spear from the Hofburg Treasure House and return it to its rightful home in Nuremberg, Germany, legendary capital of the emperors of the Holy Roman Empire.

The Holy Spear which Hitler returned to Germany may or may not have punctured the side of Christ. There were at least four spearheads in Europe vying for that distinction. But, in all fairness to Hitler, he was right about the spear signifying world dominion. Many years before the time of Jesus Christ the spear had been the symbol of both Mithras and Murrugan, two legendary names for the King of the World.

The Holy Spear's induction into the Christian faith as one of Jesus' icons may have coincided with Saint Paul's grafting of Mithra's legend to that of the Messiah. It is also possible that the Spear may have been initially "Christianized" by the Emperor Constantine who had worshipped it as a symbol of Mithras and later ascribed it to Jesus.

The Order of the Peacock Today

The worship of the Peacock Angel and King of the World survives today within the contemporary Order of the Peacock. This worldwide order recently surfaced within certain technologically advanced countries of the West, such as England and the United States, by persons seeking to align with the King of the World and use his power for both material and spiritual gain. Instead of worshipping a boy with a peacock tail as has been the tradition in the past, however, the members of the Order of the Peacock tend to solely idolize the image of a peacock either in its inanimate state as a statue or as a live animal. The most common effigies worshipped by them are stone carvings of a peacock with the name Melek Taus inscribed upon their bases.

In *A History of Secret Societies*, Arkon Daraul paints a vivid picture of the Peacock Angel's westernized cult. A gathering of members of a "Lodge" of the Order of the Peacock normally takes place within a sanctuary designed specially for the most important rites of the cult. As initiates enter the sanctuary, which is often a candle-lit room with images of serpents, sacred symbols of the Peacock Angel, surrounding a main altar, they turn their gaze upon the image of a peacock in the center of the hall. Then, while entrancing music is played in the background the initiates stare with one-pointed focus at their version of the King of the World and Son of God while moving around the peacock in a circular direction. As they dance they inwardly repeat one or

more desires they hope Mclck Taus will help them achieve. Knowing that the Peacock Angel is both savior and King of the World, they dance with full faith knowing that their prayers will be answered soon.

Daraul recounts that as the devotees dance they slowly become entranced by the presence and power of Melek Taus. As they become engulfed by his Baraka, his divine power, waves of euphoria bubble up and transformative changes begin to happen internally. If the person has come to the Peacock Angel with questions regarding life or some personal problem, the answers often spontaneously arise within, almost as if another consciousness was subtly advising him or her. If a person is in need of condolence from the loss of a loved one or the break up of a relationship, Melek Taus power will soothe him or her and then help in the release of any residual grief. If it is necessary for the person to see into a past life in order to gain perspective so they can heal in the present, long forgotten images and feelings are likely to bubble to the surface. Or, if it is courage that is needed for a person to make some important change in life, the Peacock's Baraka will assist his devotee in its actualization even after the ceremony has long concluded.

When their ritual dance has been completed, the devotees of the Peacock Angel are generally overflowing with the power and wisdom of their lord. They can then use this power for either spiritual or material gain when they leave his divine presence. And if they consume their power while away and need more, they know they can always invoke the supportive presence of the Peacock Angel wherever they are.

III

Jesus Christ Merges with the Peacock Angel

Once the legend of Jesus Christ had been disseminated to the Gentile masses by Saint Paul, the Christian savior gradually appeared more and more in the guise of his Asian ancestor, the Peacock Angel, and in some respects it became virtually impossible to separate them. Under the guidance of Saint Paul, Saint John and the Church Fathers, Jesus Christ eventually acquired the hierarchal roles of the Peacock Angel, such as the primal wielder of the Divine Mind and Creator of the Universe, and his cult even became associated with peacocks, the exotic birds which are native to southeast Asia, but not Palestine. Perhaps, at least partly because of Jesus' merger with the Peacock Angel, Saint Thomas is reputed to have visited one of Murrugan's principal temples in south India and even turned himself into a live peacock at the end of his life!

In recent history additional attempts have been made to unite Jesus with the Peacock Angel. Jesus' esoteric connection to Sanat Kumara was revealed in the 19th and 20th Centuries by the metaphysical tradition of Theosophy and the various Ascended Masters and I AM organizations worldwide, many of which have acknowledged Jesus to be Sananda Kumara, the brother and higher self of Sanat Kumara. And, seemingly to corroborate these traditions, Jesus has made spontaneous physical appearances while introducing himself to his hosts as Sananda Kumara. It therefore appears, rightly or wrongly, that in some circles the name Jesus Christ has become synonymous with the Peacock Angel.

The Christian Son becomes identified with the Peacock Angel

The Apostle Paul began dissolving the boundaries separating Jesus from the Peacock Angel nearly two thousand years ago when he declared: "He (Jesus) is the image of the invisible God, the first born over all creation. For by him all things were created; all things in Heaven and Earth…He is before all things, and in him all things hold together." (*Colossians* 1:15-17) Another apostle, Saint John, continued the trend initiated by Paul and referred to the Messiah as the Logos or "Word." He stated: "All things were made by him; and without him was not any thing made that was made." (*Gospel of St. John* 1:3)

Following the Apostles' references regarding Jesus' cosmic identity, the

Messiah and his Church were further linked to the Peacock Angel through their association with both the IHS, the "Chrismon" or "Signet of God," and the many-eyed peacock. IHS is an ancient symbol for the three powers of Cosmic Fire, the three letters symbolizing creation (I, the symbol of the One creative God), preservation (H, the crossbar symbol of balance), and destruction (S, the symbol of the destructive serpent). The Catholic Church, however, declared the symbol to be the first three letters of a Latin phrase meaning "Jesus, Savior of Man." When the Church adopted the peacock they made it the definitive symbol of the "all-seeing" Catholic Church, whose early priests prominently displayed a peacock motif upon their holy vestments.[1] In time the peacock and its feathers became a popular Christian motif and they were often displayed in association with Jesus or combined with one of his other symbols. One such unified motif consisted of the Chi-Rho symbol enclosed within a ring of peacock feathers. This feathered motif, which was a ceremonial accoutrement of Catholic Popes, had previously been a symbol within the traditions of Mithras and Murrugan.

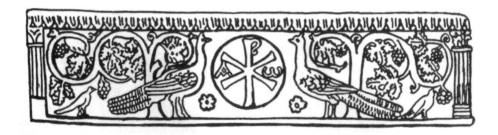

The Chi-Rho between Peacocks, old Christian motif

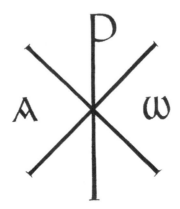

The Peacock "Chi-Rho" Fan, symbol of the Catholic Popes, was present at Charlemagne's coronation in Rome.

Baby Jesus and the Magi surrounded by peacocks
The Adoration of the Magi by Fra Angelico and Fra Filippo Lippi

Saint Thomas and the Peacock Angel

One fascinating story associated with the early Christian Church that ostensibly reveals Jesus Christ's identification with the Peacock Angel involves Saint Thomas, the apostle who is alleged to have traveled east to India and made many converts to Christianity before finally succumbing to the fatal blow of a lance. Although Thomas met with an ignoble death in ancient Bharata Varsha, legend asserts that Thomas' sojourn within the subcontinent had one unexpected but welcome benefit, he discovered Murrugan, the Peacock Angel, and the eastern heritage of his Jewish Master.

Thomas's adventures in the East are recorded within the Syrian Church, especially its Nestorian branch, which alludes to Thomas as being Jesus' twin brother and the first Nestorian missionary. Thomas' journey east across Asia is also an integral part of the legends of the Christians currently living along the coast of Indian in the state of Kerala. They claim that the apostle was a teacher of their ancestors, and the memory of his visit to India has been passed down within their families for nearly two thousand years.

The legend of Saint Thomas maintains that the apostle set off on a ship bound for the coast of India soon after Jesus' ascension. At that time the Greeks had mastered the sea routes and currents between Asia Minor and the East, so there were plenty of vessels ready to carry the apostle to his destination. Following what was to become a very arduous journey of six weeks or more, Thomas arrived on the Malabar Coast of India, which at that time had become the busiest trading center of the known world.

As he traveled alone by foot along the inland coastal routes, Thomas began working to make converts to Christianity. Besides giving informal sermons to the natives, Thomas oversaw the construction of Christian churches within which he could regularly preach the new faith. Then, during the next twenty years he succeeded in conquering much of Kerala in the name of his Jewish Master. It is because of Thomas's courage and determination that Kerala currently boasts the largest Christian population anywhere in the East.

When Thomas had nearly completed his mission in Kerala he had a vision that instructed him to travel to India's eastern seaboard. The vision revealed that there were converts to be made in what is now the state of Tamil Nadu. But there was another reason for him to go; he was to end his life there as a martyr. So, knowing he would never see his new Christian family of Kerala again, Thomas bade them a tearful farewell and set off for the eastern shore of the Indian subcontinent.

Once in the area of what is now the city of Madras or Chennai, Saint Thomas made his base of operations Mylapur, the ancient "Town of Peacocks,"

.ch was the seat of Murrugan worship on the eastern seaboard. In that mecca ui peacock worship Thomas was introduced to the legend of his master's Hindu ancestor, Murrugan, and apparently found affinity with the Peacock Angel.

Thomas' proselytizing along the east coast eventually got him in trouble with the local authorities, who eventually resolved to kill the missionary. After capturing the prophet they bound him in chains and led him to the top of what is now called "Saint Thomas' Mount." After granting the resigned Thomas a few minutes of silent prayer, they then proceeded to stab and murder him with a very sharp lance. One prevailing legend associated with this incident asserts that the prophet had turned himself into a peacock previous to his assassination, so the authorities murdered a live bird, not a man.

In Tamil Nadu a "peacock dance" is currently performed annually to commemorate Thomas's martyrdom. While making symbolic gestures, dancing actors playing the part of Thomas' assassins slay an actor who is dressed as their peacock victim. Those involved with the dance conceive of the peacock as both Saint Thomas and Murrugan - thus acknowledging that the Christian prophet and the Peacock Angel had become one and the same. Quite possibly, Thomas had discerned the Peacock Angel as the Hindu counterpart of his Master and thus merged with him just prior to his death.

The Christ is also called Sananda Kumara

Within the last 150 years certain prophets and mystics associated with the I AM Church, the schools of the Ascended Masters, and the Theosophical Society - which was originally headquartered in Adyar, next to Mylapur - have revealed that Jesus Christ's esoteric name is Sananda Kumara, a designation which obviously links the Christian Son of God to the Peacock Angel and Sanat Kumara. The name Sananda is synonymous with the term "Christ," both of which are names for Jesus' higher self. Jesus became the Christ, or Sananda, after attaining full enlightenment and merging with his inner Spirit.

The epithet of Sananda is also synonymous with the names Michael and the Persian Ormuzd. It is, therefore, equally correct to conclude that when Jesus merged with his higher self he united with Christ, Michael/Melchizedek, Ormuzd *or* Sananda. The name Sananda means "the bliss of Being," or "the bliss of Holiness," and carries a special import associated with the highest level of spiritual attainment. The names Michael or Melchizedek, along with Mithras, Melek Taus and Murrugan, also convey a spiritual meaning by virtue of having as their first letter the sacred letter M. M is the synthesis of two As, thus making it a symbol of the polarity union which the Son of God embodies. The beginning M at the beginning of these names also link them with Sananda, because the prefix San is written

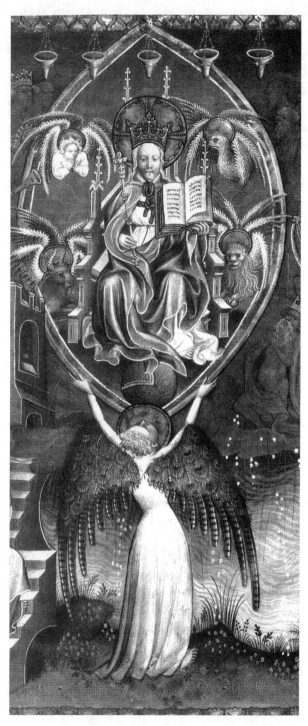

A Peacock Angel holds up a vesica pisces containing Jesus Christ
From the 15th Century *Bramberg Apocalypse*

as M in the ancient Greek alphabet. San has provided the prefix for such "holy" or "pure" terms as saint, sanctify, and sanitation.

Since Christ, Sananda, Michael and Ormuzd are all names for the High Self, each forms a pair with a manifestation of the lower self. Sananda's polarity is Sanat or Lucifer (Sanat fell to become Lucifer); Christ forms a pair with Satan; Michael pairs with Belial; and the light of Ormuzd is reflected by the darkness of Ahriman. Collectively, each of these pairs denote the two opposing aspects of the androgynous Peacock Angel. This is why every pair has been portrayed as seated at the right and left hands of God. The Ancient of Days, who sits upon a golden, heavenly throne is, essentially, a manifestation of the Peacock Angel, a truth acknowledged by some branches of the Great White Brotherhood, such as the Church Universal and Triumphant, who call Sanat Kumara the Ancient of Days. Thus, Christ and Lucifer or Sananda and Lucifer or Ormuzd and Ahriman all denote the polar opposite aspects of Sanat Kumara, the Peacock Angel.

Sananda, the Avatar

The name of Sananda is most often associated with the legends of India and the cult of the Avatar, the spirit of Vishnu which occasionally incarnates physically to uplift humanity and lead it out of darkness. Depending on which Hindu scripture one subscribes to, there have been anywhere from 10 to 22 Avatars who have incarnated on Earth in ages past. Many traditional sages and pundits of India have maintained that the last Avatar was Lord Buddha and that there will be one more, the Kalki or "Horse" Avatar, who will usher in a new, golden age on the planet. But some contemporary teachers and gurus maintain that Jesus Christ was also an incarnation of the Avatar spirit, and therefore its most recent manifestation.

If Sananda is truly the Avatar spirit, it holds that he has been on Earth many times. Hindu records seem to point to at least one of his previous incarnations. According to the *Puranas*, Vishnu once took physical form as the Kumara brothers, one of whom was Sananda. The *Shrimad Bhagavatam Purana* lists the four Kumaras, Sananda, Sanat, Sanaka, and Sanatana, as the first of a lineage of twenty-two Avatars, whereas other *Puranas* designate them as being the second or third Incarnation of Vishnu. Esoterically, the four Kumara brothers are recognized as one united Avatar, with Sananda being the Avatar's spirit and Sanat being its soul and personality.

The Puranas claim that as forever-young twin boys the Kumaras were placed on Earth by Brahma, their father, for the purpose of procreating and populating the planet. But rather than spending their time interbreeding as they had been instructed to do by the Creator, they chose to teach the wisdom of renunciation, alchemy and yoga, and thereby guide much of Earth's population along a path to

From: *"The Last Judgement"*

In this portrait Archangel Michael wears wings covered with peacock "eyes," thus revealing his connection to both Sananda and the Peacock Angel. On his chest is a Chintamani, the 3-petalled symbol of Cosmic Fire and its triune powers

spiritual freedom. The Theosophists and teachers within the Ascended Masters school similarly maintain that the Kumaras brought their wisdom of yoga and meditation from Venus and then sacrificed themselves to the work of leading worthy humans to the hallowed goal of immortality.

Legends contend that Sananda, Sanat and their Kumara brothers initially appeared on Earth within the legendary "Garden of Eden," the continent of Lemuria, wherein they established schools of yoga and alchemy. In their adopted home they built magnificent temples for worship, one of which became home to a huge, golden Sun Disc, which esoteric wisdom maintains was brought by the Kumaras from Venus. This disc, which was later taken to the Andes by the sage Aramu Muru, a later disciple of the Kumaras, served as a continual reminder to the citizens of Mu of their Venusian heritage.

Sananda, the Elder Brother of Native American History

Apparent references to Sananda can also be found within the traditions of the Hopi of Arizona, U.S.A. As mentioned in the previous chapter, the Hopi refer to the ruler of the Third and Fourth worlds as Massaw, which is an apparent name of Sanat Kumara. The Hopi also have legends regarding what appears to be the twin brother of Massaw, Pahana, the elder White Brother. If Massaw is Sanat, it follows that Pahana is a name for Sananda, Sanat's twin brother. The Hopi legends seem to confirm this truth.

The Hopi claim that the twin brothers, who are referred to as culture bearers, protectors, and creators in their texts, were separated in ancient times, with Pahana going to the East. The younger brother, who is apparently Massaw, the King of the World, remained in the West and later met the Hopi in Oraibi after they had completed their ancient migrations throughout the Americas. Massaw then instructed the Hopi in the practical sciences they would need to survive while living on what is now the Hopi Reservation of northern Arizona. Since that time, the Hopi have made do with poor soil and scorching summer heat, but when Pahana returns from the East, which the Hopi prophecies claim he will soon do, then a new age will commence on Earth and all Hopi will be rewarded for their stoically accepted tribulations. At that not-to-distant time the Twin Boys will reunite, which from a metaphysical perspective means that the powers of Spirit (Sananda) will reunite with matter (Sanat). From what is currently happening on a planetary scale, the validity of the Hopi prophecy can not be doubted. Since the rise of technology, the West has become the leader and home of materialism (ruled by Sanat or Lucifer), while the East has sought to preserve the ancient ways of the Spirit (ruled by Sananda). Beginning in the last century, when it began to be as-

similated into our western, materialistic paradigm, the wisdom of the East has been gradually making its way to the West.

The northern neighbors of the Hopi, the Cheyenne, also preserve a legend of the Twin Boys. Their legend is worth mentioning here because it provides clues regarding certain unclear elements of the Hopi myth, such as the identities of both the Elder and Younger Brother. The Cheyenne refer the Elder Brother as Sweet Medicine and remember him as a great prophet who taught them their ceremonial rites, including the pipe ceremony, and how to love and live in harmony with each other. He also established the lineage of Cheyenne "Peace Chiefs" that continues today, apparently having been the first chief himself. One of Sweet Medicine's symbols, the cross, which is identical to the Christian cross of Christ, has been passed down among the Cheyenne chiefs for hundreds of years and worn by them as part of their ceremonial regalia. The Cheyenne also remember Sweet Medicine's brother for having taught them certain religious rites, but these rites were diametrically opposed to those of Sweet Medicine. These rites, which have become known as the rites of Massaum, have for hundreds of years been observed by the tribes' "Contraries," those who do everything backwards. The term Massaum obviously links the Cheyenne Younger Brother with Massaw, whose name is also written as Masauu. Therefore, if the Cheyenne and Hopi share a similar knowledge regarding the Twins, which they seem to do, then the Hopi Younger Brother must indeed be Massaw or Sanat Kumara and the Elder Brother must be a manifestation of Sananda.

The native legend of the Twin brothers is not exclusive to the Hopi and Cheyenne tribes, but can be found all over the Americas, thus indicating that the legend of the Twin Brothers was once ubiquitous. The Twin Boys are, for example, an important part of Iroquois, Apache, Navaho, Yuma, and Zuni history. They are known by the Iroquois as Ioskeha and Tawiscara, the White and Dark Ones; they are remembered by the Navaho as Monster Slayer and Child of the Waters; and they are referred to as the Ahayutas by the Zuni. Within the myths of other native tribes the Younger Brother appears as a coyote, wolf, or some other form of the "Trickster," and his Elder Brother is the righteous recipient of his mischievous and sometimes murderous plots. Author Lucille Taylor Hansen, who once to spend her summers among the Chippewa, learned many native legends of the Twins, especially those connected to the Elder Brother, directly from certain tribes' record keepers. She was once invited to a conclave of native chiefs and told many of the names and symbols ascribed to the Elder Brother when he appeared anciently to each tribe. Ultimately, she learned that wherever the Elder Brother appeared he gathered a group of disciples or apostles around him. He also claimed to be going about his "Father's business," and he eventually became associated with certain symbols, such as the cross. Then, following his departure

from each tribe he was worshipped by his converts as the Morning Star. In her seminal work, *He Walked the Americas*, Hansen compiled many of the assorted North American manifestations of the Pale Prophet, and she also revealed that the prophet had appeared not only in the north, but throughout the Americas. In two of his southern manifestations, Quetzlcoatl (Mexico) and Viracocha (Peru), he had appeared to the natives of Central and South America in the form of a pale prophet holding a cross or clothed in cross symbology. As Quetzlcoatl, the Pale Prophet was also later worshipped by his admirers as the Morning Star. Thus, Native American records imply that the Elder Brother once visited the entire Western Hemisphere. But, states Dhyani Ywahoo, a Cherokee record keeper who claims to preserve records that are 100,000 years old, the Elder Brother was not only ubiquitous but he manifested simultaneously within all the scattered tribes of the Americas (*Voices of Our Ancestors,* Shambala, 1987). And, state both Hansen and Ywahoo, his appearances directly preceded the coming of the white settlers and were partly for warning and preparing the tribes for the ensuing five hundred year cycle of darkness soon to be set into motion by the advent of the avaricious and irreverent white man. The Pale Prophet instructed the natives to secure their records and tenaciously cling to their sacred rites, because only in this way could they survive a potentially devastating future.

A Cheyenne Peace Chief wears a cross, symbol of Sweet Medicine
From the Smithsonian Archives

The Kumara School of Wisdom and the Seven Rays

Since the Pale Prophet was associated with both Venus and the cross, there is sufficient reason to believe that he was a manifestation of Jesus or Sananda. If he was indeed Sananda, perhaps he wandered the Americas as a prophet of the Great White Brotherhood, the worldwide organization that emerged out of a school he and his brother Sanat had founded on Lemuria. This was apparently Hansen's conclusion, although she believed that the Pale Prophet had taught the wisdom of the Essenes, a branch of the Brotherhood.

Before it became the Great White Brotherhood, Sanat and Sananda's school was known on Lemuria as the Kumara School of Wisdom. It was alternately known as the Solar or Seven Rays Brotherhood, because the goal of its members was to unite with the Sun behind the Sun while serving the seven rays of the Goddess which emanate from it. The Kumara School of Wisdom was founded by Sananda and Sanat Kumara in order to spread and preserve their doctrines of alchemy and yoga that they had brought to Earth from Venus. Although the ancient organization is currently known as the Great White Brotherhood, its membership has always been open to both men and women.

When Lemuria sank to the bottom of the Pacific Ocean, the wisdom of the Kumara School of Wisdom traveled to both the East and the West. Missionaries trained within the school migrated to various parts of the globe for the purpose of creating a network of spiritual adepts aligned with the Seven Rays Brotherhood. Some missionaries went east and founded branches of the Brotherhood in parts of the Americas, such as Peru, where the Seven Rays united as the Inca flag. Other prophets went westward, establishing branches of spiritual adepts in India, China, Egypt and eventually the Middle East, home of the Essenes. Collectively, all the orders thus founded were part of the Great White Brotherhood and governed by a "central" authority of Kumaras, at the head of which were the founders of the organization, Sananda and Sanat Kumara. The greatest Kumaras have become known in the esoteric histories of the Great White Brotherhood as Saint Germain, Serapis Bey, Lanto, Master Morya, etc, each of whom was or is a Kumara governing one of the Seven Rays. All seekers in the Brotherhood are especially aligned with one ray and its corresponding Kumara.

The Seven Rays of the GWB were initially created by the Peacock Angel at the beginning of time. They first existed as his full-spectrum, Cosmic Fire (or life force) body, but as the universe expanded they separated and now manifest as the seven powers which oversee and govern the seven aspects of Creation (the 7 colors, 7 tones, etc.). Thus, the Peacock Angel provided the cosmic substratum of the Seven Rays and now, as Sanat Kumara, serves as their overseer on Earth.

Mu and The Divine Trinity

Of the Seven Rays, the first three have principal importance, while the other four are extensions and variations of the Third Ray, the Ray of Action. The three principal rays, known as the Divine Trinity, vibrate as the three primary colors of blue, yellow and red. They represent the triune split of Cosmic Fire into the powers of creation, preservation, and destruction, or will, wisdom and love, and action. In India, the Divine Trinity has for thousands of years been worshipped as the trinity of Brahma, Vishnu, and Shiva, while within the Great White Brotherhood they are sometimes associated with Sanat, Sananda, and Lucifer.

All trinities, including the Hindu and later Christian trinities, had their origin on Lemuria as the primeval three rays of the Peacock Angel. They are thus historically and metaphysically linked, as any simple comparison will reveal. Both Brahma and Sanat Kumara, for example, are basically synonymous with the Christian "Father," because like the Father they are said to have created the Earth and now oversee it. Vishnu and Sananda, the spirit of the Avatar, are synonymous with the Son of the Christian Trinity because they, as the preserving aspect of Spirit, are occasionally sent down to Earth to save and uplift humanity. Finally, Shiva (or Rudra) and Lucifer are counterparts of the "third person" of the Holy Trinity, the Holy Ghost, because they personify the fiery, active energy of Spirit which has the power to destroy and transform.

In acknowledgment of Sanat's at-one-ment with the Father of the Christian Trinity, certain branches of the Great White Brotherhood, such as Elizabeth Clare Prophet's Church Universal and Triumphant, have designated him the "Ancient of Days," the revered form of Yahweh as a white bearded king sitting upon a heavenly throne. As the Ancient of Days, Sanat is part of a heavenly trinity with Sananda and Lucifer, who sit at his right and left hands respectively.

The Trident, Symbol of the Trinity

One of the most ancient symbols of the three primary rays is the trident. This three-pronged weapon or implement represents all trinities, as well as the three powers intrinsic to the Word, AUM, and the Cosmic Fire it generates. In India, the trident is the emblem of Rudra, the Peacock Angel as Cosmic Fire. It is also the symbol of Sanat Kumara, the Peacock Angel as Earth's monarch, who wields the three powers of Cosmic Fire while orchestrating the affairs of Earth. Prophet's Church Universal and Triumphant renders Sanat's trident in the form of a fleur-de-lis, the three "petals" of which represent will, wisdom-love, and action. The petals also represent the three powers of Cosmic Fire, and, therefore, Prophet's students refer to Sanat Kumara as the primeval "Keeper of the Flame," and to themselves as the "Keepers of the Flame."

The Trident, *drawn by Anthony Devoe*

The outer prongs of the trident represent the God and Goddess, the universal male and female principles, which unite as the Son, who is symbolized by the center prong, a vesica pisces, the archetypal symbol of polarity union.

Sananda and Raphael, Heart of the Peacock Angel

As the second "person" of the Divine Trinity, which corresponds to the middle prong of the trident, Sananda is the personification of the power of preservation associated with the Hindu God Vishnu. His preserving power is the power of love, because love is the refined emotion that heals, unites, and preserves all that exists in Creation. The power of love is symbolized by the middle prong of the trident because it unifies and harmonizes the outer two prongs of Spirit (the prong left of center when facing the trident) and matter (the prong right of center). Therefore, Sananda and the love he embodies reside within the center or heart of the trident. Since the trident symbolizes Sanat Kumara or the Peacock Angel, Sananda is the loving heart and spiritual essence of the Peacock Angel.

If Sananda is synonymous with Vishnu, the second "person" of the Hindu trinity and God's power to heal and preserve, it follows that he is related to Vishnu's incarnation of Lord Krishna, the Avatar of love and beauty, whose name means "the one who attracts through the power of love." As the power of love Krishna also dwells within the center of the trident, and it is for this reason that he is often depicted with peacocks, the symbols of polarity union, balance, and love, and sometimes wears a peacock crown. Krishna's connection to Sananda is evident in his name, "Krishna," which as a version of Christ is an alternate name of Sananda.

An important Jewish deity who is synonymous with Sananda and Vishnu is the Archangel Raphael, the angel of love and friendship who is often portrayed wearing peacock wings. Raphael corresponds to the second "person" and central "prong" of a trinity of archangels, which includes Michael, Raphael, and Gabriel. Michael, the "first person" or "Father" of this trinity, is often depicted with the symbolic images of the male principle he embodies, such as bright red coloration and a sword. Raphael, whose name means "God heals" (He heals through the power of love), is the second "person" of this Jewish trinity, and Gabriel, whose name translates as the "power of God," is the third "person." Gabriel is commonly depicted iconographically as a feminine-featured man or as a woman carrying a pure, white lily. Such endowments reveal that Gabriel is the embodiment and personification of the female principle.

As the angel of love, Raphael is the union of the male and female principles, Spirit and matter, which are represented by Michael and Gabriel. This is why he occupies the middle position between his two fellow archangels, and why he is sometimes depicted as possessing striking peacock feathers. The young Tobias, who is occasionally represented strolling next to Raphael, symbolizes all humanity. Every human on Earth is loved and protected by the Son and savior, the power and embodiment of love.

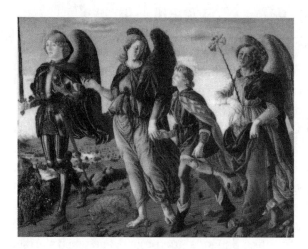

"The Three Archangels with Tobias," by Francesco Botticini
With green wings covered with peacock eyes, Raphael strolls with
Michael, Gabriel and Tobias

The Jewish trinity of Michael, Raphael, and Gabriel are closely associated with the three columns of the Sephirothic Tree of Life found within the Kabbala, the canon of "hidden wisdom" studied by the ancient Jewish prophets. Just as he is associated with the center prong of the trident, Raphael is accorded rulership of the "Column of Equilibrium" in the center of this geometrical tree. He is especially associated with the middle column's central Sephiroth, which is known as Tipareth, meaning "beauty." Michael's column, situated to the left of the center column, signifies the positive male principle, while Gabriel's column, which is to the right of center, denotes the negative female principle. According to many Kabbalistic philosophers, such as those affiliated with the Order of the Golden Dawn, Michael rules over "male" fire, Gabriel rules "female" water, and Raphael rules over air, the element which unites fire and water.

The Sephirothic Tree

Tipareth is the sixth Sephiroth. It unites the left and right columns.

"My name is Sananda Kumara"

One of the fortunate devotees of Jesus/Sananda whom the Master has appeared physically to in recent times is the late Sister Thedra of Mount Shasta, California and Sedona, Arizona. In 1954 Sister Thedra, who was in her fifties at the time, was suffering from terminal cancer and realized that her days were numbered. She prayed continuously: "Father thy will be done. If it is thy will, heal me...if not I am ready to go." One day Jesus suddenly materialized before the bedridden Thedra, walked directly over to her and instantly healed her diseased body through his laying-on-of-hands. He then told her to "Go feed my sheep, I will give you the food." Soon afterwards Sananda informed Thedra that from that moment onwards she was to address him by his rightful name, Sananda Kumara, and assume the responsibilities of his prophetess on Earth. She was healthy most of her remaining years while fulfilling Sananda's command, and when she died in 1992 she was 92 years old.

When Sister Thedra began receiving messages from Sananda soon after her miraculous healing she quickly found that none of her acquaintances or family believed she could actually be communicating with Jesus. Some of Thedra's former caretakers decided that her illness must have left her psychologically impaired and recommended she be institutionalized. Perceiving from on high the danger ahead for his servant, Sananda sent Thedra down to the Peruvian Andes in 1956 for protection and to study within an ancient monastery containing the early records and teachings of the Kumaras. This abbey, the Monastery of the Seven Rays, had been founded thousands of years previously by the Lemurian sage Aramu Muru for the purpose of storing and preserving the records and power objects of Mu, including the golden disc the Kumaras had allegedly brought with them from Venus. Thedra remained five years at Aramu's monastery and then Sananda informed her that she was ready to resume her mission as his prophetess in the U.S.A. Following her return in 1961, Thedra founded the *Association of Sananda and Sanat Kumara* and then received a series of *Lessons* from Sananda, as well as a newsletter called *A Call to Arms*, which was designed to advise and assist people through Earth's coming transformation.

Sananda first guided Thedra to Mount Shasta, a powerful vortex ethereally connected to the Kumaras. Later, apparently to keep his channel safe and perhaps for additional spiritual training, Sananda orchestrated her move to Sedona, Arizona. In Sedona, *ASSK* operated out of a house on the road to Boynton Canyon, the strongest vortex in the area and a headquarters of the etheric Kumara brotherhood in the southwest portion of the United States. After Thedra passed away in Sedona *ASSK* returned to Mount Shasta.

I personally met Sister Thedra in 1997 at Mount Shasta. A small, thin women well into her eighties at the time, she appeared to have more energy

than a person half her age. She invited me to lunch and then entertained me with stories of her meetings with Jesus. I was spellbound as she recounted how Sananda first appeared physically in front of her and then continued to appear to her for years to come. During his later appearances, stated Thedra, Jesus had also manifested to her in disguise. He had, for example, appeared as an old man needing assistance, and as an anonymous passerby bearing specific directions for her. -MAP

"My Home is Venus"

In the 1950s Jesus/Sananda also appeared to a British man named George King. What transpired before and during their meeting formed the basis of King's Aetherius Society, an organization founded for interplanetary communication which has since helped convince some of the world's population of Jesus-Sananda's Venusian heritage.

Leading up to his encounter with Jesus, King had been designated "Primary Terrestrial Mental Channel for the Cosmic Masters" by a Venusian master calling himself Aetherius. Aetherius first contacted King while he was in a meditative trance, the result of the Englishman's ten years of intense yoga practice, and told King to prepare for a special mission. Soon afterwards, a well-known yogic master from the East walked straight through the closed door of King's apartment and began instructing the startled Brit in some special yogic practices for telepathic development. A few months later, a more psychically attuned King resumed communication with Aetherius and their dialogue continued until King's death in 1997.

Once he had become an adept medium King received transmissions from many extraterrestrial masters, including Jesus-Sananda, who instructed him to travel to a remote location for a special meeting. King arrived at the agreed upon location just in time to witness the landing of a Venusian lightship and Jesus' emergence from within it. The white-robed Sananda blessed the startled King and introduced himself as another Venusian who, like Aetherius, had been assisting the Brit in his mission as interplanetary contactee. Jesus-Sananda then expounded part of the "Twelve Blessings," a version of the Sermon on the Mount which included specific instructions for humanity's next evolutionary step. When Jesus ended his monologue he advised the grateful King to remain in telepathic communication with him, and then returned to his native planet. King heeded his Venusian teacher's instructions, and the remainder of the "Twelve Blessings" were soon transmitted to him while King sat within the comfort of his London apartment. Today, the "Twelve Blessings" constitute the bedrock of the Aetherius Society, and all members of the organization make a concerted effort to live according to its mandates.

"I am the root and the offspring of David, *and* the bright and morning star."

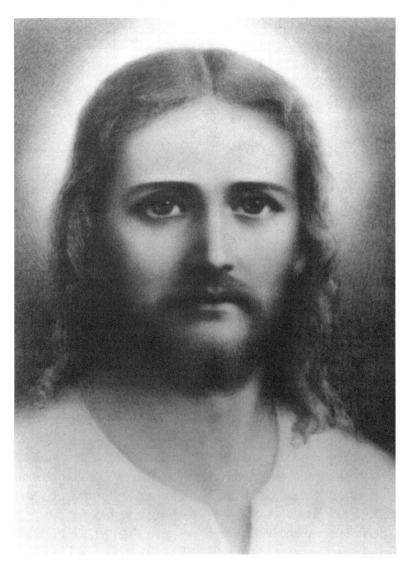

Actual photograph of Sananda Kumara

The above reproduction is from a photograph taken June 1, 1961, when Sananda (Jesus) appeared physically at Chichen Itza in Mexico and allowed this photo to be taken. At that time he gave permission for Sister Thedra to use it in association with the work she was doing in spreading his work. Copies of the photograph and transcripts of his words are available by writing to: The Association of Sananda and Sanat Kumara
P.O. Box 197, Mt. Shasta, CA 96067

Part II

In
Search of
The
King of the World

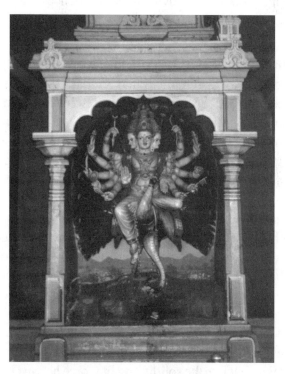

With his many arms, Murrugan/Sanat Kumara
rules from Palni, India

IV
The World is a Giant Peacock

According to doctrines espoused by worshippers of the Peacock Angel worldwide, as well as legends and manuscripts compiled by occultists and travelers to the Far East, after Sanat Kumara arrived on Earth from Venus he elected to become not only the planet's king and guide but its indwelling spirit. Since then, the Earth has become the physical body of the Peacock Angel and the will of Sanat Kumara has reigned supreme throughout the planet. Although in some respects this notion appears to be a very outlandish one, a few years ago I resolved to discover the truth of it through not only historical references and metaphysics, but most importantly through my own direct experience. In this chapter I present the results of my investigation.

Sanat Kumara Becomes the Planetary Peacock

As I began my research into Sanat Kumara's manifestation on Earth I decided to be open-minded regarding the many references to him, including those which are mythological. Thus, I was eventually drawn to the conclusion that Sanat Kumara was a magical being who should have been able to assume almost any physical form he desired. Some texts and traditions I referenced make claims to this effect and maintain that in the past Sanat Kumara has taken on such diverse forms as Cosmic Fire, a peacock, and a forever-young boy. The historians of the laying-on-of-hands healing tradition known as Reiki, for example, claim that as "Sonten" Sanat Kumara first arrived on Earth six million years ago and alighted on Mount Kurama in Japan while in the form of life force or Cosmic Fire.[1] As a forever-young boy or as a boy with peacock feathers growing out of his hind end, Sanat Kumara has appeared to the Yezidhi prophets and to certain advanced yogis in India; and among members of the worldwide Order of the Peacock he has manifested as his sacred animal, the peacock, as well as a snake. Taken together, all these references to Sanat Kumara seem to imply that his essential form is Cosmic Fire, but like the solidifying life force he can crystallize and mold himself to any physical shape he desires. I thus concluded that as Cosmic Fire or the life force, Sanat Kumara must also be able to enter a preexisting form, such as the Earth, and make it his own. This conclusion was also based upon the legends

of Vulcan and the Devil, other fire gods who according to legend made the fiery inner core of our planet their home. Vulcan, the Egyptian Ptah, as well as the later Devil, are all three intimately related with Sanat Kumara and appear to be synonymous with him. All are embodiments and wielders of Cosmic Fire

The Watchers

One of my most dramatic revelations concerning Sanat Kumara's earthly manifestation came while researching a Jewish scripture, the *Book of Enoch,* an ancient text which refers to the "Watchers." Supposedly the Watchers were a group of beings who came to Earth millions of years ago with their leader, Azzazel, Azzazel is a name of the Peacock Angel in the tradition of the Yezidhi, so his legend is intimately related to Sanat Kumara. The Watchers' mission was to mate with the "Daughters of Men" and then teach their spouses the mundane and spiritual sciences. After completing their mission these culture bearers had the option of returning to their native planet, but instead chose to remain on Earth as the Watchers. Thereafter they served as a hidden gestapo which occasionally reported back to Lord Yahweh the transgressions of humanity. The rest of the myth maintains that the Watchers eventually underwent a "fall" and ended up serving their own egos rather than Yahweh, although it remained unclear whether they still exist today or not.

After studying all the references to the Watchers I could find, it became clear to me that they were (and perhaps still are) sentinels and employees of Azzazel or Sanat (or Lucifer), who is the principal Sentinel or Satan-el. I thus concluded that all Watchers must, therefore, be the Eyes of Lucifer. If this is true, and Sanat Kumara is in fact Azzazel, then Sanat Kumara's eyes must also be everywhere. My conclusion was corroborated by the ancient, clairvoyant prophets of Judaism, who designated the ubiquitous eyes of Satan-Lucifer or Azzazel as the "Eyes of the King."[2] The King of the World is one of Sanat Kumara's roles.

Could Sanat, the Satan-el, truly manifest on Earth as a multitude of eyes? Mystical and religious history asserts that he can and has. Both the Jews and members of many contemporary and ancient pagan or nature religion cults have claimed to have experienced their gods of nature as being endowed with innumerable eyes. The worshippers within the ancient sects of Greece, India, Egypt and Babylonia have proclaimed in unison that their nature gods, i.e., Osiris, Dionysus, Tammuz, and Murrugan, are many-eyed and omniscient. In Persia's holy scripture, the Zend Avesta, Mithras was also accorded hundreds of ears and eyes by which he knows and hears all. If this text and these experiential testimonials are true, I decided, I could in all fairness only arrive at one verdict, that the eyes of the King of the World have been and still are populating the landscape of our planet.

Vesica Pisces Eyes Surround Us

With scriptural and mythological information regarding the "Eyes of the King" under my belt, I also referenced science for evidence confirming that we are indeed surrounded by numerous eyes. In found it with Albert Einstein, who in his *Special Theory of Relativity* maintained that the gravitational field which forms around any physical object, be it a galaxy, star, planet, plant, cell, or human, takes the shape of a vesica pisces or eye-shaped envelope. Added to this, the science of Sacred Geometry maintains that the vesica pisces is the primal geometrical form from which all others emerge. Therefore, even conservative science affirms that we are surrounded by the vesica pisces eye, whether we are aware of this truth or not.

It is easy to discern the shape of a vesica pisces and eye from the photograph of a galaxy turned on its side. The same shape surrounds all form.

I encounter Sanat Kumara in Peru

My quest to know Sanat Kumara finally came to a climax in the Andes Mountains of Peru, where for a couple of years I had been studying with one of those unique shamans whose psychic "eyes" allowed him to see the world and the cosmos from a different perspective than most average human beings. Thanks to his expert guidance and a cactus called San Pedro or Wachuma, I was able to directly experience Sanat Kumara's eyes and discover firsthand that they do indeed surround and constantly watch us from another dimension.

Shamans are our contemporary priests of nature, as well as our guides to other realms and dimensions. If we desire to connect more intimately with nature, or if we long to experience the realms above and below the physical dimension, we can utilize their vast knowledge and expertise. If we persevere on a path delineated by them, we may eventually get to know alternate, parallel dimensions as well as we know our own physical world.

One way that shamans stimulate and enhance psychic vision is through the preparation and ingestion of plant medicines called entheogens. A.C., the shaman

I had been studying with in Peru, is a native descended from a tradition of Mochica shamen who, for thousands of years, have used San Pedro or Wachuma cactus to connect with nature spirits and to interact with dimensions which transcend our own. San Pedro, which is the Spanish name for Saint Peter, the holder of the keys to the Heaven realms, was first used by the shamen who built and resided within the Andean settlement of Chavin de Huantar, a temple compound which is recognized by archaeologists to be not only one of the earliest colonies in Peru, but one of the most ancient settlements in the entire Western Hemisphere, possibly dating back to 3000 B.C. or even earlier. A.C.'s own experiences with Wachuma, the cactus' Quechuan or Incan name, psychically revealed to him that the shamen of Chavin de Huantar migrated from Lemuria, the legendary continent of the Pacific. He also "saw" that the colonists of Chavin were descended from Masters who had anciently arrived from the planet Venus. A.C.'s belief in Wachuma's connection to Venus was corroborated by visits from Venusian aliens during ceremonies using San Pedro. During one such ceremony A.C. was taken aboard one of their airships, and following a later ceremony, during which he experienced a dramatic death and rebirth and officially became a shaman, the Venusians buzzed him in an apparent gesture of congratulations.

My unexpected meeting with Sanat Kumara occurred during a San Pedro ceremony at Huanca Wasi, a mountain top retreat 11,000 feet in the Andes where A.C. took me and his female translator for some intense and transformational shamanic work. On our way to Huanca Wasi we stopped off at Churin, a small Peruvian village famous for its bubbling hot springs. For thousands of years San Pedro shamans have come to Churin in order to purify themselves before proceeding to Huanca Wasi. We three utilized four of Churin's natural hot pools, as each one's cleansing effect was a little different from the others.

On the morning of our special ceremony at Huanca Wasi, we arose well before sunrise and walked briskly through the darkness of Churin to a beat-up, old public van waiting to take us to our destination. Almost immediately after leaving the small town behind us we found ourselves swaying violently back and forth as our vehicle navigated the large stones which peppered the dirt road leading into the high mountains. We thus understood why the bus was in such a dilapidated condition. I soon congratulated myself for having spent a day soaking in Churin. Instead of developing a bad case of motion sickness, I remained inwardly calm and enveloped by a euphoric assurance that "everything is and will be okay."

After an hour or so on the rugged road we reached Huanca Wasi. As I stepped out of the bus I was met by the pinkish glow of dawn which danced above the mountains encircling the small mountain village. Or new retreat was magically enveloped by a breathtaking beauty and a surreal calmness. Many of the surrounding mountains were snowcapped and towered over Huanca Wasi,

which I decided was situated at an elevation of approximately 11,000 feet above sea level. Thus, its adjoining lofty peaks had to have been at least fifteen to twenty thousand feet in height.

After exiting our vehicle, we passed a couple of slow moving villagers of the sleepy town before entering a gate leading into private property. Then as we cut through a grassy, dew-covered meadow next to the only house on the property, it quickly became apparent to me that A.C. had been here before. He warmly greeted the native landlady who stood outside on her doorstep to greet us, and he then knowingly lead me and his translator down a descending path behind her house.

I had been informed by A.C. that we would be performing our ceremony near or within a hot spring, so in my mind I had pictured a rustic pool, possibly bordered by a ring of jagged, arbitrarily placed rocks. I was, therefore, quite pleasantly surprised when our trail led us to a small, beautifully constructed pool made of natural stone and nestled comfortably among the tall grass and surrounding peaks. The entire scene was as close to paradise as I could imagine.

At A.C.'s request the three of us set about making our new environment as "San Pedro friendly" as possible. We placed our drinking water and shamanic instruments, such as drums and rattles, at strategic places around the outside of the pool. We then went in search of private locations for changing into our swimsuits before meeting at the side of the pool for the beginning of our ceremony.

When we were gathered again and A.C. handed me the familiar large mug full of frothy green liquid, I instantly knew that this batch of San Pedro was different than what I had consumed in the past. It seemed to be much thicker and heavier. Feeling a bit anxious, I hesitated, knowing that thicker often meant stronger. But then A.C.'s resonant command split the mountain silence. With the stern voice of a presiding shaman he instructed me to "drink it all right down."

Moments later we all entered the warm pool and the three of us quietly moved to our own private corner of it. I proceeded to play a cassette tape of Sanscrit mantras while the translator, who was also studying San Pedro shamanism, shook rattles and danced in the center of the pool. Then, for the following hour or so we either sang along with the mantra, played our instruments to its hypnotic rhythms, or meditated on our surroundings - all depending on how the San Pedro inspired us.

After a sudden episode of projectile vomiting, I quickly descended into that familiar place that I like to refer to as "San Pedro Land." Since we had all reached that space of heightened awareness at about the same time, A.C. asked us to converge on one side of the pool so he could begin some shamanic teaching. Once together, A.C. had us fix our gaze on one of the tall peaks surrounding our little oasis while trying to surrender to whatever visions or communication the spirit

of the mountain (or of the San Pedro) had to give us. Andean shamans do not consider the mountains as simply colossal mounds of inanimate rock, but *Apus*, fully conscious beings. As we opened ourselves to this particular *Apu* I did indeed feel as though I was communing with a live, animate being. I could "see" the pulse of its respiration, and felt its eyes upon us as we meditated upon it. Then, almost in unison, we all spotted the form of a temple just below the mountain's summit. This wasn't just any dilapidated temple ruin, but a glowing, magical temple from a storybook world of fantasy. And even though it was in pristine condition, it gave the impression of being older than the oldest megalithic temple I had ever seen. I fantasized that it had probably been made thousands or millions of years ago by some masters from another world, or perhaps by missionaries from the fabled lands of Atlantis or Lemuria. Perhaps it was originally physical and later became part of a dimension different from our own.

Staring at the mountain made me dizzy, and I was soon helplessly vomiting with an intensity and amount I was not accustomed to. I decided that my retching was the result of my having consumed an inordinately strong dose of San Pedro. But I was trained by A.C. not to be too concerned by it. Vomiting the cactus is considered auspicious by the Peruvian shamen; it is cleansing to the digestive system and allows one to enter into more profound depths of "San Pedro Land."

Having completed another episode of vomiting, I sunk back into the warm water in order to heal my aching and exhausted internal organs. Then, while slouching against the side of the pool, I looked glassy-eyed at my surroundings as they magically transformed into the surreal terrain of another world. I didn't completely lose touch with the physical world; another dimension seemed to simply superimpose itself over the one I was accustomed to. In this new, psychedelic realm every plant and animal magically glowed with the light of consciousness, and I was suddenly surrounded by a host of new friends.

Then, in what seemed like the very next instant, all the surrounding rocks and plants acquired large, expressive eyes. It seemed as though all the forms of nature had suddenly awakened from a long slumber and were now opening their sleepy eyes. My equipoise was quickly shaken when I realized that all these myriad eyes were staring directly at me! As I anxiously studied these multitudinous eyes I searched for clues as to their owner and what, if anything, they wanted from me. They seemed to be not entirely human, in fact, they looked more like the "eyes" on a peacock feather. My further examination of them revealed that each eye was indeed part of a graceful, sweeping, peacock feather. I chuckled in delight as I realized I was engulfed in a sea of peacock feathers!

Gradually more eyes and feathers appeared in the terrain surrounding our pool until everywhere I looked thousands of eyes peered directly at me. Feeling a little frightened and confused, all I could do was keep mumbling out loud "There

are eyes everywhere." But then I recalled Murrugan, the Peacock Angel, who is intimately associated with peacocks. And I also remembered that Sanat Kumara's eyes are supposed to be everywhere. So, with a deep sigh of relief, I thanked God and my good fortune for allowing me to be in the presence of Sanat Kumara. I then began meditating on his eyes in hopes of somehow communicating with him.

Soon the peacock shape of the Sanat's eyes began to alternate with a luminescent form of the Flower of Life, a geometrical figure comprised of numerous vesica pisces. Having visited Egypt just months before going to Peru and been shown the symbol on a pillar of the Osirion at the Temple of Osiris in Abydos, I was familiar with the Flower of Life but not entirely clear about its meaning. Now, having witnessed this interchange between the peacock eye and Flower of Life, I realized that both were related and somehow intimately connected to the geometrical matrix which underlies all physical form. Then, in a sudden flash of intuition, I understood that all form merges out of the Eye of God, which in its primeval state first appears as a peacock eye followed by the precise geometries of the Flower of Life. I knew unequivocally that the peacock eye and Flower of life are manifestations of the Creator and the parents of all physical form.

As my consciousness continued to merge with that of Sanat Kumara, my environment magically changed again. Soon I found myself in what I concluded was a version of the legendary Garden of Eden, with our pool right in the center of it. As I swam alone in the pool I completely lost identification with the personality of Mark and fully merged with the persona of Murrugan. A.C. and his translator, who were sitting together on the edge of the pool at the time, thus became my mother and father, Shakti and Shiva, and I felt as though they had recently given birth to me. Intense desire for both wisdom and experience in this "new" world of mine emerged within me, and I felt pride in my young, supple body, which, with its smooth skin, seemed to magically glisten in the Andean sunshine. I also felt pride in the peacock feathers which surrounded me, perceiving them now as glorious extensions of my own universal body.

After a couple of hours in our Eden, A.C. instructed his translator and I to gather up our belongings so the three of us could move to another location for further shamanic lessons. I was still seeing peacock eyes everywhere and found it difficult to do anything, including walking a straight line, but my emerging egotistical boy relished the idea of further adventure. When we finally reached our new destination, a grassy knoll on the side of a mountain, I recognized another characteristic of Murrugan emerging within me, rebelliousness. My defiance compelled me to wander off by myself even though A.C. had explicitly instructed me to sit in one place and meditate until told otherwise.

My illicit wandering soon led me past a stonewall and into a large field where I sat down to admire the vibrant green meadow and the towering moun-

tains which surrounded it. One lofty mountain directly in front of me appeared particularly interesting, so I studied its contours and ridges from beginning to end. To my amazement I discovered that one of the longer ridges resembled the features of a peacock's back in both color and shape. As I followed this ridge further, it seemed to slope down before tapering into what appeared to be a huge tail covered with peacock feathers. Scanning the adjacent mountains for more peacock shapes, I found could distinctly make out not only tails, but also complete peacock bodies. It seemed as if each mountain was a living peacock. Then I noticed that where two mountains joined together a larger peacock was formed, and when they were joined with other mountains in the area an even larger bird emerged. I could only speculate that peacocks were joined together in a never-ending succession of increasingly larger shapes until the entire Earth itself was a peacock, followed by the Solar System, the Milky Way, and, ultimately, the entire universe. Such a revelation was almost too much for my limited western mentality to grasp, and I didn't know where to go or what to do with it. "Who would believe me anyway?" I solemnly asked myself. So feeling both enlightened and deflated at the same time, I slowly ambled back to the company of A.C.

Later, after returning to the U.S., I did some research in order to better understand my San Pedro experience in the Andes. After studying the experiences of certain shamen and nature worshippers, I ceased to doubt that I had seen peacock feathers and entire birds embellishing the Andean scenery. I also understood my experience of Eden. Apparently, by seeking to unite my consciousness with the Peacock Son of God I had succeeded in becoming one with him in his form of Melek Taus, the rebellious boy who "fell" from too much ego. And in the same way that the followers of the Greek Dionysus had mimicked their deity after merging with him, I had acquired the egotistical and rebellious behavior of Melek Taus. I now clearly comprehended Melek Taus' fall from grace from having experienced it directly. My pride and ego had swelled to unprecedented proportions, and this had fueled a rebelliousness capable of almost any defiant action.

Finally, I now understand at least partially how or why San Pedro gave me my special experience of Sanat Kumara. I intensely yearned for the experience, but that is only a small part of the reason. San Pedro is linked to Venus, the original home of Sanat Kumara. Some esoteric texts even claim that Sanat Kumara was the spirit of Venus before he became the spirit and king of our Earth. So perhaps Sanat Kumara, or any other Venusian for that matter, is a being one is likely to encounter after imbibing San Pedro cactus.

Since having felt and seen the presence of the spirit of the Earth all around me, I have developed a new respect for the Earth. I now know that whenever I walk upon the Earth I am treading upon the body part of a living entity, Sanat Kumara. I am also more acutely aware of how humanity is constantly harming and

endangering the planet, and how each one of us needs to cultivate an attitude of reverence for our Earth if it is going to survive. My wish is that more people could have the benefit of an experience like I had in the mountains of Peru, and thus learn to see and feel with the eyes and heart of a shaman.

The author and a tall San Pedro Cactus, Nazca, Peru

This image was discovered at "El Brujo," a Mochica pyramidal compound in the northern coastal regions of Peru. Archeologists working at the site have determined that the figure's crown of five points indicates that it is the personification of the spirit of Venus (five was a sacred number of Venus throughout the Americas). This image, which was found in conjunction with symbols relating to the preformance of sacred rites, seems to reveal that the spirit of Venus would anciently manifest among the Mochica during their San Pedro rites. Could this be an image of Sanat Kumara, the crown King of the World and once the spirit of Venus?

V

The Peacock Angel and Shamballa

After experiencing Sanat Kumara in the refined air of the Peruvian Andes, I felt compelled to know even more about him, especially in regards to his role of King of the World. Since I was scheduled to leave for a tour of Tibet soon, I decided to seek more clues regarding Sanat Kumara there, especially in light of the fact that legends contend that the King of the World has an intimate connection to this intriguing Himalayan country. Tibet and Central Asia are home to the Gobi Desert and Shamballa, the legendary Land of the Immortals, which has traditionally been an important destination for all occultists and adventurers in search of the illusive King of the World. Luck was on my side once again. While visiting the Roof of the World I was able to find the wisdom I sought and thus took one step closer to comprehending our planet's clandestine monarch.

The Peacock Angel in Tibet

Before entering Tibet I had done some cursory study on Tibetan Buddhism or "Vajrayana," the "Way of the Vajra" or "Way of the lightning bolt," however I was not aware of any "peacock" influence within its pantheon of gods or arcana of sacred symbols. But that changed as soon as I arrived in Nepal, my gateway to Tibet and one of the primary destinations of Tibetans who had escaped the Communist Chinese invasion of their country. One of the largest colonies founded by the Tibetan refugees in Nepal is located in the eastern end of its capital city, Kathmandu, in an area now nicknamed "Little Tibet." It was here that I first recognized the Peacock Angel's influence within Tibetan Buddhism.

I was brought to Little Tibet by my Nepalese guide for the specific purpose of visiting Bodhnath, one of the largest stupas in the world. Bodhnath sits in the very center of the thriving Tibetan community, so upon arriving at the stupa I quickly scampered halfway up it in order to get a sweeping view of Little Tibet. From my elevated vantage point I perceived a sea of newly built Tibetan monasteries looming over the surrounding homes and public buildings. This ring of impressive monasteries had golden pagoda-style roofs glistening brightly in the midday sunshine, and over the entrance of each was a solid-gold motif of two deer flanking a wheel of eight spokes, a symbol my guide informed me denoted the Buddhist eightfold path. My interest was peaked when I noticed that the wheel was set within a motif, known as a "chakra," which closely resembled the "eye" of a peacock feather. Since I had, by this time, examined literally hundreds of peacock feathers and their corresponding "eyes" as part of the research for this book,

I felt like an expert on peacock symbology and decided there was no mistaking it." Unfortunately my guide had no explanation for the link I had made, so while sliding down Bodhnath I vowed to keep my eyes open for further manifestations of peacock eyes in Tibet.

Buddhist symbol of "peacock eye" between two deer
on Tibetan monastery

A few days later I officially entered secret Tibet. My guide, a short, friendly Tibetan man named Lobsang, met me at the Lhasa airport and then whisked me and two other tourists away on a whirlwind tour of his mysterious country. Our first stop was the capital city of Lhasa and its numerous temples and monasteries. As we visited the various monasteries of the city, I soon noticed the same "peacock motif" I had observed in Little Tibet consistently peering down at me at each monastery's entrance. I also discovered versions of this symbol embellishing certain chapels and dimly-lit chanting halls inside the monasteries. Some of the peacock "eyes" I encountered enveloped the traditional eight-spoked wheel, but other "eyes" encompassed a different symbol or were completely devoid of any interior

contents whatsoever. I eventually concluded that peacock "eye" with all its nuances must be the foundation of much of Tibetan Buddhist iconography.

Sometime later, while strolling through the inner chapels of one of the monasteries, I again found the "peacock eye" in association with colorful images of Bodhisattvas, sages and protective deities. But now I found the peacock eye incorporated into the crown designs of these effigies, or that the deities were surrounded by feathery peacock motifs embellished with shiny turquoise or other stones of the blue-green coloration associated with a peacock's exotic body. I also recognized a new variant of the peacock "eye." This eye motif was made with jagged edges, thus giving it the appearance of being engulfed in fiery flames.

Tibetan deity with "Peacock Eye" crown

Shigatse, Home of the Peacock Angel

Peacock imagery continued to pursue me throughout my tour of Tibet, ultimately reaching its climax at the Tashi Lunpo Monastery in Shigatse. Having dreamed of visiting this monastery for many years, I was familiar with the many legends about its connection to King of the World, including the remarkable claim that it is linked by a secret tunnel system to Shamballa. Certain members of the Great White Brotherhood, including Madame Blavatsky, Alice Baily and Elizabeth Clare Prophet, maintained that they had been in contact with "Masters," including Master Morya, Dwal Khul and Kuthumi, who had traveled the tunnels

between Shigatse and Shamballa. Perhaps to prove their dubious claims, in 1947 Kuthumi, who was also known as the Prince Regent of Agartha (an underground civilization linked to Shamballa), emerged from one of these tunnels and then traveled to France to alert the western world of his underworld kingdom. Once in Paris, he succeeded in procuring an interview with *Point de Vue,* [1] a prestigious French magazine, during which he freely disclosed the network of tunnels, some of which he said were five hundred miles in length and punctuated with huge caverns the size of Notre Dame Cathedral. Kuthumi's interview helped generate widespread interest in Agartha and an expedition of Europeans was soon organized to accompany him back to his subterranean home. Unfortunately Kuthumi mysteriously disappeared just before the expedition was scheduled to depart, thus diminishing any credibility he may have gained from his improbable story.

But even though Kuthumi's expedition was indefinitely sidetracked, there are Europeans who claim to have visited Shamballa or at least discovered tangible evidence of a civilization under Central Asia. Included in this elite group are the Russian adventurers Nicholas Roerich and Ferdinand Ossendowski, as well as the German explorer Theodore Illion. In Ossendowski's journal of his Asian adventures, which was published as *Beasts, Men and Gods,* the Russian claims that while visiting a Buddhist monastery in Mongolia he was shown the entrance to a tunnel which supposedly connected the abbey to Shamballa. The resident monks of the monastery told him that the ruler of Agartha, the "King of the World," had emerged from the tunnel sometime in 1890 and presented them with a prophecy concerning the next hundred years. The throne the monarch sat upon during his disclosure is, presumably, still in the monastery.

Within the numerous books he wrote recounting his two-year expedition in Asia, including *Shambhala* and *Heart of Asia,* the famous Russian painter and diplomat Nicholas Roerich mentions those experiences that convinced him that Shamballa and its tunnels were more than just mere fantasy. While caravaning across Tibet and Mongolia, for example, Roerich heard many unusual sounds under his feet which his Tibetan guides claimed were the result of shifting movements within the underground tunnel system, and later, while visiting Turfan in eastern China, he was shown an entrance into that tunnel system which had apparently been used by individuals many times in the past. Roerich's education regarding Shamballa also included meeting Master Morya, an occasional resident of Agartha, from whom he received a special form of yoga that he and his wife, Helena, later shared with the world. Supposedly this yoga, known as Agni Yoga, originated in Shamballa /Agartha and was destined to be the Yoga of the New Age.

Of all western explorers who searched for clues to a city of immortals in Tibet or Central Asia, Theodore Illion stands alone as the only one who actually

visited a subterranean civilization. In the 1930s, after teaching himself the language and strengthening his legs by walking the length and breadth of his native Germany, Illion entered Tibet disguised as a native and then traveled alone on foot throughout the rugged country. During a subsequent visit to Lhasa, he met an initiate of a secret brotherhood who consented to give Illion directions to the organization's underground headquarters, the "City of the Initiates." [2] After discovering the hidden entrance to this city, Illion entered a tunnel system which linked caverns occupied by a multitude of resident initiates. Illion then had numerous interactions with the "Prince of Light," the ruler of this subterranean city, who was apparently also known as the King of the World and controlled the events upon the Earth's surface with his mystical powers. Illion was invited to remain indefinitely in the underground civilization as a guest of the king, but his own paranoia eventually forced him to flee the colony once he had become convinced that his host was none other than the "evil" Lucifer. Perhaps Illion had truly met the King of the World, Sanat Kumara, who was then (and still is) ruling the planet as the egotistical Lucifer.

But, as expected, the most authoritative evidence for the existence of Shamballa comes from a Tibetan, Tashi Lunpo's abbot, the Panchen ("Great Scholar") Lama. The Panchen Lama's association with Shamballa is very ancient and has existed since the dignitary incarnated there as the kingdom's most famous king, Manjushkriti, the ancient reformer of Kalachakra, the version of Vajrayana Tantrism practiced in Shamballa. Ever since that pivotal incarnation the Panchen Lama has been the principle Tibetan authority on the Kalachakra and Shamballa, and certain Panchen Lamas, especially the third, Lobsang Palden Yeshe, have formally revealed their intimate knowledge of Shamballa by writing guidebooks on how to get there. Eventually, claim the Tibetan prophesies, the Panchen Lama will once again incarnate in Shamballa. He will be the kingdom's last king, Rudra Chakrin, the fiery "Red Circle," who will purge the entire world of darkness while spreading the light and wisdom of Shamballa.

Of course, technically it is not the Panchen Lama who incarnates as the king of Shamballa, but his indwelling spirit, the Dhyani Buddha Amitibha. The identity of the Panchen Lama's incarnating spirit was revealed in the seventeenth century by the greatest Dalai Lama, the "Great Fifth," who simultaneously proclaimed himself the incarnation of the Bodhisattva Avalokiteshwara, the angelic student and "emanation" of Amitibha. Amitibha is one of five Dhyani Buddhas and therefore higher up in the heavenly hierarchy than Avalokiteshwara or any of the other Bodhisattvas worshipped in Tibetan Buddhism. Amitibha's celestial home is one of the Tibetan heavens known as Sukhavati, the "Pure Land of the West," where he monitors the universe as its guru and savior. Sukhavati, which means "Happy Land," has its reflection on Earth as Shamballa, meaning "Source of Hap-

piness." Both places are governed by the spirit of Amitibha.

Amitibha, also known as Amitayus, is the Dhyani Buddha of Infinite Light and Infinite Life. He is commonly portrayed as a red-colored buddha sitting in deep in meditation and/or riding upon a peacock mount. He thus appears to be the Tibet version of the Peacock Angel and a Himalayan manifestation of Murrugan or Sanat Kumara. Murrugan was probably transformed into Amitibha following the northern migration of certain Tantric Yoga missionaries from India, such as Padmashambhava, who is revered as the founder of Tibetan Buddhism. Perhaps a stage of Murrugan's evolution into Amitbha can be found in Nepal, the country Padmashambhava allegedly stopped in long enough to achieve enlightenment inside of a cave. In that lofty Himalayan kingdom a cross between Murrugan and Amitibha can today be found as Rato Matsyendranath, the "Red" Matsyendranath, a forever-young boy with reddish skin color and a Star of David upon his breast.

Amitibha-Amitayus sitting over his symbolic peacocks

When I finally arrived at the entrance of the Tashi Lunpo Monastery I was immediately greeted by numerous ochre-robed monks scurrying around a magnificent temple compound the size of small city. Above this sea of pagoda-shaped enclosures, I could distinguish three towering temples crowned with gilded, golden rooftops. But before I could study any more of the temple landscape Lobsang whisked me away to a special temple in the back of the monastery compound which housed a gigantic, sixty foot statue of Maitreya, the future Buddha. One of the largest statues in the world, I learned that this golden effigy required nine

hundred artisans and three hundred kilograms of gold for its construction. I stood solidly transfixed in front of this colossal image, partly because the intense devotional energy surrounding would not let me move, but then my guide gently nudged me in the direction of our next destination, the tomb chamber of the Tenth Panchen Lama, the most recently deceased Panchen Lama. Also mammoth in size, the Tenth Panchen Lama's stupa-shaped tomb reminded me of a step pyramid covered with thick sheets of gold and embellished with an abundance of precious stones. Hovering above the tomb is a ceiling mural of the Kala Chakra, an intricate mandala which ostensibly reveals the Panchen Lama's link to Shamballa and its special form of Tantra. After inwardly bowing to the manifest greatness of the Tenth Panchen Lama, I visited the nearby tomb of the First Dalai Lama, the reputed builder of the Tashi Lunpo Monastery. While studying this much smaller tomb, which is also constructed in the form of a stupa, I noticed a small, doll-like image of the First Dalai Lama enclosed in an oval part of the stupa which resembled a peacock eye. I had seen similar diminutive images of other high lamas enclosed with the "eye" of their tomb-stupas and seemed to imply that at death the each lama merged with the Eye of God and became all seeing or omniscient.

The tomb of the first Dalai Lama, Shigatze, Tibet

Soon I was taken down a flight of stairs to the "Holy of Holies," a temple in the most ancient and sacred part of the Tashi Lunpo Monastery. As I walked into this revered chapel I immediately had what I can only describe as an "epiphany."

The room seemed to vibrate with an etheric presence, which I intuitively sensed was that of the Peacock Angel. Everywhere were "peacock" related signs and symbology. In front of me was what I discerned to be a classic image of the Peacock Angel, a statue of a seated forever-young boy with what appeared to be a stylized peacock motif projecting from him. Flanking the boy were deities adorned with peacock eyes, tails, and feathers, all of which were inlaid with jewels sparkling with the greenish-blue coloration of a peacock. As I scanned the chapel for additional peacock imagery I noticed that flanking the wall were ten-foot tall images of bodhisattvas adorned with crowns made of peacock eye-shaped "leafs," and situated in front of the "peacock" boy were two images of the Goddess Tara, who were also adorned with peacock symbolism. I couldn't help but congratulate myself for my good fortune. I had entered the "Temple of the Peacock" and was now being given an audience by the Peacock Angel!

After paying off the presiding monks the equivalent of seventeen U.S. dollars for the privilege of taking some photos, I worked feverishly to capture on film as much of the sacred "peacock" chapel as I could. Then, while some monks inquisitively studied the craftsmanship of my western-made camera, I sat against one of the chapel's walls and let my mind become absorbed by the spiritual light which pervaded the shrine. Soon I felt my third eye open wide and psychic information begin to pour inside. As bits and pieces of the cosmic information became intelligible to my conscious awareness, I began to understand some fundamental, esoteric truths about the Peacock Angel. I understood, for example, that fire and the peacock are interrelated and this is why the graceful motifs surrounding the young boy and other Tibetan gods and goddesses appeared both like swirls of fire, as well as silky peacock feathers. The peacock form of the Creator emerges out of Cosmic Fire; a simple truth. I also finally comprehended the meaning behind the motif of the two deer flanking a "peacock eye," the golden symbol adorning the monasteries of Tibetan Buddhism. The center "eye" of this trinitized symbol represents the union of the polarity, which is denoted by the opposing deer.

A couple minutes later I found myself overcome by a strong intuition that the "Temple of the Peacock" had a direct link to Shamballa/Sukhavati and its peacock-riding king, Amitibha. I was convinced that the chapel was a replica of the court of the Peacock Angel at both Sukhavati and Shamballa. The forever-young boy was thus a replica of the King of the World, Amitibha or Sanat Kumara, and the huge deities flanking the chapel's wall were life-sized models of his attendants. And, even though I did not physically see them, I intuitively sensed that the tunnels leading to Shamballa were in the vicinity of the chapel. But I also knew that such subterranean passageways were only necessary when someone desired to travel physically to the mythical kingdom. The Temple of the Peacock provided a direct psychic link to Shamballa and one could, while meditating there with intense

focus, directly link his or her consciousness with the land of the immortals. When I had finally returned to normal consciousness moments later, I felt as though I had done just that. With an inebriated smile on my lips, I picked up my camera and staggered out of the chapel while feeling as though I had just taken a journey into the heartland of Shamballa.

Forever-young Buddha set in a stylized peacock motif, Shigatze, Tibet

Jowo Shakyamuni, the Forever-young Boy

Sometime later on my tour of Tibet I learned that the forever-young boy image in the "Temple of the Peacock" is known by the monks of Tashi Lunpo as the Jowo Shakyamuni, a generic name for certain images of Buddha as a young boy between the ages of eight to twelve. The original Jowo Shakyamuni, which is located within the Jokhang, the most sacred temple of Tibetan Buddhism, was brought to Tibet from China by Wen Ch'eng, a Chinese princess who married Songtsen Gampo, the first great Buddhist king in Tibet. This older Jowo Shakyamuni

is believed to be one of four identical, forever-young boy images of the Buddha which were blessed by the Shakyamuni in India just prior to his death. Another of the four identical images, the Jowo Mikyoe Dorjee, arrived in Tibet as part of the dowry of Bhrikuti Devi, Songsten Gampo's Nepalese wife. Both it and the Jowo Shakyamuni were originally installed together within the Jokhang, a name that is derived from Jowo Khang, meaning "Chapel of the Jowo."

Jowo Shakyamuni appears to be Sanat Kumara, the archetypal forever-young boy, thus making the four identical images blessed by the Buddha a version of the four Kumara twins. From his years of wandering in India and studying various forms of yoga, such as the "Yoga of Psychic Expansion,"[3] Buddha would have naturally recognized any forever-young boy image as Murrugan or Kumara, the archetypal Son of the archetypal couple, Shiva and Shakti. He would have also been familiar with the four Kumaras, who for ages have been hailed as the ancient founders of yoga, and he would have thus been accustomed to associating any four forever-young boy images with them. Thus, it seems to follow that the images sitting in the Jokhang and the Tashi Lunpo Monastery are representations of Sanat Kumara, the forever-young King of the World.

The Jokhang, most sacred temple of Tibetan Buddhism

Buddha, Incarnation of the Peacock Angel

After my visit to the "Temple of the Peacock" I traveled to the city of Tsetang, site of Yumbulagang, the oldest temple in Tibet, within which I discovered a statue of the Buddha set within a peacock motif reminiscent of the one I had seen at Shigatse. Since this was the second time I had encountered an image of the Buddha enveloped within a peacock motif, I decided it was time to investigate Lord Buddha's own connection to the Peacock Angel.

My inquiry bore immediate results. According to most traditional Tibetan Buddhist texts, Buddha was an incarnation of Amitibha. The sects of Tibetan Buddhism which have delineated a hierarchy of gods and deities designate Shakyamuni Buddha as being Amitibha's physical counterpart. They recognize Buddha is part of a step-down in vibratory frequency which begins with the heavenly Amitibha, contracts to become the Bodhisattva Avalokiteshwara, and then descends into further density to become the physical Buddha. When Buddha achieved enlightenment under the Bodhi Tree, the Shakyamuni merged with Amitibha, his higher self, and then authored the doctrines of the new religion of Buddhism. Like his counterpart, Sanat Kumara, Amitibha has thus distinguished himself as both King of the World, as well as World Guru.

Buddha's affiliation with the peacock may also be linked to the Shakyas, his family tribe from Kapilavastu. One legend asserts that King Ashoka's ancestral tribe, the Mauryas - a name derived from Mayura, meaning "peacock" - originated as a branch of the Shakyas.[4] This connection might explain why Ashoka readily accepted the doctrines of Buddhism and made it the national religion of India. It may also reveal why he embellished many important Buddhist stupas and shrines throughout the subcontinent with peacock motifs, including the famous stupa at Sanchi.

Buddha was also associated with Cosmic Fire. The Triune Flame sits upon the Buddha's head in this unique Buddhist motif.

Maitreya Buddha, the future King of the World

One final deity in Tibetan Buddhism with apparent affiliations to the Peacock Angel is Maitreya, the "Future Buddha." Maitreya is the bodhisattva who resides in the Tushita Heaven while awaiting the predetermined moment to incarnate as the Buddha of the New Age. During his prophesied incarnation Maitreya is destined to revive the Buddhist Dharma of truth and righteousness while simultaneously cleansing the planet of evil.

Maitreya appears to be a name for Rudra Chakrin, the future king of Shamballa and prophesied incarnation of Amitibha. At least this was the esoteric

information given to the Russian traveler Nicholas Roerich by the presiding lamas when he visited Tibet in the early part of the Twentieth Century.[5] Therefore, Rudra Chakrin, Maitreya, and Sanat Kumara (ruling as Sananda) are all names for the King of the World who is destined to rule during the New Age. Not surprisingly, each one is worshipped as a forever-young boy. Maitreya's forever-young boy image, whose features are nearly identical to the Jowo Shakyamuni at Shigatze and the Jokhang, can be found at the Drepung Monastery in Lhasa.

Maitreya, the coming Buddhist savior. Drepung Monastery, Tibet

In order to prepare for Maitreya's inevitable reign, the current Dalai Lama gives annual Kalachakra initiations which guarantee incarnation into the coming new world of Shamballa. The Dalai Lama is himself intimately connected to Shamballa by virtue of being an incarnation of Avalokiteshwara, an emanation of Amitibha.

The Peacock Flag of Shamballa

Since returning from Tibet, one additional bit of evidence I have found that links the Peacock Angel to the King of the World and Shamballa is contained within a thanka or Tibetan scroll painting. In this end-times scenario the King of the World, in his latter day manifestation of Rudra Chakrin, is depicted rushing into battle against the world's unrighteous hordes while one of his warriors races

beside him holding the national flag of Shamballa. The flag of Shamballa consists of peacock feathers surrounding the symbol of fire, the Chintamani. At the center of the flag's motif is a cluster of mountains which have been interpreted as implying that Shamballa must be situated deep within a secret mountain range.

Rudra Chakrin and the Peacock Flag of Shamballa

VI

The Redemption of the Peacock Angel

This chapter is one of the most important of this book. It recapitulates the "fall" of the Peacock Angel, who has been ruling Earth as Lucifer or Sanat Kumara for thousands of years, and then proceeds to describe the Peacock Angel's redemption and what that means for all of humanity since collectively *we are Sanat Kumara*. But there is much more here as well, because to truly understand the fall and redemption of the Peacock Angel necessitates comprehending **the past and future destiny of humanity, as well as the entire unfoldment of consciousness, from God to Man and from Man to God.** Humanity is the vehicle which brings this momentous evolution of consciousness to its predestined conclusion.

The Cosmic Drama

Throughout the preceding chapters of this text we have seen how the Infinite Spirit contracted to become the Son of God, the Peacock Angel, who then proceeded to create the physical cosmos and rule over it as its king. We have traveled with Sanat Kumara, the Peacock Angel, from Venus as he established his throne on Earth and then made his will supreme. And, finally, we have seen how Sanat's will, which is the will of all humanity, fell through the development of an intellect and ego, thus transforming the King of the World into Lucifer. But why did all this have to happen? What purpose was served by the Peacock Angel's "fall?" Is there any logical reason for it or the chain of events leading up to the Fall? According to many of the enlightened Masters around the globe of the past and present, there is. God needed to "fall" in order to know himself, and the best way to do that was through us humans. God needed the vehicle of self conscious humans and their focused, discriminating intellects before He could, through inquiry, identify Himself as the Universal, Infinite Consciousness and Creator of the Universe. The tragic part of this evolution is that, preceding His enlightenment, God needed to experience the pain of humanity and the trials and tribulations which come from being acutely self-conscious and separate from everything and everyone in the universe. This suffering needed to occur before each human being would embark on a path of self discovery, which eventually culminates in the realization of *God exists within Me as Me.* This, states the Hindu scriptures and the enlightened Masters of the East, is the reason for the entire "play of consciousness" which began billions of years ago with the Big Bang and lead to the "Fall."

During the past six million years Spirit has sought to know itself through innumerable humans seeking enlightenment. But until now only a small portion of the human population has zealously taken to the arduous path leading to Truth. But this is destined to change, claim the Yezidhi and prophets worldwide. In the days to come much of the world's humanity will be given the opportunity to achieve rapid expansion of consciousness and realize their divine selves. And when enough of us have finally shaken off the shackles of materialism and the ego, the symbol of our collective consciousness, the Peacock Angel, will be redeemed. Spirit will then realize the purpose for having taken a physical form and the evolution of the universe will have come to its conclusion. But to fully understand the implications of the coming **Redemption of the Peacock Angel** we must reacquaint ourselves with the events leading up to and following his fateful fall. To know where you are going, you need to know where you have been.

The Three Ages

The history of both the Peacock Angel and all humanity can be understood according to an esoteric tradition which maintains that we on Earth have undergone two major ages, a Lemurian or Matriarchal Age and an Atlantean or Patriarchal Age. The first age preceded the "fall" of Sanat Kumara, while the latter corresponded to it. Aleister Crowley, a great occultist and leader of the *Hermetic Order of the Golden Dawn,* was one of the modern proponents of these ages, which he referred to as the Age of Isis and the Age of Osiris respectively. Throughout the very ancient **Lemurian Age**, which began perhaps six million years ago when much of the Earth's crust was united as Gondwanaland, and then ended approximately twenty five thousand years ago during a fateful planetary cataclysm, humanity strove to live in accordance with the Divine Will of God. As a reflection of this age, Sanat Kumara, the collective consciousness of humanity and King of the World, governed the Earth while in continual union with his higher self, Sananda. At this time Sanat Kumara was known as Melchizedek, which is also a name for Sananda. This ancient Lemurian epoch is represented in *The Book of Genesis* of *The Holy Bible* as the early stages of the Garden of Eden scenario, when Adam and Eve scrupulously obeyed the will of God.

Then came the **Atlantean Age**, the era when the Peacock Angel experienced his fateful "fall" and both he and the majority of humankind became dominated by an ego and "lower self." This era, which marked the demise of the human race, is represented in the Garden of Eden scenario as Adam and Eve, the divine couple and representatives of the early human race, who disobeyed the will of God by eating the forbidden fruit. The sense of differences and the modesty that Adam and Eve felt for each other after eating from the Tree of the Knowledge of Good and Evil symbolizes humanity's development of an ego and intellect and the

experience of separateness which accompanied the emergence of the discriminative faculty. Thus, as a consequence of acquiring egocentric self consciousness all humanity was evicted from the Garden and made to grope in ignorance of their own true nature for the duration of the Patriarchal Age, which is just now coming to a close.

In some of his readings the great clairvoyant Edgar Cayce alluded to the fateful "fall" which befell Atlantis. He claimed that the empire's decline corresponded with the emergence on the motherland of the imperialistic and technologically advanced "Sons of Belial" or Sons of Lucifer, who sought to conquer the Earth and govern it in accordance with their own self centered desires. These Sons of Lucifer, were quietly opposed by the "Sons of the Law of One," [1] the Sons of Sananda, who as the remaining vestiges of the righteous Lemurians sought to preserve the principals of love and harmony. While the Son of Lucifer were seeking to control and conquer the world with their advanced technology, the Sons of Sananda continued offering their daily rites and prayers to the Creator for world peace, just as their Lemurian ancestors had done before them. When Atlantis eventually sank to the bottom of the Atlantic Ocean, the Sons of Lucifer and the Sons of Sananda relocated to various parts of the world, but the struggle between light and darkness, ego and Higher Self, continued throughout the ensuing Patriarchal Age. Wherever the Sons of Sananda relocated cultures and institutions guided by freedom and democracy flourished. By contrast, wherever the Sons of Lucifer settled there has been the emergence of imperialistic and patriarchal governmental systems designed to effectively control the populace while exalting the individual ego and intellect. Since the Luciferian agenda has been the theme of the Patriarchal Age, the self serving Sons of Lucifer have nearly exterminated the Sons of Sananda. Luciferian Patriarchy has eclipsed Sananda inspired Matriarchy, and hate and war has continued to prevail over love and harmony. But the coming Redemption of the Peacock Angel heralds a time when this trend will be reversed and Sananda and his "Sons" will once again return to world dominance.

The final showdown between Sananda and Lucifer is referred to in scripture as the "Armageddon," an event which is destined to precipitate the third era of human history on Earth, the **Age of the Son**, an era Crowley referred to as the Age of Horus. This will be an age when the male and female principles, or their manifestation as Patriarchy and Matriarchy, will unite as the androgynous Son (or Daughter). The Armageddon officially began in the Twentieth Century during World War II and then went into high gear when the Nazis, representatives of the imperialistic Patriarchy, fought with the latter day representatives of Matriarchy, the democratic countries of the west.[2] The subsequent defeat of the Nazis signaled the end for Luciferian domination of the world and heralded a revival of the expansive and humane principles inherent to Sananda ruled Matriarchy. We are now

faced with at least one last uprising from the Patriarchy before its torch is reduced to a flicker. This is currently manifesting as a reign of terror with roots in the eastern Moslem-ruled countries. The religion of Islam, which fully embraces patriarchal principals, preserves the male inspired themes of control and dominance. Islamic leaders are now desperately trying to keep Patriarchy in control by intimidating and ultimately destroying the U.S.A, a country founded by the European Secret Societies, the descendants of the ancient Matriarchy. They can't possibly succeed as too much of the world has now adopted the rudimentary principals of democracy in anticipation of the return of Sananda.

The Internal Armageddon

Since the Armageddon will continue until a balance and union of the polarity has been reached upon our planet, we can all expedite the process by harmonizing and uniting our own internal male and female principles. This inner process appears to be happening globally, with more and more persons around the Earth dedicating themselves to self-growth and spiritual evolution.

We can expect our current internal struggles to reflect the planetary Armegeddon and Matriarchy's battle against Patriarchy. But both the micro and macro battle will not proceed as simple as love crushing and obliterating hate, or the Higher Self dissolving the ego. Any Armageddon, whether it is waged externally or internally, can only be won when a balance has been created between light and dark, intellect and ego, even though ultimately the power of light is destined to control the darkness when we officially move into the New Age. Thus, although Sananda's divine authority will ultimately reign supreme, a balance between himself and Lucifer needs to occur first. The imminent harmonious balance of light and dark is what makes the coming Age of the Son so unique and separates it from the preceding two ages, which were principally based upon one or the other, either the light or the dark. The union of our internal male and female principals could not have occurred during the Matriarchal or Lemurian Age because at that time our focus as a planetary family was to cultivate the feminine qualities of intuition, love and peace. Nor could it have occurred in the subsequent Atlantean Age when humanity needed to put the intuition aside in order to fully develope an intellect and egocentric self consciousness. But during the coming Age of the Son a synthesis can occur so that a balance and a blending between higher self and ego, or intuition and intellect, can be achieved, and Isis can unite with Osiris to bring forth androgynous Horus.

Because of the current trend towards balance leading up to the Age of the Son, all of us are likely to feel acutely out of balance, at least for awhile. The opposing tendencies of the male and female principles have become painfully ob-

vious for many of us, and now the need to harmonize these polar opposite principles both externally and internally has become crucial. The outcome of our current feelings of off-centeredness has compelled many of us to become involved in self improvement regimens in order to heal and evolve ourselves. Many men are currently recognizing the importance of developing their inner females, while women, beginning with the "Women's Liberation Movement," are acknowledging the need to develop the masculine qualities of assertiveness and independence. Eventually, this universal movement towards balance is destined to culminate in a harmony of the inner polarity, the two opposing forces which the early Essenes taught are involved in a "struggle within the human heart." Ultimately the intellect will learn to work in harmony with the intuition, and the egocentric sense of self will eventually learn to cooperate and work in tandem with the universal Self.

Awakening the Kundalini

According to esoteric yogic doctrines, when the polarity balances and unites the alchemical, evolutionary fire is automatically ignited. The internal polar opposite forces then merge as the androgynous Cosmic Fire or Kundalini power at the base of the human spine, and then the normally dormant serpent fire commences its work of purification and evolutionary transmutation of the human form. Normally the inner polarity, the bipolar forces of Sananda and Lucifer residing within the human body, move through two opposing energy vessels, the Ida and Pingala Nadis, which control the male and female elements of our physiology and biochemistry. When we balance our polarity these opposing energies unite and become what they were at the beginning of time, the androgynous Cosmic Fire. Then, according to its predestined program, the inner Kundalini fire ascends the central channel of balance within the spine, the Sushumna Nadi, in order to gradually destroy our bodily impurities and transform us into perfected reflections of our collective self, Murrugan or Sanat Kumara before his infamous "fall."

Cosmic Fire, as you will recall from the previous chapters of this text, is the incipient form taken by the Peacock Angel during the early stages of the creation of our universe. Kundalini, a name for Cosmic Fire, can therefore be conceived of as the Peacock Angel's manifestation within the human body. This at least partly explains the resemblance of the names Kumara and Kundalini, they are both names of Murrugan. This esoteric truth can be found within the science of Rasayana, the Hindu path of alchemy. It can thus be said that when Kundalini moves throughout the human body and consumes it in transformative fire, each one of us will become the Kumara. Not only will we become pure energy like the Son of God, but we will acquire his wisdom and supernatural abilities. Then, like Agastyar and his lineage of Maheshvara Siddhas of ancient India, we will become

earthly manifestations of Murrugan, the Son of God.

The process of Kundalini transformation can be gradual, or it can be instantaneous. We can become embodiments of the Son of God in a matter of years or literally overnight. Much depends on how much spiritual work we have done on ourselves leading up to Kundalini awakening. But once set in motion, the Kundalini will eventually transform us into reflections of the Son. It begins by moving through our lower "chakras" or power centers situated along the spine. As it purifies and fully opens these centers we acquire the supernatural powers intrinsic to the forever-young boy, that of creation, preservation and destruction of physical matter. At this stage of our development we will learn how to use the life force to create whatever we want in our environment. Then, when the Kundalini continues its ascent and reaches the third eye, the seat of the Divine Mind in the human body, we will acquire the divine wisdom of the Son of God. Knowledge of the past and future will naturally emerge within us. Finally, once the Kundalini has completed its ascent to the Sahasrar Chakra at the crown of the head, our consciousness will be reabsorbed into the transcendental abyss of Shiva, the pure consciousness it emanated from at the beginning of time. If we then decide to return to Earth-plane consciousness in order to help uplift other seekers of wisdom, we will find that our sense of separateness and our consciousness of duality has been dissolved and replaced by the eternal vision of our selves and our world. Not only will we know ourselves as the infinite God, we will also recognize that we have created the universe and are lords over everything within it. The goal of evolution will thus have been achieved, and we will have finally realized the knowledge we took human embodiment to acquire.

Opening Our Hearts

Synchronous with the union of the inner polarity and the ascension of Kundalini is the complete opening of the human heart. The heart is the seat of the polarity within the human body; when the male and female principles unite internally, it soon opens wide. This event is essential to not only our personal evolution, but to the planet as a whole. Only after a collective heart awakening occurs on Earth can the Age of the Son truly commence. This is because the true nature of the androgynous Son of God is love. Love is the glue that cements the polarity into an eternal Oneness.

We can, however, all participate in opening our hearts now. We do not have to wait for some alchemical force within us to crack open the heart chakra. In fact, the safest and surest form of alchemy begins after we start expressing love for ourselves and others. This was the wisdom brought to Earth by the Kumaras millions of years ago. Love's power of attraction will stimulate the union of the

inner polarity, and this process will lead to the activation of the fiery Kundalini.

During an earlier "end time" similar to the one we are passing through now, the Persian Magi once strove to become one with their beloved Son of God, Mithras, by clearing out and opening their heart chakras. The Magi maintained that the heart was the battleground where the forces of light and darkness, personified as Ahriman and Ormuzd, perpetually fight for control. They taught that in the same way the lords fight for control of the Earth, which is the middle region between Heaven and Hell, they also contend for control of the heart in the center of the human body. This Persian notion of an inner polarity conflict was later adopted by the Jewish sect of Essenes who contended that "The spirits of truth and falsehood struggle within the human heart."[3] The Essene "spirits" were, of course, Michael and Belial, the Jewish counterparts of Ormuzd and Ahriman.

The Enlightenment of the King of the World

Because collectively we humans on Earth are Sanat Kumara, a massive awakening of the evolutionary power within us will correspond with a powerful activation of the collective Kundalini, the Kundalini of the King of the World. The awakening of our planetary Kundalini is referred to in prophecy as the final stages of the Armageddon, when Rudra Chakrin, the "Kalki Avatar," rides out of his home in Shamballa upon a white stallion and then proceeds to permanently decimate the forces of evil in existence throughout the Earth. The name Rudra Chakrin means the "Red Wheel" or "Wheel of Fire," and his emergence signals massive, fiery Earth changes triggered by the awakening of the Earth's Kundalini.

Early in the Twentieth Century, Dwal Khul, an adept of the Great White Brotherhood living in Tibet, initiated Alice Baily, his channel and an early member of the Theosophical Society, into the secrets of the planetary Kundalini. Within a series of occult books subsequently written by Baily and published by Lucis Publishing Co., Dwal Khul explained that the planetary Kundalini had previously emerged from Shamballa during the final days of Atlantis and World War II, two notorious epochs associated with "Armageddon" times upon the Earth, and then precipitated full-scale planetary destruction and transformation. Dwal Khul also told Baily that the planetary Kundalini is the power of Sanat Kumara, the King of the World, who resides at Shamballa.[4] It was in the form of this volatile and potentially explosive power that Sanat Kumara came to Earth, and it is in his Cosmic Fire form that the planetary monarch occasionally reverts to in order to accelerate the vibratory frequency of all physical life on Earth. As active Kundalini Sanat's fire causes explosions within the bowels of Earth, and on the surface of the planet it manifests as volcanoes and earthquakes. His heat also works directly within people's lives to intensify karmic patterns and situations in order to heal and re-

solve them. To an unregenerate human being living on Earth, Sanat's heat will be experienced as a heightened desire to control and dominate others, as it did within some dictators during the final days of both Atlantis and WWII. But within spiritually advanced individuals seeking to improve themselves and unify with all life in the universe, his fiery power will precipitate alchemical transmutation and a permanent expansion beyond egocentric consciousness.

Obviously Sanat Kumara's fire is normally at rest, otherwise Earth humans would have no respite from the fiery turmoil and destruction in their lives. During times of stability, Sanat's planetary fire is divided into its polar opposite principles and work towards creating relative balance and order upon the Earth plane. But at the end of an age, for the purpose of destroying and rebuilding, Sanat's polarity reunites and our king assumes his primeval form of Cosmic Fire. This alchemy occurs at Shamballa, Sanat's residence. Shamballa is the heart chakra of our Earth, the place where the planetary polarity competes for control, and its buildings are laid out in the form of an eight-petalled heart lotus, a truth we know from Tibetan diagrams of Shamballa which still survive. Because it is the place where ego and Spirit, light and dark battle for control of the Earth, those who have traversed the central Asia territory associated with Shamballa claim to have encountered areas of both extreme light and extreme darkness. Because of its bipolar nature, Shamballa was anciently able to give birth to both the black sorcerers of the Bon tradition, as well as the highly evolved sages and lamas of Tibet.

Some Tibetan scroll paintings show Sanat Kumara sitting upon his regal throne in the center of Shamballa. This is where he normally abides, but at the completion of Earth's periodic cycles, when the male and female energies become equally strong and then unite, Sanat Kumara will assume his form of the fiery, planetary Kundalini before riding out of Shamballa with the mission of catalyzing wholesale destruction and transformation. We are living during one of those periods when Sanat is leaving his Asian home. The King of the World and his "army" began emerging from Shamballa at the beginning of World War II, a time when Nicholas Roerich was crossing Tibet in the midst of Buddhist monks exuberantly chanting: "the time of Shamballa has arrived!" [5] Sanat's army of "Kundalini" warriors began marching at that time. Their influence upon our planet is destined to reach its apex between 2000-2013, years when there will be a full scale purification of the Earth's surface. The planetary transformation will include all aspects of human society, including all governmental, religious, and economic institutions.

The Collective Spine

Just as the Kundalini will rise up each one of our spines to the chakra at the apex of the head, the Sahasrar, so will it rise up within the spine of the King of

the World. The planetary monarch's spine is the Earth's Axis Mundi, the towering mountains of the Himalayas and mythological Mount Meru, which unite our world with the heavens. When the Kundalini reaches the crown chakra within enough humans, Sanat Kumara's Kundalini will then rise to the top of the Axis Mundi and merge into the upper heaven worlds. Thus, both the Earth's ruler and much of humanity will simultaneously experience union with Sananda, the Higher Self.

The rise of the Kundalini up the King of the World's spine is alluded to in Tibetan prophecy. The legends of Shamballa maintain that a lineage of thirty-two kings will rule the land of the immortals before a New Age commences. Thirty-two is approximately the number of vertebrae in the human spine (some spines have 32, some have 33). Thus, the sequential kings of Shamballa are individuals, as well as the vertebrae comprising the spine of Sanat Kumara.

A Message from the Yezidhi

Once the Kundalini has reunited with its source in the crown of the head, we will collectively achieve unity awareness. This, claim the Yezidhi, is an essential part of the Peacock Angel's redemption. The Yezidhi maintain that as long as we keep acknowledging duality, we will perpetuate it. For this reason the Yezidhi do not allow any derogatory names to be used in reference to Melek Taus, such as Lucifer and Satan or Shaitan. They will not even allow words with an "sh" prefix to be spoken in their presence. Disparaging epithets for their deity retard the Peacock Angel's redemption and keep him bound in the chains of his own darkness. By acknowledging Melek Tuas' negative or "evil" characteristics we empower and perpetuate them. But, should we decide not to identify or "see" them, they essentially cease to exist. The same rule applies to how all humans perceive the world. As long as we continue to perceive the duality of good and bad, ugly and beautiful, or evil and good, we will never be able to open the singular eye of wisdom which recognizes all things as manifestations of one universal Spirit. We will not be able to love all things equally, and worst of all, we won't be able to love ourselves as the divine beings we inherently are. We will thus prolong our predestined redemption. Therefore, in order to assist in the Redemption of the Peacock Angel, as well as our own simultaneous enlightenment, we need to begin seeing the oneness of Spirit within all beings.

The Thousand Year Reign of Sananda

When the planetary Kundalini finally merges within Sanat Kumara's head, his redemption will be complete, and each person on Earth will have an opportunity for redemption and a chance to unite with their transcendental selves. Thus, when Sanat commences living from his higher self, Sananda, so

will we. At that time Sanat, as Melchizedek, will begin ruling the world as he did during the Age of Lemuria. But the major difference between the coming Age of the Son and the Age of Lemuria is that in the New Age there will be the utilization of an advanced intellect which was developed during the Age of Atlantis and the ensuing patriarchal era. The New Age intellect will, however, be kept in check by the intuition, and the world will see the reemergence of Sacred Science, or science in alignment with the Divine Will of God. This science once existed in the early stages of Atlantis, the era before the emergence of the ego, and allowed the Atlanteans to create incredibly advanced technology without destroying our planet.

The coming Age of the Son, the age of balance and unity, is referred to in *The Book of Revelation* as the Thousand Year Reign of Christ. According to *Revelation,* during this future age time will cease to exist. Lucifer, the Lord of Time, will be locked within a "bottomless pit" for a period of not less than one thousand years. Christ/Mithras will thus have descended from the heavens to inform the dark lord that his contract on the surface of the Earth has expired, and the Son of God can then precipitate the next stage of humanity's evolution, the "Rapture," the time when the righteous hordes will be raised up and blessed with immortal life. The Armageddon will then have come to its predestined conclusion, and the New Age can officially commence.

The King of Shamballa, a painting by Nicholas Roerich

The eight petals of Shamballa manifest as eight cities within the outer wheel of this Tibetan thanka. The king is in the center of the inner wheel.

An image of the King of the World published in *Amazing Stories* magazine, May, 1946. The accompanying article states:

"He came here ages ago from the planet Venus to be the instructor and guide of our then just dawning humanity. Though he is thousands of years old, his appearance is that of an exceptaionally well developed and handsome youth of about sixteen. Some claim to have seen him...when mankind is ready for the benefits he can bring, he will emerge and establish a new civilization of peace and plenty."

Part III
The Once and Future Myth of the Son of God

Drawing by Elizabeth Berg

VII
Thε Christ Myth
of thε anciεnt
Goddεss Tradition

In the previous chapters of this text we have followed the Christ Myth from its historical beginnings in India, to its western migration across Asia, and then finally to its amalgamation with the Christian legend of Jesus Christ. Now, in this section we will go back even further in time. We will attempt to uncover the contents of the original myth and the true nature of the Son of God by studying the most ancient version of the Son of God myth on record, that found within the Goddess Tradition of Neolithic times. Our investigation will ultimately support what we have already seen in this text, that the original Son of God is androgynous. We know this truth from having studied Murrugan, who is the androgynous union of Shiva and Shakti, the universal male and female principles, and by following his legend as it moved across Asia and diverged to become the myth of Melek Taus, a manifestation of Azazzel or Lucifer, and the legend of Jesus Christ. This division could have only occurred if the Hindu Son of God was indeed androgynous and possessed within him the seeds of both light (the Christ) and darkness (Lucifer). In this chapter we will present the Son of God in his Neolithic purity, and then in the following chapter we can we can attempt to construct a modern version of the Christ Myth which fundamentally echoes its original.

The Androgynous Son of the Goddess Culture

It is currently accepted within most academic circles that the first historical version of the Son of God myth emerged within the nature or Goddess religion, which existed during the Neolithic Age, the Earth's incipient agricultural era. According to ancient texts and those mythologists, anthropologists, and archaeologists who have done in-depth research and field work of the Neolithic period, the worshippers of the early nature religion once conceived of a Son of God who was a personification of the life force, the primal mana that every year crystallized into prolific, vegetative growth in Spring and Summer and then died the following Autumn. This primeval Son of God was synonymous with the etheric life force, so he never actually died, at least not in the traditional sense of the word; he simply went to sleep. Thus, the theologians of the Goddess Tradition proclaimed that, like the

life force which leaves the surface of the Earth and goes "underground" to become dormant for a season, the Son annually enters into the bowels of the Earth and sleeps through the winter months. The Son of God was thus designated "androgynous" in that he spent half the year above the ground and half the year below. In acknowledgment of the Son's dual nature the ministers of the Goddess Tradition worshipped him as both a snake or serpent, and a bull. In his annual underground and "dead" phase the Son of God was equated with the underground snake, the universally recognized symbol of the life force in its subterranean expression. And in his return to the surface of the Earth the Son of God was worshipped as a bull, the universal symbol of the creative life force ready to burst forth into the myriad forms of nature. Most of the early Sons of God throughout Asia and Europe, including the Greek Dionysus, the Egyptian Osiris, the Mesopotamian Tammuz, and even the Hindu Murrugan, were worshipped as both serpent and bull.

For thousands of years the bull and snake continued within the Neolithic, Goddess worshipping cultures as symbols of the androgynous Son of God. They were his two opposing halves; they were life and death, as well as the opposing forces of creation and destruction which united within the one Son. And since they were two halves of the divine Son of God, both the bull and the snake were equally esteemed. They were revered by the ministers of the Goddess Tradition both because they were the two aspects of the beloved Son, as well as because they were symbols of the polar opposite forces which were equally necessary in the annual turning the seasons. The snake of death engendered the bull of creation and vice versa; one could not exist without the other. This is why the Goddess worshipping devotees in Crete were famous for having daily chanted "The snake is father of the bull and the bull is father of the snake."[1]

The history of the Androgynous Son of God

Besides being worshipped as a snake and bull, the Neolithic Son of God was also adored in the form of a young boy. His popular image was that of a playful, androgynous, and forever-young boy who was born and "died" annually. The Greek's worshipped their Son of God as Dionysus, a forever-young, bisexual boy who was said to have even been clothed in a girl's dress during his earlier years. The Mesopotamians worshipped their androgynous Son as Tammuz, a forever-young boy, as well as in the form of polar opposite and intersecting snakes similar to the cadueseus, and the Egyptians worshipped their Son of God as Ptah, the forever-young boy with a limp. Because these Sons of God and others were recognized to be androgynous they were also worshipped as two identical boys, who were, like the snake and bull, recognized to be embodiments of the Son's polar opposite halves. These twin boys were often referred to as the "sons" of the

androgynous Son of God. Egyptian Ptah, for example, was divided into two boys, the twin Kaberoi, who were worshipped as his two sons in a temple behind his own in Memphis. Ptah was revered in Egypt as the androgynous fire god, the primeval flame, and the Kaberoi were his "Twin Flames." When these same twin Kaberoi arrived via missionaries in Greece and the sacred Aegean island of Samothrace, they were referred to as the Sons of the fire god Vulcan, as well as the progeny of androgynous Dionysus. They were especially venerated as Dionysus' kin in Thebes, which became an important headquarters of Dionysus worship. In India, the primal androgynous Son was divided into the twin Kumaras and the Ashwin Twins; and in Egypt the Son of God Osiris split to become the "twins," Seth and Horus, the gods of darkness and light.

Then came the age of civilization and the advent of patriarchal theology, during which the twin sons of the androgynous Son of God became alienated from their "father." The Twins became perceived as unrelated to each other, and the principals of creation and destruction they personified were ultimately designated eternally separate and antagonistic to each other. One of the primary countries where this evolution took place was Persia, home of patriarchal Zoroastrian religion. Through the work of the Magi priests of Zoroaster the twin sons of the androgynous Creator, Ahura Mazda, evolved into Ormuzd and Ahriman, the eternally separate lords of creation and destruction. The final chapter of the Persian Twins' evolution occurred when Ormuzd was recognized as eternally beneficent and "good" and subsequently identified with his heavenly father, while Ahriman was judged eternally "evil" and designated overseer of the infernal lower worlds. These associations were, to a degree, consistent with their Neolithic manifestations of the underworld snake and the above-ground Bull. But the moralistic element was patriarchal and new. This ethical twist entered the myth because of the Patriarchy's propensity for scientific reasoning and dualistic classifications. Dualistic distinctions of positive and negative, beautiful and ugly, eventually lead to moralistic discrimination and the polarity of good and evil. It was thus destined that Ahriman would become the evil demon of the Patriarchy, but not just for obvious reasons. The Patriarchy has always been dedicated to controlling the forces of nature through its technology, and any force or entity which is not creative and disrupts the status quo must be regarded as harmful, bad, and ultimately evil. Ahriman was recognized as the Great Disrupter.

The Patriarchal Myth

Perhaps the patriarchal theologians' most inventive addition to their myth of the Twins was added after they had separated the brothers for eternity. In order for their heavenly twin to be able to battle his underworld nemesis for control of

the Earth without ever having to leave his heavenly throne, the patriarchal priests introduced another character into their story, the Son of the Heavenly Father. This new Son of God was said to be the same as his Heavenly Father, but different from Him at the same time. The Patriarchy needed a hero to protect their interests on Earth and found one in this Son of God, who, as a spiritual warrior sent to Earth by his Father in Heaven, was dedicated to destroying evil on Earth. The new Son of God's mission during his sojourn on our planet was to destroy the underworld lord and his evil denizens, thus returning the planet to both safety and righteousness. Through the Patriarchy's final addition to the Son of God myth, the Twin Boys, who had evolved into the underworld lord and the Heavenly Father's mirror image, his Son, were thus reunited on the Earth plane in order to destroy each other.

Once the patriarchal myth of the Son of God was complete, new, modified versions of the ancient Twin Boys soon arose in many diverse cultures. The Twins took the form of Mithras and his nemesis Ahriman, as well as the archenemy pairs of Michael and Belial and Jesus Christ and Lucifer, a.k.a. the Devil.

Jesus, the Androgynous Son

With an understanding of how the Twin Boys evolved into Jesus and Lucifer, the Christian myth of the Son of God takes on an entirely new perspective. The figure of Jesus can now recognized as an evolution of the light, or spiritual Twin, while the Devil or Lucifer can be seen as having evolved out of the dark, material Twin. Jesus and Lucifer are thus the two halves of the androgynous Son of God; Jesus is a manifestation of the Son's higher self and pure spirit, and Lucifer is a version of his material lower self, which includes his physical body with its inherent passions and ego. From this perspective, Jesus' forty days in the wilderness and his battle with Satan can be understood as the Spirit and higher self (Jesus) of the androgynous Son of God coming into conflict with his material ego and passions (Satan). The story then becomes an allegory which reveals an internal conflict within the androgynous Son of God. Moreover, if the Son of God is archetypal and represents all humanity, as he does in the case of Sanat Kumara or Melek Taus, then the allegory of forty days and nights also becomes an instructive tale for the inner struggle all we humans must endure on our paths to enlightenment.

But there is yet another understanding which can be derived from Jesus' travails in the wilderness. Jesus, an evolution of the ancient Son of God, was himself androgynous and Satan was a manifestation of his lower self which tried to seduce him with the sensual enticements of material existence. This understanding is backed by one interpretation of the Christian myth which states that Jesus did

not fully merge with his pure self, the Christ, until after he had been baptized in the River Jordan by John the Baptist. Until that moment Jesus still had a human side, which has been the subject of such films as *The Last Temptation of Christ*. Leading up to his baptism and transformation into the Christ, Jesus was a student and seeker and had not completely cast off his passions and merged with his higher self. He still possessed an ego (Lucifer), along with the hot blooded desires of the physical body, but these were tempered by the light and wisdom of his inner spirit (Christ). Initially Jesus was, therefore, Christ and Lucifer, spirit and matter, united as the androgynous Son. It thus appears that somehow the androgynous nature of the Neolithic Son of God was able to survive the creation of the patriarchal Christian myth of Jesus Christ.

The Devil is Kundalini

If Jesus Christ is a model spiritual seeker, possessing both high and low selves, his life story can be viewed as an allegory for how the battle between light and darkness can be won or lost by every human seeker of truth. Not surprisingly, this is how the legend of the Son of God was taught within the ancient mystery schools, the secret organizations which had emerged out of the rites and theology of the ancient Goddess Tradition. While preparing for initiation into these schools, candidates studied the legend of the Son of God with the understanding that it was a model for their own imminent spiritual unfoldment. They recognized Satan, or any dark lord, to be both their animalistic passions as well as their fiery power of transformation, the Kundalini force which would eventually transform them into immortal beings just as it had for the archetypal Son of God. Even within the mystery schools of the early Christians, the schools of Gnosticism, the snake, the symbol of Satan or the Devil in orthodox Christianity, was worshipped as a savior and redeemer. The Gnostic serpent was recognized as the symbol of the transformative force that exists both in the world and within the human body, which awaits the time when it will be awakened and accomplish the work of transformation. It was common for the Gnostics to carve depictions of snakes onto their gems, which they then carried for both good luck and spiritual transformation. Their most prized gems had engravings of Chnouphis, an androgynous deity with a lion's head and serpent body. Chnouphis symbolized the polarity which unites as the Kundalini.

The initiates of the Egyptian mystery schools also recognized the dark lord as a personification of the Kundalini. The Egyptian Priests of Osiris taught dual interpretations of their Son of God myth, one for the profane masses and another for those candidates seeking initiation. According to the popular, mundane interpretation of the myth, Osiris' murderous brother Seth was recognized

as a personality separate from the Son of God. But according to the interpretation of the myth taught to the initiates, Seth was the transformative power in nature which destroys, transforms and recreates. Seth was thus acknowledged to be Osiris' own inner, evolutionary power, a truth implicit to Osiris' legend, wherein Seth slayed the Egyptian Son of God while the Sun was passing through Zodiacal sign of Scorpio, the sign of both death and the Kundalini. The Egyptian initiates also recognized Osiris' son Horus to be an aspect of the androgynous Son of God; he was Osiris' higher self, the polar opposite energy to Seth, Osiris' lower self. With this understanding it was easy for them to comprehend the part of the myth wherein Isis revives the dead Osiris long enough to sire Horus, who then proceeds to defeat Seth in battle and drive him from the face of the Earth. An initiate would comprehend this conclusion of Osiris' legend as a reference to the spirit (Horus), which rises up out of the destroyed or transformed Son of God while overpowering and conquering the destructive and inhibiting forces of his material passions and ego (Seth).

The Egyptian initiates acquired their special knowledge of Osiris' myth within the temples at Sais and Philae, two places where the ancient king and Son of God's legend was performed secretly by initiated actors. Inevitably the initiates in attendance of these dramatizations would come to identify Osiris as the archetypal seeker and themselves as mirror images of him. Those who had undergone the final initiation in the Great Pyramid of Giza would associate their three days within the sarcophagus in the King's Chamber with Osiris' traumatic episode when he was locked within a sarcophagus by Seth, and they would also associate their ensuing death and rebirth in the granite coffin as synonymous with Osiris' death and resurrection. The Great Pyramid, which was situated on a major Earth vortex, was designed to stimulate the flow and activation of the transformative Kundalini (Seth's power) within a candidate undergoing initiation, and it would thus have destroyed or "murdered" him or her. When such candidates later emerged following their three allotted days in the tomb, he or she was anointed with sacred oils and given the title of Khephri, the Resurrected One, as well as Priest or Priestess of Osiris. They had essentially become one with the resurrected Son of God. The Jewish prophet Moses is one of the famous figures in history who is alleged to have undergone such an initiation within the Great Pyramid.

If the Egyptian Seth is a manifestation of the Kundalini, then it follows that so are his counterparts in other traditions, Satan, Lucifer and the Devil. Therefore, it is no surprise that the character traits and functions of Seth and Satan are essentially identical, including the roles they played in the life of one version of the Son of God. There names are also nearly identical. In some of the early Egyptian scrolls which allude to Seth, the dark lord is referred to as Set or Sat, names which closely approximate Satan. Set, Sat and Satan all have the meaning of "time" and

"adversary." Time, like the Kundalini, brings all things to their conclusion and destruction, or transformation. But just because the Dark Lord is associated with destruction does not mean that he is evil. There is nothing said or implied in the earliest Greek or Egyptian texts which would indicate that Satan or the serpent was considered to be necessarily evil. We know from historical records that in the earliest dynasties of Egypt the dark lord Seth was a highly esteemed deity, in fact he was king over all the gods. The veneration accorded Seth was also directed by the early Jews towards their Satan, whom they regarded as a personification of the adversarial power of their androgynous supreme God, Yahweh. If Satan was an aspect of Yahweh, how could he be evil? The power of Satan was even embodied by the most beneficent angels, who were sent to Earth by Yahweh on special missions to obstruct the actions of humanity. Even much later, when Satan was transformed into the Devil by the Christian theologians, he continued to work in tandem with Yahweh. The Devil's principal function of punishing sinners who visit his smoldering underworld is in accordance with Yahweh's will. If the Devil was opposed to God he would praise and feast sinners for their transgressions, not inflict pain upon them. Thus, the Devil is both a friend and Son of Yahweh and, as we have seen, the twin brother of Jesus the Christ.

In **summary**, history is explicit in revealing that the Son of God of the Neolithic Age was thought of as androgynous, and it also shows that his bisexuality has survived through the ages unbeknownst to many conservative theologians controlling the later, Fundamentalist religions. History delineates the evolution of the Son of God beginning with his emergence within the Goddess Tradition as the androgynous life force symbolized as the serpent of destruction and the bull of creation. It proceeds to a later time when the serpent and bull were replaced by the Twin Boys, and then moves to a period when they became the Lords of Heaven and Hell and archenemies of each other. In their final manifestation, after they had undergone extensive alterations by the patriarchal priesthood, the Twins assumed the forms of Mithras and his enemy Ahriman, as well as Jesus Christ and his opponent Lucifer. But even though the Son of God was split into his polarity and the two parts of himself eternally separated, the Son of God still appears to have retained his inherent androgyny. Contemporary manifestations of the Son of God, such as Jesus Christ, still possess a shadow of the androgynous nature once embodied by the Son of God of the Neolithic Age.

Finally, if the Son of God is truly androgynous, possessing both high self and low self, then we are all reflections of him and both Satan and Christ exist within each one of us. The Son of God's legendary life story thus becomes a map and instructive teaching tool for the pitfalls and obstacles we all could potentially experience on our path to spiritual enlightenment, as well as how to overcome them.

VIII
A Son of God Myth for the Age of the Son

Beginning with the premise arrived at in the preceding chapter, that the Son of God is androgynous, I have in this chapter devised a universal myth which is in some ways similar in import to the original, archetypal legend. In the process I have synthesized many of the well-known myths of the Son of God from both the East and West, most of which have been fully covered and alluded to numerous times in this text. In keeping with some of the pre-Christian legends of the Son of God, some of the initial events of my composite myth will be found to precede those within most contemporary Son of God legends. Such early scenarios are important in revealing the androgynous nature of the Son. But they are noticeably absent from many contemporary myths, both because most modern theologians do not accept the androgynous nature of the Son, and also because they place more importance on the struggle, defeat and ultimate victory of the Son of God.

Please read on and feel free to add or delete parts of this myth in order that you and I can co-create a legend which strikes a cord within you. Perhaps together we can construct a legend which will have appeal for many people worldwide and even help unite the future world in a universal spirituality.

In the beginning all that existed was a cosmic void. From out of the darkness emerged a light, the **Son of God**, who was the **First Born**, the **Word** or **AUM**, and the embodiment of the **Divine Mind**. He was the first form of the **Infinite Spirit**, which after coming to a point of individuation had become clothed in a garment of contracted essence or matter. The new Son was, therefore, the union of Spirit and matter, **God** and **Goddess**. He was **Quetzlcoatl**, the androgynous "Feathered Serpent" (feathers-spirit, serpent-matter), who moved upon the "face of the deep."

The matrix comprising the Son's body was **Cosmic Fire**, the serpentine life force, which had been created from the passionate love embrace of his parents. The Son reflected his parents' passion with his own fiery desire for new experience. As the mischievous **Cupid** or **Kama**, the God of Passion and Love, he thus began to conceive of ways to shake up the serenity of the cosmic void. He

even tried to shake his father, the Spirit or **Shiva**, out of his eternal meditation. Then, as **The Fool of the Tarot**, the Son of God naively took his first steps towards three dimensional experience.

The Son first needed a playground to have his experience within, so with the help of the infinite wisdom he had inherited from his parents he proceeded to expand, cool and then harden his Cosmic Fire body into the various solidified forms of a new physical universe. As **Samael** or **Rudra**, the primal fire god, he directed the fiery atoms of his explosive body to violently smash against each other, thus precipitating the first moments of the **Big Bang**. Then, while still in a chaotic **Primal Dragon** or serpentine form, he gradually molded all the crystallizing forms into reflections of himself, so that all life was made in its Creator's image. The Son of God made the primal geometries underlying all material form a reflection of his spiralling serpentine form and his **vesica pisces** eye, and thus became the **Heavenly Father** of the entire universe.

When the vesica pisces, the fish shape or "eye" of the Heavenly Father had finally the entire cosmos, the First Born became both omnipresent and omniscient, and his will reigned supreme. He was **Osiris**, the many-eyed, omniscient Son, whose multitude of vesica pisces eyes united as the **Flower of Life**, the symbol of consciousness which expands and multiplies as it becomes the physical universe. He was also **Yod He Vau He**, the **Ancient of Days**, who reigned upon a gilded golden throne situated within Osiris' heavenly constellation of **Orion**. And he was **Murrugan** or **Melek Taus**, the **Peacock King** or **Peacock Angel**, whose omniscience is represented by his mount, the multi-eyed peacock, upon which the Son of God's consciousness "rides" from one end of the cosmos to the other.

In order to create balance within his universe, the Son divided himself into his component male and female polarity, the **Twin Boys**. One of the Twin Sons personified the Son of God's male-spiritual half and the other embodied his female-material half. The spiritual twin, **Michael** or the **Christ**, sat on **Yahweh's** right hand, and the female-material twin, **Gabriel**, **Belial**, **Satan**, or **Lucifer**, sat at the Father's left hand. Yahweh eventually assigned rulership of those parts of the universe that were dense and material to his material twin, while over those elements and levels of the cosmos which were refined and close to the vibration of pure spirit he made his spiritual son monarch. The command of the middle level of the universe, the realm of Earth, was to be shared equally by both twins. As **Jaldaboath**, Yahweh also divided himself into seven parts or angels, also known as the seven **Kumaras**, in order to further divide up the duties involved with administrating the cosmos.

Eventually the Twin Sons of Yahweh were sent to Earth to assist in the creation of the planet's flora and fauna. Initially the brothers worked cooperatively

in this task and were thus able to produce extraordinarily beautiful plants and animals. Their greatest collaboration, however, was a human being, which was designed to be a balance of their two principals and a perfect reflection of the androgynous Heavenly Father, Yahweh. **Ahriman**, the material or dark twin formed the material body of humankind, and **Ormuzd**, the spiritual twin, invested it with consciousness and the spiritual spark of life.

Earth's destiny quickly unfolded and soon the planet became more and more dense. Humans lost their capacity to live in alignment with Spirit and their communication with Yahweh was thus severed. Humanity became motivated almost exclusively by its materialistic, selfish impulses, and soon the planet was under the sole rulership of Satan, while his brother, Christ, completely disappeared. The outlook was indeed bleak. Unless a male/female balance could be restored on Earth, the planet was in danger of being enveloped by darkness and completely destroyed.

Perceiving Earth's imminent danger from on high, the king of the universe, **Yod He Vau He**, called for his spiritual son, the Christ or **Sananda**, who as **Vishnu** wielded Yahweh's power of preservation, and ordered him to return to Earth and restore balance. There was a great risk involved, however, because taking a material form and entering Satan's kingdom Christ could potentially get lost in the **Maya**, the illusion, and thus succumb to the selfsame materialistic impulses which were destroying humankind. But it was a risk the Heavenly Father was willing to take. If nothing else, his son's success in overcoming his human passions and ego would serve as a model for future generations of Earth's population who sought redemption and release from the fetters of materialism.

Christ's birth into physicality was anxiously awaited by those humans who had continued to honor the Christ after his disappearance from Earth. Their sacred prophecies had informed them that when selfishness, greed, and materialism was rife, the Savior's birth was imminent. Thus, when the **Messiah** was finally given birth to among the spiritual elect they recognized him as the incarnated Christ, the **Michael** or **Melchizedek** in a physical form. And since they knew Christ's true father to be the Heavenly Father, Lord Yahweh, they proclaimed his birth to **Mary**, a name meaning "female principle" or "matter," to be a "virgin birth."

During much of his early life the Savior struggled within the material folds his spirit had incarnated into. Although his physical body and its accompanying passionate urges partially eclipsed his spiritual light, he intuitively knew that he was more than his desires and ego, a truth which was confirmed by his teachers and the study of the ancient scriptures. He thus aspired to cultivate the "higher" spiritual qualities of love and compassion exhibited by certain persons and respected religious leaders of his community.

But the Savior continued to feel victimized by the battle being waged inside himself by the twins, his higher and lower natures. Some days the dark twin would be in control and the Son would give way to his selfish impulses, while at other times his higher nature would be ascendant and the Savior's singular desire was to help and serve those around him.

The Son's battle waged by his inner polarity continued to escalate until it reached a climax during 40 days and nights in an isolated wilderness, which the Son had retreated to for contemplation. Satan as **Mara**, the tempter, quickly asserted his power in the remote environment by making the Son acutely aware of the sensual pleasures of civilization he was depriving himself of. Satan's tantalizing and seductive voice chided the Son repeatedly with entreaties such as:. "Why deprive yourself? All you need to do is leave this desolate place and return to society and I will give you all the power and riches you could possibly ask for." But the spiritual twin was on guard against the coercive rhetoric of his wily sibling, and began intensely imploring the Savior to seek spiritual understanding and nourishment. Ultimately, the Christ succeeded in drowning out the inner voice of Satan, and the Son of God remained steadfast in his determination to continue his meditations in the bleakness of the lonely wilderness.

Now that the Dark Lord's had been silenced, the Lord of Light and inner Christ could fully assert his persuasive influence on the Son of God. He proceeded to fill the awareness of the Savior with a series of bold affirmations, such as: "I am Spirit;" "I am a spark of the Father;" "I am the Father embodied;" and "The Father and I are One." Once the Son had become fully convinced of his true, divine nature, the embodied Christ exulted in having won the battle against the dark twin. From his seat within the Son of God's heart, the Christ now became the Savior's principal guide and awareness.

Having achieved full enlightenment and become a **Buddha**, an "enlightened one," the Son left the "wilderness" of ignorance far behind and soon found himself welcomed by spiritual beauty and refreshment wherever he went. The light of his Father glowed everywhere, including within the hearts of all humans. "If only I could help my brothers and sisters realize the Truth I have gained by defeating Satan and conquering my selfish passions," he thought, "what wonderful possibilities were in store for all humanity!"

But, as fate had willed it, upon his return to civilization the Savior quickly discovered that the masses had become too immersed in materialism to understand the message of redemption he preached. Many of them had become the mouthpiece of their leader, Satan, and openly ridiculed the incarnate Christ. Some of the most faithful devotees of the dark lord openly abused or punished those seekers who tried to hear what the Savior had to say. Fortunately, there were a few men, twelve in number, who were ready to tread the path of the Son and help

spread his message to the world. They created an environment safe for the Christ to give his sermons.

Perceiving that the Son's popularity with the masses could threaten his thriving planetary dictatorship, Satan mobilized his army to rise up against the Son. He first conspired with one of his devoted disciples to set a trap for the Savior's capture. Then, once he was in their grasp, the army of the dark twin humiliated the Son of God before nailing him to a square cross, the symbol of matter and the materialism they glorified. They thus let it be known that they were not going to let the Son or any of his followers break free from the Satanic, materialistic tendencies which firmly held them in its grasp.

The savior was crucified with two others, thus creating another geometrical symbol, the triangle, whose three-sided form naturally generates the fire of transformation. Then, after he was declared dead and taken down from his cross, the Son continued his fiery transformation within a rock cut tomb for a period of days also based upon the transformative number of three. When the Son of God finally emerged from his earthly womb his body had been fully transmuted by the fire of **Kundalini**, the liberating aspect of the destructive power wielded by his nemesis Satan. Under the guidance of **Thoth**, the Divine Mind, along with the transforming power of **Isis**, the female principle, the Son of God had become the resurrected **Osiris**.

After many more years on Earth, when the Son had accomplished everything he had been sent by his Father to do, he assured his faithful followers that he would return to them and then consciously transmuted his physical body into etheric light for a final ascension into the heavens. Before he left, however, the Savior instructed his beloved devotees to always remember him as the Christ, as well as **Venus**, the **Morning Star**, while periodically taking him sacramentally into their bodies through the rite of **Holy Communion**. He implored them to stay dedicated to the path of righteousness, because as **Mithras**, the lord of contracts, he was destined to return at the end of time when the contract of **Ahriman**, the dark lord of materialism, had expired. At that predestined time, those who had remained true to the Son's teachings while he was away - a time period likely to extend over hundreds or even thousands of years - would by the Savior's grace achieve an instant ascension of consciousness and the blessing of eternal life. Such worthy humans would then become Sons and Daughters of the Heavenly Father, and a **New Age**, with the Christed **Sananda** as its king, would then dawn upon the face of the Earth.

Part IV
The Symbols and Rites
of
The Peacock Angel
&
Son of God

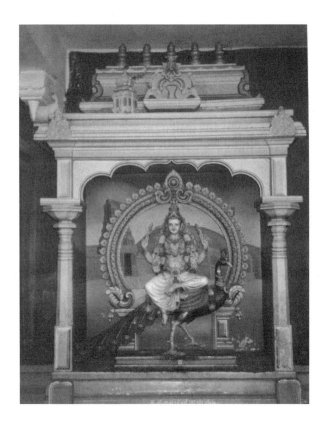

IX

The Ancient Symbols of the Peacock Angel and King of the World

In this section we will review the ancient symbols and rites of the Peacock Angel, the archetypal Son of God. Some of these symbols and rites are extremely ancient and may not be recognizable to you, however the majority have been part of religions and sects which have thrived over the last two thousand years and worshipped a manifestation of the Son of God. Many of these symbols and rites are, for example, currently linked to the Sons of God Jesus Christ and the Buddha. Their recognizable motifs, as well as those from other traditions, are archetypal and have existed within the Divine Mind since the beginning of time. Some of these symbols and rites are ascribed to ancient Lemuria and Atlantis, where the Peacock Angel was worshipped in his archetypal purity. Many eventually became defining motifs of the King of the World. In this chapter we will introduce and define the symbols of the Peacock Angel and Son of God, and we will also mention in what country or tradition they have been esteemed and worshipped.

The Peacock

The peacock is both the definitive symbol of the Peacock Angel, as well as one of the oldest symbols of immortality upon our planet. The peacock is the favorite symbol of the First Son of God because, more than almost any other animal, it reflects his myriad attributes. Its irascible disposition and bright, reddish color, for example, ideally reflects the incipient, fiery manifestation of the First Son of God at the beginning of time. The eyes adorning the bird's feathers represent the Son's omniscient nature, and the shape of these eyes, which are essentially versions of the vesica pisces, the incipient geometrical form, represent that as the Divine Mind and Creator the Peacock Angel made his symbolic eye the foundation of all material form. The spiral, another form associated with the primeval shape of the Creator, is reflected by the peacock's rain dance, as well as by his "eyes," which are laid out on his prolific feathers as intersecting spirals.

The many colors which coexist within the body of a peacock represent the inclusive nature of the Son of God, who is the synthesis of all colors and attributes.

Three colors often predominate within the peacock, however, such as blue, red, and yellow, and these reflect the trinity of powers possessed by the Son. The polar opposite colors of blue and red, as well as the color of the peacock's plumage, green, the color of balance, symbolize the union of the polarity which the Peacock Angel and Son of God personifies. The Peacock Angel's androgynous union of light and darkness are exemplified by the peacock which "possesses the feathers of an angel, the voice of a devil, and the walk of a thief."

The way the Peacock's feathers continue to molt and grow back with an ever-increasing radiance are a poignant allusion to the immortal, forever-young nature of the Peacock Angel. They also denote his ever-increasing light, wisdom and power. The immortal nature of the Son of God is further reflected by the flesh of the peacock, which is nearly immune to decay. It can remain unaffected by the elements for days and even weeks after its host's death.

The peacock's natural aversion to gold reflects the ascetic nature of the Son of God, and the predisposition of the Son to virtue and chastity can be found reflected by the peacock's lifelong devotion to a singular partner. Moreover, the First Son in his function of Savior is reflected in the peacock's habit of devouring the "evil" snakes which threaten the safety of humans.

Besides being the principal symbol of Murrugan and Melek Taus, the peacock has been a general symbol of all immortals of the East. This is why it is a defining emblem of Shamballa and Hsi Wang Mu, the legendary colonies of the immortals in Central Asia, and why it has become the accepted symbol of Lord Krishna, who is often depicted in proximity of a peacock or wearing a peacock crown. Traditionally, the union of blue and green on the peacock's feathers has been conceived of as reflecting the nature of the kings of the East, who were referred to by their subjects as the "Sons of Heaven (blue) and Earth (green)." These kings were, like the primal monarch they were descended from, Sanat Kumara, the androgynous union of Spirit and matter, and dispensed the will of God on Earth.

The Phoenix

The Phoenix is the western version of the peacock. It is the symbol of those Sons and Daughters of God in the West who have achieved immortality and become reflections of the forever-young Peacock Angel. Throughout history the Phoenix has been closely affiliated with the peacock and the two birds have alternated as the symbol of immortality. The peacock became the traditional symbol of the Christians' Saint Barbara, for example, even though she was born in Heliopolis, the headquarters of the Egyptian Phoenix.

The fiery Phoenix symbolizes the Cosmic Fire form of the Son of God in his

role of Creator. As the Phoenix, the Son of God arrived from the "Isle of Fire" and proceeded to manufacture the forms of a new universe. But the most salient and renowned feature of the Phoenix is the bird's ability to rise reborn out of its own ashes, thus symbolizing the resurrected Son of God. As a definitive symbol of resurrection and immortality, the Phoenix has been one of the principal motifs ascribed to Osiris and Jesus Christ. It has also been a symbol of royalty in the East. The Chinese empresses, for example, were often associated with the Phoenix.

The Cross

For the majority of the world, the cross is the most recognizable of the Peacock Angel's symbols. This archetypal motif symbolizes the initial union of the male (vertical shaft) and female (horizontal bar) principles, the God and Goddess, which unite at the beginning of time to produce the Son of God. The trident, a related form of the First Son, has the cross as its foundation and represents the three powers of Cosmic Fire which are born through the primeval union of the polarity.

There are many variations of the cross worldwide. The version of the cross associated with the Son of God as Jesus Christ is the Latin Cross; in the tradition of Osiris, the cross was represented as the Djed Pillar; and among the devotees of Murrugan, the preferred cross motif has been the Lingum.

The Chi-Rho

The Chi-Rho unites the cross with the above-mentioned peacock or phoenix motif. The cross of the Chi-Rho denotes the union of the universal polarity, and the vertical P, which is the first letter of Peacock Angel or phoenix, denotes their androgynous union as the Son of God. The three intersecting lines also symbolize the three powers of the First Born Son of God, and in this regard the center P can be equated with the first letter of the word preservation.

The P of the Chi-Rho also signifies Pater or "Father," the role assumed by the Peacock Angel as Creator and Sustainer of the Universe. Often the P is rendered in the form of a shepherd's staff, thus designating the First Son to be the protecting father and shepherd of his myriad "flocks. The P is also a definitive symbol of Saint Michael, the spirit which took incarnation as Jesus Christ. The high bishops of the Catholic Church carried staffs called "crosiers" with a stylized image of Michael in combat with a dragon adorning them, thus revealing the bishops' function of protecting the soul of his flocks from the Devil.

The Chi-Rho, which is also known as the Labarum, is the monogram for both the Peacock Angel and his descendants, Mithras and Jesus Christ. "Chi," sym-

bolized by the cross, and "Rho," represented by the P, are the first two letters of the Greek word for "Christ." The cross is also known as "Chi" because it is a name for the polarity union which engenders chi or Cosmic Fire.

One Chi-Rho motif from the Christian tradition places the symbol between two peacocks, thus associating the Christian Son of God with the Peacock Angel. This Chi-Rho motif reveals the inherent androgynous nature of the Son of God.

The Forever-young boy

Next to the cross, the forever-young boy is perhaps the most universally common form of the Son of God and Peacock Angel. The symbolic boy naturally

reflects the immortal nature of the Son of God who is "forever-young," and since the forever-young boy is normally portrayed as prepubescent with a chronological age of no more than twelve years, it also represents the Peacock Angel's inherent genderless nature and androgyny. The forever-young boy's unencumbered spontaneity and childlike innocence is indicative of the Peacock Angel's absolute freedom to create and enjoy a multitude of universes, as well as the Son of God's ability to always be immersed in the present moment. As one famous incarnation Son of God is quoted as saying, "You must become a child to enter the Kingdom of Heaven."

The forever-young boy form has been associated with Murrugan, Melek Taus, Rudra, Dionysus, Sanat Kumara, Mithras, and Ptah of the Egyptian tradition. The eternally young boy is also a form assumed by the gods of love, Kama and Cupid, as well as the twin Cherubs protecting the Ark of the Covenant. In order to symbolize the forever-young boy as the union of opposites, some cultures have divided him into twins, such as the Cherubs. Other twin boy manifestations: the Kaberoi Twins, who were the polar opposite "Sons" of Ptah-Osiris; the Kumara Twins, the "Sons" of Sanat Kumara; and the Dioscouri Twins, the "Sons of Dionysus-Zeus."

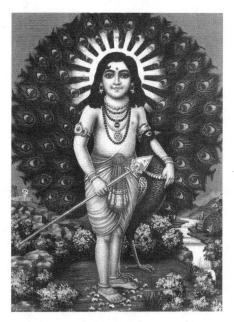

The Snake

The snake is another popular and ubiquitous icon which reflects the immortal nature of the Son of God and Peacock Angel. The way the reptile annually sheds and regrows a new body gives it the appearance of being able to live forever, and

the snake's outwardly genderless appearance reflects the androgynous nature of the Peacock Angel.

The early cosmologists asserted that in his incipient snake form, i.e., the serpentine moving energy or Cosmic Fire, the Peacock Angel created the universe out of his own divine form, and as the serpentine life force he continues to nurture and protect his progeny. Many Sons of God, especially those connected with the Goddess Tradition, have been traditionally worshipped as embodiments of the life force, thus making the coiled snake one of their definitive symbols.

The Sons of God who have been worshipped in the form of a snake include: Murrugan, the Hindu Son who manifests as a serpent with one to seven heads; Quetzlcoatl of the Mexican spiritual tradition; Dionysus, the Greek Son whose devotees carried his snake form in raucous ceremonial processions; and Tammuz, the Mesopotamian Son and "serpent who emanated from the heaven god Anu;"[2]

The Dragon

Cousin to the snake is the dragon, a potent symbol of both androgyny and wisdom associated with the Peacock Angel and the Son of God. In China, the androgynous dragon is traditionally portrayed holding a fiery "pearl," his favorite object and an archetypal symbol of androgyny. Through the hot friction (yang) caused by the movement of water (yin) within an oyster shell, yin and yang, female and male, are united as the "androgynous" pearl.

The dragon was often adopted by cosmologists as a form to depict the First Son of God when he created the universe. The dragon, which is a composite of many animals, symbolizes the multitude of creatures that coalesced out of the Cosmic Fire body of the Peacock Angel at the beginning of time. The dragon's most universally popular version, the fire-breathing and unruly variety, aptly symbolizes the volatile Cosmic Fire form of the First Son. From a scientific perspective, the fiery dragon denotes the fiery mass of colliding particles which eventually cool and crystallize into the solid forms of the physical universe.

The dragon is also a symbol of the Divine Mind, the Mind of God which he has embodied since the beginning of time. Throughout the ages the dragon has been both the teacher and protector of sacred wisdom. He has risked life and limb to protect his secret knowledge, which is often depicted as a chest of "gold." Only those who are also ready to risk their lives in the pursuit of such priceless wisdom will be gifted with the dragon's gold.

The word dragon has its origin with the Greek "drakon," which means "many-eyed." The dragon is the special symbol of the Son of God, who is the "many-eyed," omniscient protector and Savior of Humanity. As the dragon, the Son is everywhere at all times.

Many pre-Christian cultures worldwide alluded to a dragon as having been the Creator of the Universe. In Egypt, he was remembered as the creator dragon Ammon Kematuf or Kneph; in Sumeria he was venerated as Enki, the "sea-goat; and in Chinese and Quiche Maya cosmology he was remembered as the blue-green dragon or "plumed serpent," he who "moved upon the face of the waters" at the very beginning of time.

The dragon, or a version thereof, has been the symbol of nearly every organization of the Sons of God worldwide,[3] such as the Lung Dragons of China and the Quetzlcoatls of Mexico. It has also been the symbol of many priest kings of West and East, such as the Chinese Dragon Emperors and Hindu Naga Kings, some of whom have descended from the primal King of the World, Sanat Kumara.

The Cock

Through his association with the dawn, the cock has become a valued symbol of the Peacock Angel, who was given birth to during the dawn of creation. The cock also represents all Sons of God, who emerge reborn and resurrected out of the darkness of ignorance. In addition, the morning crow of the cock, which pierces the darkness and awakens the world, reflects the Sons of God who "crow" to awaken humankind to the truth. The dawn, the time of day when the polarity unites as the light meets the darkness, is the Peacock Angel's most sacred time because it reflects his inherent androgyny.

The cock also represents the incipient volatile form of the Peacock Angel as Cosmic Fire. The bird's red color and fiery nature, as well as its tendency to "come alive" at dawn, reflect the emerging mass of fiery particles which are born from the union of the polarity at the beginning of time. Since fire is normally considered the male "element," this fiery bird and its name, cock, have became associated with the male generative organ. A bronze cock with the head of a penis, a symbol of the Savior of Humanity, is reputedly hidden today within the secret vaults of the Vatican. [1]

The cock is the special symbol of the warrior chiefs Murrugan and Saint Michael. These Sons of God, in their role of Commander-in-Chief of God's army of righteousness, is reflected by the cock's fiery nature. In his warrior aspect Murrugan is Karttikeya, and his sacred planet is the "Red Planet," Mars.

The Fish

Like the snake and dragon, the fish symbol possesses a genderless appearance, and thus represents the Son of God's androgyny. Similar to the dragon, the fish also denotes wisdom and symbolizes the first form of the Peacock Angel

at the beginning of time. According to some traditions, the First Born was born out of the cosmic sea of wisdom at the dawn of creation.

In the Middle East, one of the preeminent forms of the primal Son of God was called Ea or Enki, the Mesopotamian Creator who was born at the beginning of time as a goatfish in the Apsu, the cosmic ocean of wisdom. After he had created the universe through his Mummu or "word," Enki was forever afterwards invoked by his devotees as the "Lord of Wisdom." In India, the primal form of the Son of God is worshipped as the Matsya or "Fish" Avatar, which helped save the world from a global deluge. The Matsya Avatar as the "Lord of Wisdom" also taught the fundamentals of civilization to a rebuilding world.

Among Christians the fish symbol is known as the *Ichthys* and worshipped as the symbol of Jesus Christ. It is said that the disciples of Jesus were fishermen and/or that Jesus was himself a divine fisherman, catching schools of human fish with his net of wisdom. Jesus' connection to the fish symbol may have also been tied to the Jewish sect of Essenes he was reputedly born into, the Naasoreans, a name which denotes both "serpents" and "fish."[4]

The Twin Fish

Similar to the forever-young boy form of the Son of God, the fish symbol is sometimes divided into two fish, thus denoting the Son of God's polar opposite halves. Twin fish are part of the Son's Zodiacal sign of Pisces, the sign of the androgynous savior of humanity, which has one fish pointing up towards heaven and the other directed downwards towards the underworld. Dual fishes also comprise the Tao symbol, as well as a classical Christian symbol of Jesus Christ.

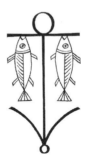

The Vesica Pisces

The fish symbol of the Son of God is often rendered as a vesica pisces, a seminal geometrical shape which is created by the intersection of two interlocking circles, symbolizing the union of the universal male and female principles. The

vesica pisces denotes the Son of God's androgyny, as well as his role as Creator of the Universe. Among secret scientists, the vesica pisces is regarded to be the primal geometrical shape out of which all forms are generated.

"The vesica…is the practical point of departure from which all other geometrical figures may be derived…In sacred geometrical terms, it is the derivation-point of the equilateral triangle and straight-line geometry…From the equilateral triangle, the hexagon and the icosahedron may be easily generated."[5]

"The Vesica is a form generator in that all the regular polygons can be said to arise from the succession of vesica constructions."[6]

The Eye of God

The vesica pisces also reflects the shape of an eye, the Eye of God, which some traditions claim was the incipient form of the Peacock Angel. The Eye of God is an important symbol of the omniscient Son of God who sees and knows all. Symbolic eyes can be found embellishing temples all over the world that were built by devotees of the Son of God.

The Eye of Horus

An Egyptian version of the Eye of God is the Eye of Horus. This symbol was adopted by the Priests of Osiris and inscribed upon their innumerable temples. It was honored as the symbol of divine wisdom and the all-protecting consciousness that continually oversaw the safe enactment of the Egyptian mystery school rites.

Within the mystery school of the Priests of Osiris there were two primary branches, represented by either the right and left eyes of Horus. The right eye of Horus symbolized the right-hand or "male" path leading to enlightenment; it was the path of intellectual wisdom, discrimination and purity. By contrast, the left eye of Horus, also known as the symbol of the Goddess Uadjet, was the symbol of the left-hand or "female" path that was guided by emotional experience and lead to the development of intuition. The union of the left and right eyes of Horus was the winged disc, the symbol of the third or "androgynous" eye of the Son of God. When a Priest of Osiris entered a temple adorned by the winged disc he or she abandoned both the left or right path in favor of the "middle" path of their union. He or she then became an incarnate Son of Daughter of God and a guide for others on the path.

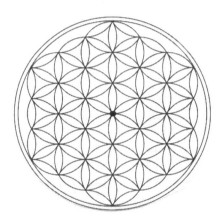

The Flower of Life, the Eye of Osiris

The Flower of Life is the preeminent symbol of Osiris, the Egyptian Son of God whose name means "many-eyed." The Flower of Life is comprised of numerous vesica pisces "eyes" which join together in the form of one large eyeball. The Flower of Life is a form associated with the first manifestation of the Peacock Angel at the dawn of time.

Besides being the Egyptian symbol of Osiris the Flower of Life is an ancient symbol of his priesthood, which legends maintain came from Atlantis with the sage Thoth-Hermes. The symbol was discovered in the early twentieth century engraved upon an excavated temple which archeologists uncovered behind Osiris' main temple at Abydos. Known commonly as the Osirian, this sunken temple was excavated from twenty-feet below the ground and exhibits an architecture which is not found anywhere else in Egypt. Its pillars are square instead of round, and its polygonal stonework is reminiscent more of the temples in Peru than those of Egypt. It is currently being scientifically dated under the auspices of Robert Temple,

but preliminary speculations have determined it to be from 17,000-20,000 years old, thus making it as ancient as the Great Pyramid and Sphinx.

The Osirion in Abydos, Egypt

The Lance or Spear

An evolution of the Eye of God is the lance or spear, a weapon used by Murrugan and Michael to defeat "evil" dragons and demons. The blade of the lance is often pictured in the shape of a vesica pisces or peacock eye, thus symbolizing that with the eye of wisdom the Son of God slays the demon of ignorance. Esoterically, the shaft of the lance represents the human spine and the lance blade, which is often golden, the classical color of wisdom, signifies the third eye, which is the seat of wisdom in the human body.

In modern times the Spear of Longinus, the Holy Spear, has become renowned as the symbol of western imperialism. The Holy Spear is a latter-day version of the shaft wielded by Murrugan as Sanat Kumara, King of the World.

Murrugan's peacock "eye" shaped lance

Scepters in the shape of Eyes

An evolution of the lance is the scepter sometimes carried by the Sons of God in different traditions which takes the shape of an eye. The "eye" scepter carried by the Peacock Angel represents that the Emperor of the Universe rules with divine wisdom, as well as that he sees all and knows all throughout the cosmos. Dionysus, a popular Greek version of the Peacock Angel, carries an "eye" scepter called a thrysus. A thrysus is normally a branch surmounted by a pinecone which represents the pineal gland, the organ associated with the Third Eye of wisdom in the human body and known esoterically as the "Holy Spear" and "Staff of God."[8] With his thrysus Dionysus awakens the eye of wisdom within his devotees or blinds his enemies with ignorance.

Dionysus and his Thrysus

The Pharaoh's Scepter, the Horus Eye of Wisdom

The pharaohs of Egypt carried a scepter surmounted by an eyeball called a "Mace." The Mace represented the Eye of Horus, the divine eye of wisdom, that reputedly defeated the demon of illusion, Seth. With his Mace, the pharaoh ruled with wisdom and discrimination.

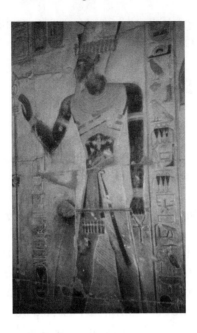

Buddha's Third Eye

In Asian countries it is common to find "Buddha Eyes." The shape of this third eye links it to the lance and scepter heads wielded by the Sons of God.

Buddha's Third Eye of Wisdom

The Trident

After the lance, the second most common weapon carried by the Son of God is the trident. The trident is the weapon of Rudra, the name of the Cosmic Fire form of the Peacock Angel. The three prongs of the trident symbolize the principal powers or "shaktis" of the Son of God, which manifest as iccha, jnana, and kriya shaktis, or will, wisdom and action. The center prong of the trident, which is often rendered in the shape of a peacock eye or vesica pisces, is symbolic of the Son of God's association with the Divine Mind of Wisdom.

Since the three prongs of the trident represent the three shaktis which unite as Cosmic Fire, it is the basis of the Hebrew letter for fire, Shin.

The Hebrew Shin, the letter for "fire"

The trident is the symbol of Rudra, the embodiment of Cosmic Fire. Rudra is primarily associated with destruction because he is the lord of fire and fire is traditionally recognized as destructive. Other gods associated with fire, such Vulcan and the Christian Devil, are also commonly associated with destruction.

The trident is also the symbol of Sanat Kumara, the King of the World, who wields the three powers of God from his throne at Shamballa. Both the trident and its myriad versions worldwide, such as the flail of the pharaohs and the fleur-de-lie, have been adopted by many priest kings as symbols of their power and authority.

Neptune and his Trident

In the west, the trident is traditionally associated with Neptune, god of the sea and patron of Atlantis. Neptune is a western version of Rudra. Like his eastern counterpart, Neptune was known to precipitate turbulence and massive destruction, such as that triggered by volcanic explosions and earthquakes. For this reason, Neptune was anciently called Enosichthon, the "Earth Shaker."[9] But he was also invoked by the name Poseidon, meaning nourisher or "Consort of the Earth," as well as Phytalmios, "He who makes the plants grow."[10] Like Rudra, Neptune is the Cosmic Fire or life force that can be both destructive, as well as constructive and nurturing. When life force arrives from the cosmos and enters the Earth's grid of vortexes and ley lines, it circulates just below the surface of the planet and nourishes all the vegetative life forms. But the life force becomes congested, it gives rise to earthquakes and volcanoes in order to release its buildup. In Greece, one of Neptune's symbolic forms was lightning bolts. The sages of Greece recognized that lightning can be creative – it was the power which initially created life on Earth – but it can also be very destructive.

In Egypt, Neptune became known as Ptah, the god of fire, who in turn

became was ushered into the Roman pantheon as Vulcan, the smith god who was said to live within volcanoes. Roman legends metaphorically depict the descent of life force to Earth as Vulcan being "thrown out" of heaven and then traveling to his abode under the surface of the Earth. Ptah-Vulcan eventually merged with his counterpart from the East, Rudra, and their east-west synthesis was the trident-carrying Devil, lord of the fiery underworld.

The Trinity in the Trident

The three prongs of the trident represent the trinity of God's power, that of creation, preservation and destruction. It therefore represents those deities which wield those powers, such as Brahma, Vishnu, and Shiva of the Hindu Trinity, as well as the Christian Trinity of Father, Son, and Holy Ghost.

Symbolic representations of the Christian Trinity can clearly be distinguished within the design of the trident. The trident's left and right outer prongs, which slant inwards as semicircles, are symbolic of "Father" and "Holy Spirit" respectively. Their union, the Son, is denoted by the middle prong, which is shaped like either a vesica pisces fish, a peacock eye, or a diamond. The diamond is a symbol of both androgyny and true wisdom, which is as hard and unwielding as stone.

A Short History of the Christian Trinity

The Christian Trinity of Father, Son and Holy Ghost began as the three aspects of Cosmic Fire signified by the trident, but it underwent a long and circuitous evolution before arriving at its current, stable form via the Church Councils of Nicea and Chalcedon in the fourth and fifth centuries. Before that time the Church Fathers had been introduced to numerous trinities from both East and West, including the Egyptian trinity of Osiris, Horus and Isis, which represented the uni-

versal male and female principles, and their union, the Son of God. When the Fathers eventually used these more ancient trinities as a model for the Christian Trinity they found themselves faced with a host of philosophical problems, such as: Was Jesus synonymous with his "Father" or separate from him? Was the Almighty equally present within all three "persons," or was one of the three persons more holy than the others? The early scholastic thinkers who broached such questions often did so at the risk of arriving at unpopular conclusions and being branded a heretic.

One of the first great Christian teachers to tackle the Trinity question was Justin Martyr, the man whose last name became synonymous with self sacrifice and torture. Martyr, who was originally a philosopher from Palestine, claimed that the Father and Son were not equal or the same because one was transcendent and infinite while the other was immanent and finite. He adopted the Greek concept of the "Logos," the Divine Mind or 'Word," which had been introduced popularly by Philo of Alexandria as a designation for the primal manifestation of the Son, and then constructed a celestial hierarchy wherein the Logos was the imminent aspect of the transcendental Spirit. The Logos or Son was different from Spirit, but derived from it. It was made of the Divine Father's substance, but vibrated at a lower rate of density. Martyr's hierarchal conception of the Father and Son nearly survived the Council of Nicea one-hundred and fifty years later, where it was submitted by Arius, an Alexandrian, to be part of the Nicene Creed.

Martyr's conceptual hierarchy of frequency was eventually meticulously delineated by the followers of Neo-Platonism living in Alexandria. Plotinus, the founder of Neo-Platonism and a student of Plato's philosophy of archetypes, taught that the universe was comprised of a hierarchy of levels, each of which corresponded to one of the successive degrees of density take up by the Infinite as it became physical matter. Plotinus proposed a Trinity comprised of the One, the Nous, and the World Soul, which were three aspects of the one Spirit, but characterized by being at successively lower levels of density. Clement of Alexandria and his student Origin adopted Plotinus' hierarchical scheme but added their own Christian vernacular to it. Thus, in Egypt, the One, Nous and World Soul became the Christians' Father early version of Father, Son and Holy Ghost.

The first formal use of the term "Trinity" by a Christian Father is ascribed to Theophilus, Bishop of Antioch from 170 AD. During the time of Theophilus Antioch had become a breeding ground for enlightened teachers and heretical philosophers, so new ideas were constantly emerging from it. It was also the storehouse of the radical doctrines left behind by the early Ebionites and their Aramaic Church, and many of the ideas percolating in the city were no doubt derived from the study of these doctrines. In 260 AD, another heretical Bishop of Antioch, Paul of Samosata, asserted the Ebionite-like notion that Jesus had been

a mortal human being before evolving into a Christ. His proclamation would have gotten many Church officials excommunicated or even executed in other parts of the world, but in Antioch "heretical" notions had become commonplace. Paul's idea regarding Jesus' humanness eventually gathered a healthy following, and it was close to becoming the accepted theory throughout Christiandom when, during the Council of Nicea, it was suddenly voted down as a version of the heretical philosophy of Arianism. But the idea of Jesus' humanness refused to go quietly into the night and again raised its head at the Council of Ephesus in 431 AD when Nestorius, a native of Antioch who had become Patriarch of the Eastern Church, contended that Jesus was a mortal who had channeled his higher self - the angelic Christ - during the years of his ministry. According to Nestorius, Christ was not the human Jesus, and therefore Mary could not have been his mother. Nestorius's radical proclamation eventually got him excommunicated from the Church, but a seed had been planted which would eventually flower throughout much of Asia as the Eastern, or "Nestorian" Christian Church.

An acceptable compromise regarding Jesus' divinity or nondivinity was finally reached at the Council of Chalcedon in 451 AD. The Church Fathers attending this pivotal council concluded that Christ had existed as the man Jesus both before and after his baptism. Christ was Jesus' higher self, which shone brilliantly during his ministry, but it had also taken the form of Jesus' human personality and his mortal disposition. Thus, every aspect of Jesus became divine and irreproachable. The Christian doctrine of the Trinity succeeded in coming full circle and returned to its mystery school roots, wherein Spirit and matter were both manifestations of God and divine. Following the Council of Chalcedon, a conditional philosophy was touted by the Church, wherein both matter and spirit were divine. But this theological notion applied, of course, only to the Savior, Jesus.

The Caduceus

The "trinitized" caduceus, which incorporates two intertwined snakes and a central shaft, representing the male and female polarity (the snakes) and their union (the middle shaft), is related to the trident and to the Kabbalic Tree of Life. Esoterically the symbol represents the human subtle anatomy, and it is, therefore, an important guide for those on the path to Kundalini awakening and enlightenment. The two snakes of the caduceus symbolize the Ida and Pingala Nadis, which spiral around the human spine, and the central shaft denotes the Shushumna Nadi, the Royal Road ascended by the Kundalini. When the Kundalini moves up the Sushumna it bestows the powers and wisdom aspired to by the seekers of wisdom.

The caduceus was the symbol of a lineage of masters from Atlantis. Known

collectively as Thoth-Hermes, they had, through the ascension of Kundalini, merged with the Divine Mind and the three powers of Cosmic Fire. Thoth-Hermes was an Atlantean Son of God who possessed a body of tinitized Cosmic Fire, a truth reflected in one of his names: Tresmegistus, the "thrice born." Because of his versatile life force body, Thoth-Hermes alternately took the shape of a dragon and a forever-young boy. Thoth-Hermes was also known as Mercury, the androgynous messenger who split into the Twins of Gemini, the Zodiacal sign he rules.

Like the trident, the "trinitized" caduceus was an ancient symbol of priest kings who wielded the triune powers of Cosmic Fire. It was also a symbol of the Sumerian kings, who were recognized to be incarnations of the nature god Tammuz, and it was carried as part of the regalia of the Roman Ceasars, thus symbolizing that these emperors were not just common priest kings, but divine wielders of immense supernatural power and wisdom.

The Tripundra and Tilak

The Tripundra and Tilak are symbolic marks worn by the holy men and women of India and closely related to the trident. The Tripundra is the name for the three horizontal lines which cover Murrugan's forehead. The three lines are ritually displayed by the Shaivites, the followers of Murrugan and Shiva, and represent the three powers of Cosmic Fire, as well as their manifestation as Sattva, Rajas, and Tamas, or peace, activity, and ignorance, the three gunas or "characteristics" of material nature. By transcending all three gunas a devotee of Murrugan can hope to unite with the Hindu Son's essence, transcendental Shiva.

The Tilak is a version of the trident which is drawn vertically on the forehead rather than horizontally. Since the Tilak-trident is a symbol of Vishnu worn by his devotees, the Vaishnavas, it emphasizes the middle "prong," which corresponds to Vishnu, the "Son" and second "person" of the Hindu Trinity.

The Fleur-de-lies

This icon is also a version of the trident and carries the same meaning. The three branches or petals of the Fleur-de-lies are, like the trident, representative of the three powers intrinsic to Cosmic Fire, but they are rendered softer and more feminine than those of the trident. Its graceful appearance reveals the Fleur-de-lies' intimate association with the Goddess. It denotes Her womb, from which issues the eternal Son of God.

The Fleur-de-lies has been the symbol of kings and queens for millennia. Its association with royalty harkens back to an era when monarchs were recognized as embodiments of the life force and wielders of its three powers. The symbol is associated with both Sanat Kumara and Mithras, two names of the primal

King of the World, and is historically affiliated with the kings of Palestine and the monarchs of France, who wove the Fleur-de-lies into their crown designs.

The Fleur-de-lies

The Flail or Flagellum

The Flail is a version of both the trident and Chi-Rho symbols. The Flail is an accoutrement of the Egyptian Son of God, Osiris, as well as of the pharaohs who once ruled ancient Egypt as his representative. Like the trident, the three branches of the Flail denote the three powers of Cosmic Fire, and it thus designates its bearer to be an embodiment of the life force and infinitely powerful. When the other symbol of authority accompanying Osiris, the shepherd's crook, is united with the Flail, the Chi-Rho symbol is created.

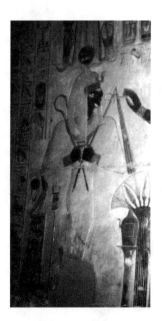

Egyptian Pharaoh with Crook & Flail

The Antahkarana

The Antahkarana is a version of the trident wherein the three prongs are united in the form of a fan or propeller, thus denoting the turning of the cycles of

nature by the three powers of creation, preservation, and destruction.

The Antahkarana is a symbol of Sanat Kumara and represents him to be a manifestation of pure Cosmic Fire or life force, and the official turner of the seasonal cycles on Earth. It is an important symbol within Reiki, a Japanese form of laying-on-of-hands, which Sanat Kumara is the patron and primeval teacher of. Certain schools of Reiki, such as Johrei Reiki, the "Way of the Fire Dragon," maintain that the symbol has been used for ages in the rituals of Tibetan monks, the modern descendants of the masters of Shamballa. I have personally seen the symbol engraved upon one of the stone steps leading to the Potala Palace in Lhasa.

The Antahkarana

The Aum

The Aum, which is the "name" of the Son of God, is also intimately related to the trinity and the trident. The three letters of Aum denote the three powers and three "persons" of the trinity. The Aum assumes the shape of the number three when placed horizontally and becomes a trident when positioned vertically.

Aum is the sound vibration of Cosmic Fire, the first form and "name" of the primeval Son of God. When Saint John tells us in the *Gospel of John*, "In the

beginning was the Word, and the Word was with God and Word was God," he is referring to Aum or Amen, the vibration which manifested the life force or Cosmic Fire that crystallized into the forms of the physical universe. Aum is traditionally chanted at the beginning and/or end of prayers because its repetition generates Cosmic Fire that will eventually crystallize into the desired form of the supplicant's wishes.

The Word or name of the Son of God continually vibrates within his bodily seat, the third eye or Ajna Chakra, the place where the polar opposite nadis, the Inda and Pingala, unite. By intoning Aum, the third eye will be activated and intuitive awareness stimulated.

The Triangle of Fire

The symbol of the triangle is synonymous with both the trinity and Cosmic Fire. The triangle, as well as its three dimensional form, the tetrahedron, one of the five Platonic Solids, are the yantras or geometrical forms of the element of fire.

The Tantric sects of India recognize the fiery nature of the triangle. The Tantric texts on cosmology assert that at the beginning of time Cosmic Fire took the form of a fiery triangle called the Kamakala Triangle, the triangle of passionate heat and time, whose sides and corners corresponded to the fifty letters of the Sanscrit alphabet. Many Tantric sects traditionally build their ceremonial firepits in the shape of a triangle, thus implying that life emerges from the triangle of fire and is eventually consumed within it. Some Tantric worshippers refer to their triangular firepit as a "Yoni," or female sexual organ, thus denoting that all life emerges from the womb of the Goddess.

The Pyramid

The pyramid, which unites the three dimensional forms of the triangle and square, the tetrahedron and cube, is the preeminent geometrical form of the Son of God. The triangle represents fire, and the square denotes dense matter. When these opposing forms come together dense matter is "cooked," and its vibration is raised to a higher frequency. The polarity union produces the pyr-a-mid, meaning "fire in the middle," which transforms solid matter back into Cosmic Fire.

According to John Michell in *The New View Over Atlantis*, the architects of the Great Pyramid incorporated into its structure sacred numerology especially associated with the Son of God. These numbers were taken from the "Mercury Square," a block of numbers intimately associated with Mercury or Thoth-Hermes, an archetypal name for the Son of God. When all the numbers of the Mercury Square are added together they equal 2080, which is an identical sum equal to the Greek word for "artificer's fire" converted into numbers. [7]

The Eye within the Triangle

The symbol of the eye enclosed within a triangle or pyramidal capstone is a comprehensive motif of the primal Son of God. The eye is the symbol of the First Son's omniscience, and the triangle represents the three powers of Cosmic Fire wielded by him.

This symbol is the definitive emblem of many mystery school traditions founded by various Sons of God. The first order to adopt it in recorded history was the Egyptian Illuminati founded by Thothmes IV.[11] Supposedly the Illuminati had inherited it from the adepts of Atlantis, who had themselves acquired it from missionaries from Sirius, illuminated masters that the Dogon of Mali refer to in their legends as Nommo, the primeval culture-bearer who visited their tribe hundreds and thousands of years ago. The Egyptians, who inherited the mystical tradition of Sirian Alchemy, evolved a hieroglyph of Sirius in the form of a triangle.

During the Renaissance period in Europe the eye in the triangle motif became an accepted symbol of the Christian Holy Trinity, as well as certain secret societies, such as the Bavarian Illuminati. Under the influence of this order the symbol subsequently became part of the reverse side of the Great Seal of the United States.

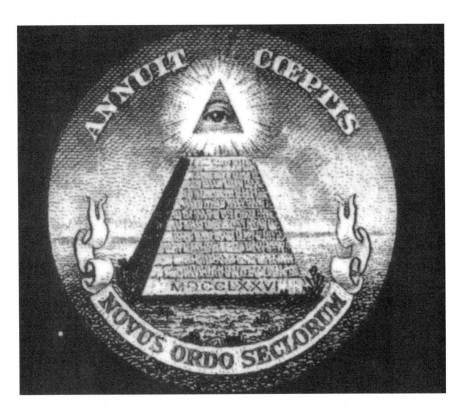

The Eye within the Triangle is at the center of this Christian motif

The Mayurapiccha

The Mayurapiccha unites the peacock feather and its "eye" with the three-pronged trident. Its meaning is basically the same as the trident, however it emphasizes the immortal nature and eternal wisdom of the Son of God. The Mayurapiccha can be found in Tibetan Buddhism as the symbol of Goddess Mahamayuri, a female version of the Peacock Angel. The Mayurapiccha also adorns the head of the Hindu Lord Krishna, whose crown signifies him to be the wielder of the three sacred powers of creation, preservation, and destruction.

The Chintamani

The Chintamani is a popular eastern symbol of the immortal Sons and Daughters, and it is a close relative of the fiery triangle. Chintamani, which means "Flaming Gem," denotes fire and wisdom, or "fiery wisdom." There are three common shapes of the Chintamani, each of which represent the fiery trinity. The first form has three circles united and the second form is a three-faceted gem enveloped in fire.

The third form of the Chintamani is a flame or "eye" with three levels, thus representing the three powers intrinsic to the primal flame. This form of the Chintamani is an alternate form of the trident and similarly accompanies the Son of God as his weapon.

Lord Murrugan is sometimes depicted carrying a form of the Chintamani as his spear or lance, thus symbolizing the three powers of Cosmic Fire he wields.

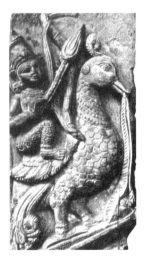

The Star of David

The Star of David, which unites two triangles together, is a profound symbol of the archetypal Son of God because it represents both his androgyny, as well as his association with Cosmic Fire. The two component triangles of the Star of David are representative of the male and female principles which unite as the androgynous First Son of God, whose form is Cosmic Fire or life force. Throughout the ages the Star of David has been an important symbol among alchemists whose goal has been to unite the polarity and produce fire which will transform them into gods and goddesses. Beginning with the famous Jewish alchemist King Solomon, whose association with the symbol has endowed it with the name "Seal of Solomon," the Star of David has been a seminal emblem of alchemists throughout the entire western world. In India, it has been a symbol of Murrugan, the androgynous Son who wears it over his royal breast, as well as an emblem of Rasayana or Hindu Alchemy. The path of Rasayana, which was founded by the sage Bogarnath under the guidance of his deity, Murrugan, leads to uniting the internal polarity and awakening androgynous Murrugan as Cosmic Fire or Kundalini at the base of the spine.

Murrugan's Star of David

The Places of Sacred Fire

The builders of the ancient temples and pyramids incorporated the trinity and triangle into their sacred structures so that they would generate the fire of transformation. The trinity was incorporated as triangles, three pyramids placed together, temple compounds with three levels, etc..

The Trinity of Giza

Perhaps the most famous trinitized complex of temples built in the West by the ancient builders is Giza, Egypt, and its trinity of colossal pyramids. These three pyramids produce a steady stream of Cosmic Fire and were, along with the temple-college which once existed at nearby Heliopolis, the focal points for initiation and the study of alchemy in the western world. Ancient Egyptian texts maintain that the alchemical doctrines of Thoth-Hermes, a missionary from Atlantis, were stored and studied there by the Djedhi, the Priests of Osiris.[12]

The pyramidal complex at Giza was aligned to two trinitized star groups, the three stars of Orion's belt and the three stars of the Sirius group, thus making it a receptor of fire from the outer cosmos. Sirius was known among the Egyptians as Au Set, thus associating it with both Isis (Isis is the Greek translation of Au Set) and Set, the two deities which ruled over the esoteric arts that utilize life force power, such as magic and alchemy. Set, the embodiment of Kundalini, was depicted as reddish in color and possessing a fiery, destructive temperament. He is the oldest patron of an Egyptian alchemy, which some legends maintain was brought from Sirius via Atlantis. Initially Set rose to the position of king over all the other gods in Egypt, but later, during the patriarchal era, he was delegated to the lowest rung of the pantheon.

The Trinity at Kashi, India

Another important trinitized headquarters of the Great White Brotherhood was founded in India at Kashi, the "City of Light." Kashi, which is now known as Varanasi, was built upon three hills which symbolize of the trinity of Shiva-Rudra's trident. Legend has it that on one of these hills there once stood a huge pyramidal complex known as Bindh Madhu. Unfortunately this compound was eventually turned to dust by the fanatical Moslem despot, the Emperor Aurangzeb, who replaced it with a mosque in order to dis-empower the religion of the Hindus.

Kashi was built near "Prayag," the meeting place of India's three most sacred rivers, the Ganges, the Yamuna, and the Saraswati. Prayag is the place where Murrugan, the fiery Son of Shiva was born. Legend has it that after Shiva's

hot sperm was tossed into the Ganges, the goddess of the sacred river threw it into some reeds growing on the river's bank where it cooled and crystallized into the forever-young boy form of Murrugan. The Prayag is said to have its reflection in the human body at the base of the spine, the place where the Ida, Pingala, and Sushumna Nadis converge and Murrugan resides as Cosmic Fire.

The Trinity at Chavin de Huantar

A few hundred miles north of Lima and thirteen thousand feet up in the Andes Mountains lies Chavin de Hauntar, one of the most important vortexes in the Western Hemisphere and home to a trintized temple compound. One of the oldest sacred cities in the world according to modern archaeologists, Chavin incorporates the trinity in its three level design, which from an Andean cosmological perspective reflects the "three worlds," the underworld, the middle world (Earth), and the upper world (Heaven). The trinity is also focalized at Chavin by virtue of the site being aa important energetic point in South America where the three terrestrial "nadis" or energy vessels of the continent converge. Like Kashi, the Paecock Angel as Cosmic Fire was "born" at Chavin. At his "birth site" the builders of Chavin erected a ten-foot tall monolith with the features of an androgynous dragon, the primal form of the Son of God. Known today as El Lanzon, the "Lance," this dragon motif unites the features of the puma, serpent, and condor, the three Andean animals associated with the Three Worlds - Heaven, Earth and the underworld - and the three powers of Cosmic Fire. Androgynous El Lanzon also joins Heaven and Earth together with his hands, one of which is pointed upwards and the other down. El Lanzon is popularly referred to by the Peruvian shamen as the Axis Mundi , the Spine and "Center of the Earth," where all polarities and dimensions unite. Since it can catapult a shaman into another dimension, El Lanzon is the place where shamen travel to in their astral bodies before journeying to other worlds.

Those who constructed the pyramid compound at Chavin de Huantar apparently arrived there as a very technologically advanced civilization. There are no traces at Chavin of a people having progressed through the normal stages of cultural evolution. On the contrary, one only finds evidence of a race of extreme technological and spiritual maturity. Their spiritual advancement is also reflected in the carved, stone heads the occupants of Chavin left behind of themselves. These heads unite the serpent, puma, and condor, and denote that these alchemical adepts had mastered the three worlds and acquired the three powers of Cosmic Fire. They had become one with El Lanzon, the archetypal Son of God, and united the polarity, Heaven and Earth, within themselves.

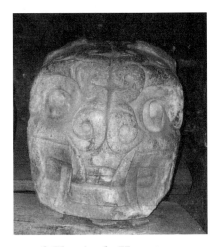

The heads of the Masters of Chavin de Huantar

The Trinity at Tashi Lunpo Monastery of Shagatse, Tibet

At Shigatse, Tibet, the Great White Brotherhood built a trinity of temples adorned with glistening, pagoda-style roofs. This trinity of temples exists at the temple compound of the Tashi Lunpo Monastery, which legends assert has a special connection to the Great White Brotherhood and its mystical colonies of Shamballa and Agartha. Alchemy is practiced at Tashi Lunpo in the form of the Kalachakra Tantra, a form of Buddhist Tantra which came from Shamballa. The Kalachakra disciplines awaken Kundalini and ultimately release its practitioner from the fetters of kala or "time." Initiation into Kalachakra, which is currently given annually en mass by the Dalai Lama, will both assist in the awakening of Cosmic Fire and align one with the masters of Shamballa and their overlord, Sanat Kumara.

The Trinity of Boynton Canyon in Sedona, Arizona

For many years Sedona, Arizona has been recognized as one of the world's major vortex centers and a focal point of Cosmic Fire. Not only is it a convergence point for many important ley lines and their prodigious energy, its natural power is greatly enhanced by an abundance of iron and quartz crystal contained within its famous red rock formations, which swirl heavenward like collosal conductors and capacitors of electrical energy. The ironized red rock makes Sedona unusually fiery and instrumental in the activation of everyone's root chakra who lives or visits there. Because of its Kundalini activating power, Sedona is one of the principal initiation centers on Earth.

Recognized by many as the most powerful vortex of the four main votexes in Sedona is Boynton Canyon, an area full of collosal but graceful red rock formations. It is also the only principal vortex in Sedona which is both yin and yang (the other vortexes are one or the other), thus making the canyon the principal place in the area where the polarity unites to produce the androgenous serpentine Kundalini. Boynton Canyon can, therefore, be considered a vortex within the vortex, or the fire within Sedona's fire and the stongest place for Kundalini activation. Futhermore, like other important initiation centers around the globe, Boynton is also trinitized. There are three finger-like projections at one end of the canyon which form a huge trident, the symbol of fire and fire gods worldwide. It is thus the dwelling place of Kundalini power and the abode of the Peacock Angel, the primal fire god who resides on Earth as Murrugan, Sanat Kumara, or Lucifer.

Trinitized Mountains

Trinitized mountains have, for ages, been worshipped as terrestrial homes of Lucifer or Vulcan, the fire god. They are recognized as places conducive to transformative spiritual work because of the naturally occurring flames of subtle Cosmic Fire which surround and interpenetrate them. Wherever you find three mountains or hills grouped together, you can be sure you have found the fire god's abode. Check the ground around you and you might find a rock shard with scalloped or jagged edges resembling an arrowhead, daggar, or some other kind of weapon. This is a gift from Vulcan, whose service to the gods and humanity is the creation of weapons.

In my previous books I have mentioned a couple trinitized mountains of note, the Ahaggar Moutains in southern Algeria and the three sacred moutains surrounding Grindelwald, Switzerland - Monch, Eiger, and Jungfrau. The Ahaggar Mountains were chosen to be the headquarters of the Taureg people thousands of years ago because of they were recognized to be the home of the fire god which the Tauregs had previously worshipped on their original homeland, Atlantis (see *The Return of the Serpents of Wisdom*). The three mountains of Grindelwald have revealed themselves as a home of the fire god to certain select indivduals, such as a woman I once met after giving a lecture in Zurich. She recounted a recent dream in which she found herself in Grindelwald during an earthquake, when emerged from out of one of the three sacred mountains Vulcan as Lucifer or Sanat Kumara, who was dressed in a solid red bodysuit and displaying long golden hair, an attribute of Venusians (see *Conversations with the Goddess).*

Another home of the fire god is Montserrat in Spain. Montserrat Monastery is surrounded by a jagged set or moutains called Sawtooth Mountains, within which one can find a trinity of moutains. Next to the monastery is a church with a statue of the Black Madonna, which has been associated with both the Virgin Mary and Mary Magdalene. The Black Madonna was worshipped as an embodiment of the transformative power of the Goddess by European seekers and alchemists following the path of the Goddess, such as the Cathars and Templars. Black and red were regarded by the European initiates as the colors of transformative, Cosmic Fire, and statues such as the Black Madonna were installed in places where Cosmic Fire was particularly concentrated. It is because of Montserrat's abundance of Cosmic Fire that the monastery and its surrounding mountains have been recognized as the dwelling place of the Holy Grail, which legends assert was hidden there by Joseph of Aramathea. The true Holy Grail is Cosmic Fire or Kundalini, the "elixir" of immortality, so this myth appears to be true. The Holy Grail is intimately related to, and perhaps a name for, the Cauldron of Keridwen, the vessel which bestowed immortal life upon the Druids. Keridwen's

cauldron was full of fiery dragon's brew, or liquid Kundalini.

Montserrat has also been mentioned in regards to the Ark of the Covenant, which one legend maintains was brought to Spain by Phoenician's under the guidance of the prophet Jeremiah. Supposedly it can be found in one of the caves dotting the Sawtooth Mountains, thus adding additional power to their already potent rock formations. The symbol for the monastery of Montserrat is three mountains together with a box resting upon the center one. Perhaps this box represents the Ark of the Covenant (see *Lost Cities of Atlantis, Ancient Europe, and the Mediterranean*, by David Hatcher Childress, Adventures Unlimited Press).

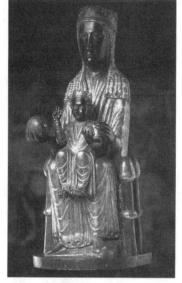

The Black Madonna of Montserrat

The Sawtooth Moutains. Photo by Marsha Beery

The Trinity at Machu Picchu

One final trinitized mountain configuration can be found at Machu Pichhu in Peru. The main temple compound is situated upon a hill which is surrounded by three mountians, Huayna Picchu, Machu Picchu, and Putacusi. These three mountains form a tiranglular configuration with the temples of Macchu Picchu at its center. They roughly correspond to the trinity of Father, Son and Holy Ghost. Machu Picchu, or "Old Peak," is the Father; Putacusi, the only female *Apu* or moutain spirit of the area, is the Holy Spirit; and Huayna Picchu, the "Young Peak," is the Son. Machu Picchu is believed to have once been a spiritual city of the Inca and pre-Inca peoples and a place where esoteric teachings were disseminated and initiations performed. The stairway leading up the natural pyramid in the center of the compound suggests the human spine and the path of the Kundalini, and the Inti Huatana and Temple Plaza at the pyramid's apex and base seem to correspond to the Ajna and Root Chakras at the top and base of the spine. Peruvian shamen currently use the Inti Huatana for Third Eye activation.

During my first visit to Machu Picchu I experienced Kundalini aggressively ascend up and down my spine for three days. When I left the area I went to Aguas Caliente, the small town at the foot of Machu Picchu Mountain, where I gratefully soaked by back for many hours in the village's therapeutic hot springs. When I returned to Machu Picchu the following year and experienced the same Kundalini movement. But this time the energy could be felt all the way from the heals of my feet to the top of my head! -MAP

Machu Picchu with Apu Huayna Picchu in the background

X
The Rites of the Peacock Angel and Son of God

The rites of the Peacock Angel began as archetypal supplications and gestures to the Son of God and have since become part of numerous spiritual traditions throughout the world. Many of the archetypal rites were reputedly spread to various parts of the globe by missionaries of the Peacock Angel from ancient Lemuria and Atlantis and then later revised by the adepts of the various spiritual civilizations they were assimilated into. Today, as in the past, the rites of the Peacock Angel are observed for the purpose of communing with the archetypal Son of God, and ultimately for becoming eternally one with him.

The Peacock Dance

The Peacock Dance, which is normally performed around the image of a peacock, is one of the oldest and most enduring rites of the Peacock Angel. Its historical origins can be traced back to the cult of Murrugan in India, a branch of the ancient Goddess religion, and perhaps before that to Lemuria. In more recent times the dance has been associated with the spiraling/circular dances of other later branches of the Goddess Tradition, such as those of the Sufis and Witches. A version of the Peacock Dance is reputed to have traveled to Europe via the Sufi tribes of the Maskara and Aniza before becoming amalgamated to the nature rites of the European Witches. Upon its arrival in Europe the Peacock Dance was found to blend well with these European nature rites, especially those of the wild and orgiastic Dionysian tradition. But this is no surprise, especially in light of such texts as *Shiva and Dionysus* by Alain Danielou, wherein a body of evidence has been presented to prove that Murrugan and Dionysus are one and the same deity.

The Peacock Dance is performed with dancers moving in a clockwise direction around a peacock effigy while staring intently at the image. The dance is performed either circularly or in a spiral pattern, thus mimicking the spiral rain dance of the peacock. As the dancers revolve around the peacock image they spiral inwardly towards it and then return to the periphery of the circle.

The dancers meditating on the image of the Peacock Angel acknowledge that they are communing with the King of the World and strive to become energized with his creative and transformative spiritual power, the Kundalini. When the Peacock Angel's fiery life force begins to move through them it works in ways which are supportive to their spiritual evolution and the realization of their material

desires. It also helps to awaken their latent intuition and thus assists the dancers in communicating directly with the archetypal Son of God. If a person is ripe for a major life change, the Peacock Angel will communicate information to him or her about how to make the change. If releasing emotional residue from past traumatic events is required, then the Peacock Angel's fiery energy will precipitate an emotional purge within the animated dancer. If the dancers are focused on their material desires, then the energy of the Peacock Angel can be used to help them manifest them. The Peacock Angel is the King of the World, so the Earth's resources are his to dispense as he sees fit. After the dance is completed and the participants leave the presence of the Peacock Angel, they are often so full of his creative power that they can often manifest whatever they want.

The Peacock Dance, like all rites of the Peacock Angel, should be observed during times when the Son of God's energy, the universal life force, is strongest and most pervasive, such as during the equinoxes, solstices and full moons. After gathering together and bowing to the image of their deity, the dancers should mentally formulate the goal of their dancing and then begin their clockwise rotations. The dancing should continue until a pre-determined number of revolutions around the peacock are complete, or when the participants feel intuitively like the rite has ended. The dance can also be conducted while the participants join arms to make a closed circle and then move around the peacock image while keeping the front part of their bodies turned towards the effigy.

Lamps with a peacock image attached to the top are still manufactured in India where they are used for long chants, dances, and yogic ceremonies. These lamps have the image of a peacock in the center of an oil trough, which is made in the shape of a pentagon or five-pointed star, symbol of the Goddess and mother of the Son of God. After placing the lamp in the center of the circle and lighting its wicks, the dancers can proceed to move around it while continuously meditating on its peacock image.

Meditation on the Peacock Angel

When not actively involved in the Peacock Dance, devotees of the Peacock Angel can daily walk around the image of the peacock while meditating on their deity. While doing so, they should ask for assistance from the Son of God in whatever area of their lives they need it for the coming day. They should also constantly affirm that "The force of the good and the bad are one," thereby transcending duality and uniting with the androgynous presence of the Peacock Angel.[1]

While standing or sitting, meditation on the Peacock Angel will reveal many of the mysteries of the universe, as well as the process of spiritual evolution.

The "eyes" of his peacock feathers, his lance, the serpent, the cock, and the Star of David all have a message regarding the nature of the Son of God and how to unite with Him.

The Peacock Angel's images are very transformative. They are constantly emitting Cosmic Fire or Kundalini, which the Peacock Angel is an embodiment of. Besides transmuting his devotee, the Peacock Angel also imparts to him or her certain techniques related to yoga and alchemy. The First Son is the primeval author and patron of such disciplines.

Before one begins their daily period of closed-eye meditation it is advisable to mediate on the form of the Peacock Angel in order to absorb some of his spiritual power. Or the image can be visualized mentally with eyes closed, if that is preferable, and its effect will be felt just as powerfully. Once the Peacock Angel's energy begins to move through a person, he or she you will gradually sink into a deep meditation and may even have visions or receive psychic messages from the Son of God.

Reiki, Power of the Peacock Angel

Reiki is a form of laying-on-of-hands which was brought to Earth by the Peacock Angel as Sanat Kumara millions of years ago. The schools of Reiki maintain that its healing techniques were reintroduced to the world in the last century by a Japanese man named Dr. Usui on Mount Kurama, a holy mountain where legends claim resides the spirit of Sonten, a name for Sanat Kumara. Supposedly the fiery life force came from Venus as Sonten six million years ago and then made Mount Kurama his permanent home. Japanese legends claim he arrived with his trident in the form of a threefold flame.[2]

Besides certain hand positions for moving the life force in the body, Dr. Usui also received special symbols for accelerating and amplifying the life force. Some of these symbols, which are ancient yantras or geometrical form bodies of the Son of God, were given the doctor for the purpose of awakening progressive levels of the indwelling Kundalini within aspiring practitioners, thereby making them progressively clearer channels of the life force.

When practicing Reiki it is efficacious to call upon the Peacock Angel and then channel his fiery power through you for both healing and Kundalini awakening. Such invocations will empower and accentuate your Reiki. It is also useful to have the Antahkarana symbol of Cosmic Fire hanging on the wall of your Reiki room, or to place the symbol over the chakras or areas in need of special directed energy.

Yoga, Ancient Disciplines of the Peacock Angel

The Peacock Angel was the first teacher of Yoga on Earth and he continues to oversee this science as its invisible patron. The Hindu scriptures maintain that Yoga was first taught by the Peacock Angel as Sanat Kumara, who brought it from Venus and then taught it on Kumari Nadu or Lemuria. Yoga was later spread by the missionaries of the Peacock Angel to the pan-Pacific countries, such as China, India, and Peru.

The practices of Yoga, which unite the inner polarity and culminate in the awakening of Kundalini, will eventually transform a person into the living image of the androgynous, forever-young Son of God. In the form of Kundalini or Cosmic Fire the Peacock Angel will work to consume all the impurities and limiting concepts which prevent a person from living as an immortal child of God. It will also give them the ability to perform supernatural feats and live for hundreds or even thousands of years

The cannon of Yoga is overflowing with practices for uniting the inner polarity and activating Kundalini. Many yogic meditation poses, for example, unite the male and female by joining the right (male) and left (female) sides of the body. While sitting for meditation one need only cross the legs and cradle the hands to precipitate the inner yogic union. Of all the yogic sitting poses, Padmasana, the "full lotus," is the most efficacious for uniting the polarity. It unites the opposing sides of the body while also keeping the life force from exiting the body through its lower extremities. Because of the body lock it produces, this position will bring together the polarity as prana and apana, which will gather in the lower abdomen and unite as Cosmic Fire. When the full lotus is combined with the other bandhas (locks) and controlled breathing or pranayama, this Cosmic Fire can be moved to the base of the spine in order to awaken the dormant Kundalini. Besides catalyzing inner alchemy, the full lotus is also an excellent tool for meditation. While locking the legs together it similarly locks the mind into a one-pointed focus.

Mantra repetition is another excellent yogic practice for uniting the inner polarity. Many mantras, such as Om Mani Padme Hum, contain syllables associated with both the male and female principles, such as "ma" and "pa." By repeating these mantras the polarity is internally activated and united, and the Peacock Angel as Cosmic Fire is subsequently awakened at the base of the spine. Aum is also a beneficial mantra to use because it is the name of the Son of God. It can also fully awaken the Peacock Angel as the Divine Mind at the third eye.

Alchemy, Creating Cosmic Fire

Alchemy, which in India is known as Rasayana, the "Path of Essence," is a spiritual science that synthetically creates Kundalini by uniting certain polar-opposite substances, such as mercury and sulfur. When combined correctly, the resultant alchemical mixture will transform a base metal into gold or a human into a god. As a reddish powder the alchemical mead is sprinkled on base metals, or as an elixir it is taken internally for both transmutation and longevity. Once the elixir begins to move within a person it works to catalyze the awakening of Kundalini and move it up to the head. After the Kundalini reaches the brain, the body's store of inner elixir is released and transmitted to all the internal organs.

There are four grades of elixirs, called "Lions," each of which has a more profound transformative effect than its predecessor. The highest grade of elixir, the Red Lion, is only given to those properly prepared for full-scale Kundalini awakening as it is itself just one step away from being the pure, transformative life force. Anyone not sufficiently purified could have a violent reaction to it and its negative effects could even pursue him or her through countless future lifetimes. A good description of such indiscriminate use of this Lion can be found graphically presented in the semi-fictional work *The Red Lion and The Elixir of Eternal Life*.

The path of alchemy also includes the ingestion of certain longevity herbs, such as ginseng and mushrooms, both of which increase the body's store of life force and seminal fluids. Mushrooms are especially efficacious alchemical substances because they both increase the sexual fluids as well as transmute them into Kundalini. Fly Agaric, the mushroom associated with the ancient Soma of the Hindus, is believed to have this effect when ingested internally.

Communing with the Son via Sacraments

Besides being used for their transformational effect, special sacraments have been consumed all over the world for the purpose of altering consciousness and directly communing with the presence of the Son of God. Through imbibing strong wine the devotees of Dionysus succeeded in uniting their consciousness with the Greek Son of God; the Mexican devotees of Quetzlcoatl used psychedelic mushrooms, which they referred to as the "Flesh of Quetzlcoatl," for uniting with their version of the Son of God; and the Tantric worshippers of Shiva, as well as their western cousins, the European Witches, used datura to experience communion with their lord. The followers of Mithras and Jesus Christ used the sacramental bread and wine, the elements of "Holy Communion," to unite with their version of the Son of God, although Mithras' cult first incorporated the ritual use of the much stronger Hoama.

As I shared in Chapter IV, through the sacrament of San Pedro I was able to both see and commune with the Peacock Angel. But I did so under the guidance of an experienced shaman, and it is my belief that for the safest and most efficacious results a sacrament should always be consumed with the appropriate precautions and under experienced guidance. A shaman knows the right dosage and how to work with a person if he or she encounters difficulties during the sacramental experience. While on sacraments I have personally encountered the Peacock Angel as a snake or a dragon, or in one of his gruesome Kundalini forms, and I know how frightening such visions can be. I wrote about my own firsthand experiences with such demonic Kundalini images in *Conversations with the Goddess.*

Pyramids and Crystals, The Homes of Cosmic Fire

The best places for communing with the Peacock Angel are the geometrical "bodies" of the Son, pyramids. Pyramids are alchemical cauldrons wherein the Son of God manifests as Cosmic Fire or Kundalini. If you enter a pyramid the Son will consume you in his transformative fire and eventually make you one with Him. Crystals and pyramids work well together because crystals are "frozen" Cosmic Fire. On the molecular level they are composed of innumerable tetrahedrons, the Platonic Solid which generates fire. For optimum results, a yantra grid of crystals in the form of a Star of David, the symbol of polarity union, can be set within a pyramid, and then a person can then either lie down or sit up within this grid. Cosmic Fire will soon begin working within a person this way.

Footnotes

Chapter I

1. *Paul: The Mind of the Apostle*, A.N. Wilson, W.W. Norton and Co., NY, 1997
2. Ibid
3. *A Separate God*, Simone Petrement, HarperSanFrancisco, 1984
4. *The Jesus Mysteries*, Freke and Gandy, Harmony Books, NYC, 1999
5. *A Separate God*
6. *Holy Bible*, King James version, Cambridge University Press
7. *The Book of Daniel*
8. *The Dead Sea Scrolls*: I QS 4:12-14
9. *Edgar Cayce on Jesus and his Church*, Warner Books, NY, 1988
10. *Bloodline of the Holy Grail*, Laurence Gardner, Barnes and Noble Books, NY, 1997
11. *Celestial Teachings: The Emergence of the True Testament of Immanuel*, James W. Deardorff, Wild Flower Press, Tigard, Oregon, 1990
12. *Angels, A Modern Myth*, Michel Sorres, Flammarion Press, Paris
13. *World Religions: From Ancient History to the Present*, edited by Geoffrey Parrinder, Hamlyn Publishing Group, NY, 1983
14. *The Travels of Marco Polo The Venetian*, translated by William Marsden, Doubleday & Co. Garden City, NY, 1948
15. *Zoroastrianism, An introduction to an Ancient Faith*, Peter Clarke, Sussex Academic Press, Brighton, England, 1998
16. *The Woman's Dictionary of Symbols and Sacred Objects*, Barbara G. Walker, Harper Collins, San Francisco, 1988
17. *The Hiram Key*, Christopher Knight and Robert Lomas, Element Books

Chapter II

1. *The Return of the Serpents of Wisdom*, Mark Amaru Pinkham, Adventures Unlimited Press, Kempton, Illinois, 1997
2. Ibid
3. *Lemurian Scrolls, Angelic Prophecies Revealing Human Origins*,

Satguru Sivaya Subramuniyaswami, Himalayan Academy, India, 1998

4. *Beasts, Men and Gods*, Ferdinand Ossendowski,
5. *Mithriac Studies*, edited by John R. Hinnells, Manchester U. Press, Manchester, England, 1971
6. *Survival Among the Kurds, A History of the Yezidhi*, John S. Guest, Kegan Paul International, NY
7. Ibid
8. Ibid
9. Ibid
10. *The Way of the Hopi*, Frank Waters, Viking Press, 1976
11. *A History of Secret Societies*, Arkon Darual, Citadel Press, NY
12 *The Sufis*, Idries Shah, W.H.Allen Co. London, 1977
13. *The Secret Doctrine*, H.P. Blavatsky, Theosophical Publishing House
14. *Edgar Cayce on Atlantis*, Edgar Evans Cayce, Warner Books, NY, 1968

Chapter III

1. *The Lost Language of Symbolism*, Harold Bayley, Citadel Press, New York, NY

Chapter IV

1. *Reiki Fire* by Frank Arjava Petter, Lotus Light, Shangri-la
2. *Angels, A Modern Myth*, Michel Sorres, Flammarion Press, Paris, 1995

Chapter V

1. *One Hundred Thousand Years of Man's Unknown History*, Robert Charroux, Berkeley Publishing, NY, 1963
2. *Darkness Over Tibet*, T.Illion, Adventures Unlimited Press, Kempton, Illinois
3. *The Cultural Heritage of India*, The Ramakrishna Mission, Calcutta, India, 1958
4. *Chandragupta Maurya and his Times*, Dr. R. K Mookerji, Motilal Banarsidas, Dehli, India, 1966
5. *Shambhala*, Nicholas Roerich, Nicholas Roerich Museum, NYC, 1985

Chapter VI

1. *Edgar Cayce On Atlantis*, Edgar Evans Cayce, Warner Books, NY, 1968
2. *Conversations with the Goddess*, Mark Amaru Pinkham,

Adventures Unlimited Press, Kempton, Illinois, 2000
3. *The Dead Seas Scrolls*: I QS 4:12-14
4. *Ponder on This*, Lucis Pubulishing Co., New York, 1980
5. *Shambhala*, Nicholas Roerich, Nicholas Roerich Museum, NYC

Chapter VII
1. *Dionysos*, Karl Kerenyi, Princeton University Press, 1976

Chapter IX: The Symbols of the Peacock Angel
1. *The Woman's Dictionary of Symbols and Sacred Objects*, Barbara Walker, Harper San Francisco, 1988
2. *The Sumerians*, Samuel Noah Kramer, University of Chicago Press, 1963
3. *The Return of the Serpents of Wisdom*, Mark Amaru Pinkham, AU Press.
4. *The Hiram Key*, Knight and Lomas, Element Books
5. *Sacred Geometry*, Nigel Pennick, Harper and Row, San Francisco, 1980
6. *Sacred Geometry, Philosophy and Practice*, Robert Lawlor, Thames and Hudson, London, 1982
7. *The New View Over Atlantis*, John Michell, Harper and Row, San Francisco, 1983
8. *Man, Grand Symbol of the Mysteries*, M.P. Hall, The Theosophical Research Society, LA, 1972
9. *The Greeks And Their Gods*, W.K.C. Guthrie, Beacon Press, Boston, 1955
10. Ibid
11. *Rosicrucians Questions and Answers, with complete history*, H. Spencer Lewis. AMORC Publishers, San Jose, 1975
12. *The Return of the Serpents of Wisdom*, M.A.Pinkham

Chapter X: The Rites of the Peacock Angel
1. *A History of Secret Societies*, Arkon Daraul, Citadel Press, NY, 1989
2. *Reiki Fire,* Frank Arjava Petter, Lotus Light Publications, Twin Lakes Wisconsin,1997

Bibliography

The Ancient Atlantic, L. Taylor Hansen, Amherst Press, Amherst, Wisconsin, 1969

Angels, Peter Lamborn Wilson, Pantheon Books, NY, 1980

Angels, a Modern Myth, Michel Sorres, Flammarion Press, Paris, 1995

Angels, An Endangered Species, Malcolm Godwin, Simon and Schuster, NYC, 1990

The Ancient Secret of the Flower of Life, vol.1+2, Drunvalo Melchizedek, Light Technology Pub. Flagstaff, Az.

Babaji and the 18 Siddha Kriya Yoga Tradition, M. Govindam, Kriya Yoga Publications, Montreal, 1991

Beasts, Men and Gods, Ferdinand Osendowski, E.P.Dutton and Co., 1922, NY

Bloodline of the Holy Grail, Laurence Gardner, Barnes and Noble Books, NY, 1997

Celestial Teachings: The Emergence of the True Testament of Immanuel, James W. Deardorff, Wild Flower Press, Tigard, Oregon, 1990

Chandragupta Maurya and his Times, Dr. R. K Mookerji, Motilal Banarsidas, Dehli, India, 1966

The Complete Dead Sea Scrolls in English, Geza Vermes, Penquin Books, NY, 1997

Conversations with the Goddess, Mark Amaru Pinkham, Adventures Unlimited Press, Kempton, Illinois, 2000

Darkness Over Tibet, T.Ilion, Adventures Unlimited Press, Kempton, Illinois, 1997

Dionysos, Karl Kerenyi, Princeton University Press, 1976

Edgar Cayce on Atlantis, Edgar Evans Cayce, Warner Books, NY, 1968

Edgar Cayce on Jesus and his Church, Warner Books, NY, 1988

Encyclopedia of Angels, Rosemary Ellen Guiley, Facts on File, NY, 1996

The Greeks And Their Gods, W.K.C. Guthrie, Beacon Press, Boston, 1955

The Hiram Key, Christopher Knight and Robert Lomas, Element Books, Rockport, Mass., 1996

A History of Eastern Christianity, Aziz S. Atiya, U. of Notre Dame Press, Notre Dame, Indiana, 1968

A History of Secret Societies, Arkon Daraul, Citadel Press, NY, 1989

The Jesus Mysteries, Timothy Freke and Peter Gandy, Harmony Books, NYC, 1999

Lost Cities of China, Central Asia and India, D.H. Childress, Adventures Unlimited Press, Kempton, Illinois, 1987

Lost Cities of Ancient Lemuria and the Pacific, D.H. Childress, Adventures Unlimited Press, Kempton, Illinois, 1988

The Lost Language of Symbolism, Harold Bayley, Citadel Press, NY

One Hundred Thousand Years of Man's Unknown History, Robert Charroux, Berkeley Publishing, NY, 1963

Man, Grand Symbol of the Mysteries, M.P. Hall, The Theosophical Research Society, LA, 1972

Men and Angels, Theodora War, Viking Press, NY, 1969

The Message of the Sphinx, Graham Hancock and Robert Bauval, Crown Publishers, NY, 1996

Mithriac Studies, edited by John R. Hinnells, Manchester U. Press, Manchester, England, 1971

The Mysteries of Asia, M.P.Hall, Manly Hall Publications, LA, 1935

The Mysteries of Mithra, Franz Cumont, Dover Publications, NY, 1969

The New View Over Atlantis, John Michell, Harper and Row, San Francisco, 1983

The Orion Mystery, Robert Bauval and Adrian Gilbert, Crown Publishers, NY, 1994

Paul: The Mind of the Apostle, A.N.Wilson, W.W.Norton and Co., NY,1997

The Principal Upanishads, edited by S. Radhakrishnan, George Allen & Unwin Ltd, London, 1978

The Prism of Lyra, An Exploration of Human Galactic Heritage, Lyssa Royal and Keith Priest, Royal/Priest Research, 1993

The Red Lion and the Elixir of Eternal Life, Maria Szepes, Horus Publishing, 1998

Reiki Fire, Frank Arjava Petter, Lotus Light Publications, Twin Lakes Wisconsin, 1997

The Return of the Serpents of Wisdom, Mark Amaru Pinkham, Adventures Unlimited Press, Kempton, Illinois, 1997

Rosicrucian Questions and Answers, with complete history, H. Spencer Lewis, AMORC Publishers, San Jose, CA, 1975

Sacred Geometry, Nigel Pennick, Harper and Row, San Francisco, 1980

Sacred Geometry, Philosophy and Practice, Robert Lawlor, Thames and Hudson, London, 1982

The Secret Doctrine, H.P. Blavatsky, The Theosophical Publishing House, NY, 1888

Secret of the Andes, Brother Phillip, Leaves of Grass Press, San Rafeal,

CA, 1976

The Secret Teachings Of All Ages, Manley Palmer Hall, Philospical Research Society, LA, 1975

A Separate God, Simone Petrement, HaperSanFrancisco, 1984

Shambhala, Nicholas Roerich, Nicholas Roerich Museum, NYC, 1985

Shiva and Dionysus, Alain Danielou, Inner Traditions International, NY, 1984

The Shrimad Bhagavatam, J.M.Sanyal, Munshiram Manoharlala Publishers, New Dehli, India, 1973

The Sirius Mystery, Robert Temple, St. Martin's Press, NY

The Sufis, Idries Shah, W.H. Allen Co., London, 1977

The Sumerians, Samuel Noah Kramer, University of Chicago Press, 1963

Survival among the Kurds, A History of the Yezidhi, John S. Guest, Kegan Paul International, NY, NY

The Travels of Marco Polo The Venetian, translated by William Marsden, Doubleday & Co. Garden City, NY, 1948

The Ultimate Frontier, Eklal Kueshana, The Adelphi Organization, Quilan, Texas, 1986

The Vishnu Purana, H.H.Wilson, Nag Publishers, Dehli, India, 1980

The Way to Shamballa, Edwin Bernbaum Phd., Jeremy Tarcher Inc., LA

The Wisdom of the Ancient ONE, An Inca Initiation, Anton Ponce de Leon Paiva, Bluestar Communications, Woodside, CA, 1995

The Woman's Dictionary of Symbols and Sacred Objects, Barbara G. Walker, Harper Collins, San Francisco, 1988

World Religions: From Ancient History to the Present, edited by Geoffrey Parrinder, Hamlyn Publishing Group, NY. 1983

Zoroastrianism, An introduction to an Ancient Faith, Peter Clarke, Sussex Academic Press, Brighton, England, 1998

The Author

Mark Amaru Pinkham is an author, teacher, spiritual tour leader, astrologer and shamanic practitioner. He is the author of ***The Return of the Serpents of Wisdom*** and ***Conversations with the Goddess***, two books which cover the history and teachings of the ancient Goddess Tradition and the branches of enlightened Masters it has engendered around the world.

Mark's spiritual journey began in 1976 when he traveled to India to live at the ashram of the meditation master Swami Muktananda. For the following seven years Mark lived in Muktananda's ashram's in India and America while practicing intensive yoga and meditation. After Muktananda's death, Mark was involved in intensive training of acupuncture and Chinese medicine, during which time he apprenticed a Chinese doctor and studied at a college at Harbin, China. Mark's life took another dramatic turn in 1993 when he and his wife, Andrea, traveled to Peru. This journey began a long relationship with the country and culminated in the founding of a tour company through which Mark and Andrea could lead others to Peru for spiritual experience. This company was eventually acquired by New Age Journeys, a national tour company through which Mark now leads spiritual tours to Peru, India, Nepal and Tibet, Egypt, Sedona, Az., and England.

In the past ten years Mark has become a disciple of Mata Amritanandamayi and visited her ashram in south India numerous times. Through her Mark has learned Bhakti Yoga, a branch of the Goddess Path. Mark has also been initiated into two Andean brotherhoods and spent three years apprenticing an Andean Shaman while undergoing intensive study on the path of San Pedro Shamanism.

In 2001 Mark moved to the southwest USA to revive the ancient Kumara School of Wisdom. At the vortexes of Sedona, Az. he now conducts shamanic ceremony and initiations which are designed to spiritually transform people and align them with the Masters of this very ancient school.

More about Mark can be found at **www.SerpentsOfWisdom.com**.

The symbol of The Kumara School of Wisdom, Paracas, Peru

The Kumara School of Wisdom

The Kumara School of Wisdom was founded by Sanat and Sananda Kumara, the Sons of God, on the legendary Pacific continent of Lemuria. When Lemuria sank to the bottom of the Pacific Ocean, branches of the school were established around the globe and collectively became known as the Great White Brotherhood.

Sanat and Sananda Kumara designed The Kumara School of Wisdom to be a vehicle through which humanity could evolve spiritually. It thus became a focus of such practices as yoga and meditation, alchemy, and mantra repetition. These practices culminate in the awakening of Kundalini, the evolutionary force which normally lies dormant at the base of the human spine.

The Kumaras also taught the path of love. They came from Venus, the planet of love, with the teachings of love. Their path of love, which includes service to others and chanting of the divine names, is the safest and surest path to Kundalini awakening and spiritual enlightenment.

The Kumara School of Wisdom is now being revived. Its practices and teachings are needed presently during Earth's rapid evolution. The school's headquarters are currently located in Boynton Canyon in Sedona, Arizona, a vortex area which was anciently home to a Lemurian temple city. The school also continues to exist within the Andes Mountains of Peru, as well as other places around the globe where branches of the school were founded by the ancient missionaries of The Kumara School of Wisdom.

Initiations into The Kumara School of Wisdom are currently being given in Sedona. They are also given at other power spots during Mark Amaru's tours. For a schedule of upcoming tours and initiations, check www.SerpentsOfWisdom.com and www.NewAgeJourneys.com.

Sacred Journeys
to Earth's Mystical Sites

Mark Amaru leads **Sacred Journeys** to the Earth's ancient temples and vortex sites in association with New Age Journeys. During these unique pilgrimages Mark Amaru lectures on the ancient mysteries, teaches yoga and meditation, and conducts rituals to connect with the natural, indigenous energies and with the Masters who reside there on other dimensions. Local shamen and teachers of each country join Mark to provide an experience which is both authentic and powerful.

Mark currently leads Sacred Journeys to **Egypt, England, India, Peru, and Tibet/Nepal**, as well as to **Sedona**, AZ and other sacred places in the southwest of the United States.

Mark Amaru and friend in Tibet

For complete itinerary information (with photos!), pricing, and secure on-line registration for **Sacred Journeys** with Mark Amaru, please visit **www.NewAgeJourneys.com** and **www.SerpentsOfWisdom.com**.

Astrology
Western and Vedic (Hindu)

Mark Amaru Pinkham is an astrologer with over 25 years of professional experience. His focus is principally spiritual, but he also looks at the mundane indications with in an astrology chart. Please choose from either the Western or Vedic Astrological Systems.

Western Astrology Options:

Natal Charts * Transits and Progressions * Composites
Synnastries * Relationship Readings * Solar Returns

Vedic Astrology Options:

Natal Charts * Transits and Progressions

The special features of Vedic Astrology include:

***The Dasas or Planetary Cycles of Life**
*** Rahu and Ketu, the Dragon's Head and Tail**
*** The Houses of Moksha, Spiritual Liberation**
*** Nakshatras, Lunar Signs**
*** Gems and Mantras**

Please contact Mark for an astrological reading
All readings are 1-11/2 hours in length and recorded on cassette tape.
Mark@SerpentsOfWisdom.com
800-231-9811

PHILOSOPHY & RELIGION

THE TRUTH BEHIND THE CHRIST MYTH
The Redemption of the Peacock Angel
by Mark Amaru Pinkham

Return of the Serpents of Wisdom author Pinkham tells us the Truth Behind the Christ Myth and presents radically new information regarding Jesus Christ and his ancient legend, including: The legend of Jesus Christ is based on a much earlier Son of God myth from India, the legend of Murrugan, the Peacock Angel; The symbol of the Catholic Church is Murrugan's symbol, the peacock, a bird native to southeast Asia; Murrugan evolved into the Persian Mithras, and Mithras evolved into Jesus Christ; Saint Paul came from Tarsus, the center of Mithras worship in Asia Minor. He amalgamated the legend of the Persian Son of God onto Jesus' life story; The Three Wise Men were Magi priests from Persia who believed that Jesus was an incarnation of Mithras; While in India, Saint Thomas became a peacock before he died and merged with Murrugan, the Peacock Angel; The myth of the One and Only Son of God originated with Murrugan and Mithras; The Peacock Angel is a historical figure who has been worshipped by many persons worldwide as The King of the World; Hitler, the Knights Templar, and the Illuminati sought to use the power of the Peacock Angel to conquer the world; more.
174 PAGES. 6X9 PAPERBACK. ILLUSTRATED. BIBLIOGRAPHY. $14.95. CODE: TBCM

CONVERSATIONS WITH THE GODDESS
by Mark Amaru Pinkham

Return of the Serpents of Wisdom author Pinkham tells us that "The Goddess is returning!" Pinkham gives us an alternative history of Lucifer, the ancient King of the World, and the Matriarchal Tradition he founded thousands of years ago. The name Lucifer means "Light Bringer" and he is the same as the Greek god Prometheus, and is different from Satan, who was based on the Egyptian god Set. Find out how the branches of the Matriarchy—the Secret Societies and Mystery Schools—were formed, and how they have been receiving assistance from the Brotherhoods on Sirius and Venus to evolve the world and overthrow the Patriarchy. Learn about the revival of the Goddess Tradition in the New Age and why the Goddess wants us all to reunite with Her now! An unusual book from an unusual writer!
296 PAGES. 7X10 PAPERBACK. ILLUSTRATED. BIBLIOGRAPHY. $14.95. CODE: CWTG.

RETURN OF THE SERPENTS OF WISDOM
by Mark Amaru Pinkham

According to ancient records, the patriarchs and founders of the early civilizations in Egypt, India, China, Peru, Mesopotamia, Britain, and the Americas were colonized by the Serpents of Wisdom—spiritual masters associated with the serpent—who arrived in these lands after abandoning their beloved homelands and crossing great seas. While bearing names denoting snake or dragon (such as Naga, Lung, Djedhi, Amaru, Quetzalcoatl, Adder, etc.), these Serpents of Wisdom oversaw the construction of magnificent civilizations within which they and their descendants served as the priest kings and as the enlightened heads of mystery school traditions. The Return of the Serpents of Wisdom recounts the history of these "Serpents"—where they came from, why they came, the secret wisdom they disseminated, and why they are returning now.
332 PAGES. 6X9 PAPERBACK. ILLUSTRATED. REFERENCES. $16.95. CODE: RSW

THE AQUARIAN GOSPEL OF JESUS THE CHRIST
Transcribed from the Akashic Records
by Levi

First published in 1908, this is the amazing story of Jesus, the man from Galilee, and how he attained the Christ consciousness open to all men. It includes a complete record of the "lost" 18 years of his life, a time on which the New Testament is strangely silent. During this period Jesus travelled widely in India, Tibet, Persia, Egypt and Greece, learning from the Masters, seers and wisemen of the East and the West in their temples and schools. Included is information on the Council of the Seven Sages of th World, Jesus with the Chinese Master Mencius (Meng Tzu) in Tibet, the ministry, trial, execution and resurrection of Jesus.
270 PAGES. 6X9 PAPERBACK. INDEX. $14.95. CODE: AGJC

THE BOOK OF ENOCH
The Prophet
translated by Richard Laurence

This is a reprint of the *Book of Enoch the Prophet* which was first discovered in Abyssinia in the year 1773 by a Scottish explorer named James Bruce. In 1821 *The Book of Enoch* was translated by Richard Laurence and published in a number of successive editions, culminating in the 1883 edition. One of the main influences from the book is its explanation of evil coming into the world with the arrival of the "fallen angels." Enoch acts as a scribe writing up a petition on behalf of these fallen angels, or fallen ones, to be given to a higher power for ultimate judgment. Christianity adopted some ideas from Enoch, including the Final Judgment, the concept of demons, the origins of evil and the fallen angels, and the coming of a Messiah and ultimately, a Messianic kingdom. The *Book of Enoch* was ultimately removed from the Bible and banned by the early church. Copies of it were found to have survived in Ethiopia, and fragments in Greece and Italy. Like the Dead Sea Scrolls and the Nag Hammadi Library, the *Book of Enoch* translated from the original Ethiopian Coptic script, is a rare resource that was suppressed by the early church and thought destroyed. Today it is back in print in this expanded, deluxe edition, using the original 1883 revised text.
224 PAGES. 6X9 PAPERBACK. ILLUSTRATED. INDEX. $16.95. CODE: BOE

THE CHRIST CONSPIRACY
The Greatest Story Ever Sold
by Acharya S.

In this highly controversial and explosive book, archaeologist, historian, mythologist and linguist Acharya S. marshals an enormous amount of startling evidence to demonstrate that Christianity and the story of Jesus Christ were created by members of various secret societies, mystery schools and religions in order to unify the Roman Empire under one state religion. In developing such a fabrication, this multinational cabal drew upon a multitude of myths and rituals that existed long before the Christian era, and reworked them for centuries into the religion passed down to us today. Contrary to popular belief there was no single man who was at the genesis of Christianity; Jesus was many characters rolled into one. These characters personified the ubiquitous solar myth, and their exploits were well known, as reflected by such popular deities as Mithras, Heracles/Hercules, Dionysos and many others throughout the Roman Empire and beyond. The story of Jesus as portrayed in the Gospels is revealed to be nearly identical in detail to that of the earlier savior-god Krishna and Horus, who for millennia preceding Christianity held great favor with the people.
256 PAGES. 6X9 PAPERBACK. ILLUSTRATED. $16.95. CODE: CHRC

PHILOSOPHY & RELIGION

THE STONES AND THE SCARLET THREAD
New Evidence from the Bible's Number Code, Stonehenge & the Great Pyramid
by Bonnie Gaunt

Researcher Bonnie Gaunt's latest work confirms the authenticity of the Bible's Number Code (Gematria). New evidence has been found linking its amazing pattern of numbers and its time prophecies with the sacred geometry of ancient stone structures such as Stonehenge and the Great Pyramid. In this, her ninth book, Gaunt builds on the research presented in her previous eight books, and brings to light new evidence that a Master Plan involving man and his future on planet earth has been in the process from the beginning. She shows, through the Number Code, that the Bible's ancient story of the scarlet thread has been intricately woven through the history and future of man. This exciting book will open new vistas of understanding and insight into the marvelous works of the Master Designer.

224 PAGES. 5X8 PAPERBACK. ILLUSTRATED. APPENDIX. $14.95. CODE: SST

THE BIBLE'S AWESOME NUMBER CODE!
by Bonnie Gaunt

Researcher Bonnie Gaunt continues her research on Gematria and Bible codes. In this book, Gaunt details a new discovery of the numeric patterns in the Gematria of the Bible and their relationship to the 3:4:5: triangle, and the earth, moon and sun. Using the Number Code, it is found that the parable of the Good Samaritan is, in fact, a time prophecy, telling the time of Jesus' return. His miracles of healing and of turning water into wine have been encoded with evidence of the time and the work of the beginning of the great "Third Day." The Number Code takes us on a journey from Bethlehem to Golgotha, and into the Kingdom of Jesus Christ, the Kingdom of God and the building of the New Jerusalem.

220 PAGES. 5X8 PAPERBACK. ILLUSTRATED. $14.95. CODE: BANC

BEGINNINGS
The Sacred Design
by Bonnie Gaunt

Bonnie Gaunt continues the line of research begun by John Michell into the geometric design of Stonehenge, the Great Pyramid and the Golden Proportions. Chapters in this book cover the following topics: the amazing number 144 and the numbers in the design of the New Jerusalem; the Great Pyramid, Stonehenge and Solomon's Temple display a common design that reveals the work of a Master Designer; the amazing location of Bethlehem; how the process of photosynthesis reveals the sacred design while transforming light into organic substance; how the Bible's number code (gematria) reveals a sacred design; more.

211 PAGES. 6X8 PAPERBACK. ILLUSTRATED. $14.95. CODE: BSD

JESUS CHRIST: THE NUMBER OF HIS NAME
The Amazine Number Code Found in the Bible
by Bonnie Gaunt

Gaunt says that the numerological code tells of the new Millennium and of a "Grand Octave of Time" for man. She demonstrates that the Bible's number code reveals amazing realities for today's world, and gives evidence of the year of the "second coming" of Jesus Christ. The book reveals amazing evidence that the code number for Jesus Christ has been planted in the geometry of the Earth, ancient megalithic buildings in Egypt, Britain and elsewhere, and in the Bible itself. Gaunt examines the mathematics of the Great Pyramid, Stonehenge, and the city of Bethlehem, which she says bears the number of Jesus in its latitude and longitude. Discover the hidden meaning to such number codes in the Bible as 666, 888, 864, 3168, and more.

197 PAGES. 6X9 PAPERBACK. ILLUSTRATED. BIBLIOGRAPHY. $14.95. CODE: JCNN

STONEHENGE AND THE GREAT PYRAMID
Window on the Universe
by Bonnie Gaunt

Mathematician and theologist Bonnie Gaunt's study on the Sacred Geometry of Stonehenge and the Great Pyramid. Through architecture, mathematics, geometry and the ancient science of "measuring," man can know the secrets of the Universe as encoded in these ancient structures. This is a fascinating study of the geometry and mathematics encompassed in these amazing megaliths as well as the prophecy beliefs surrounding the inner chambers of the Great Pyramid, the gematria of the Bible and how this translates into numbers which are also encoded within these structures. Interest is high in ancient Egypt at the moment, with attention focused on how old the Sphinx and Great Pyramid really are. Additionally, the current crop circle phenomenon is centered around Stonehenge.

216 PAGES. 6X8 PAPERBACK. ILLUSTRATED. $14.95. CODE: SAGP

THE COMING OF JESUS
The Real Message of the Bible Codes
by Bonnie Gaunt

Gaunt tells us the Codes of the Bible reveal a story that takes us on a magnificent journey through time, and into the amazing realities of today's world. It is exciting to find, encoded into the end-time prophecies, never before published evidence of a timeline for their fulfillment. Gaunt says that clues of this Golden Age to come can be found in the Great Pyramid, Stonehenge, the Bible, and other "ancient texts." Chapters in the book discuss: The Symbol Code and the symbol of the lamb; The Number Code and the ancient system of Gematria; The ELS Code (the amazing Equidistant Letter Sequence code) and the revealing of its message regarding the coming of Jesus; The Constellation Code and how the constellations combine with the number code and the ELS code; and more.

220 PAGES. 6X9 PAPERBACK. ILLUSTRATED. $14.95. CODE: COJ

STONEHENGE ...A CLOSER LOOK
by Bonnie Gaunt

Like the Great Pyramid, Stonehenge is steeped in mystery and is a masterwork in stone. Gaunt decodes the megaliths and tells not only of 4,000 years of history, but of the timeless forces of the universe and of the future of this planet.

236 PAGES. 6X8 PAPERBACK. ILLUSTRATED. $9.95. CODE: SCL

CONSPIRACY & HISTORY

THE HISTORY OF THE KNIGHTS TEMPLARS
The Temple Church and the Temple
by Charles G. Addison, introduction by David Hatcher Childress

Chapters on the origin of the Templars, their popularity in Europe and their rivalry with the Knights of St. John, later to be known as the Knights of Malta. Detailed information on the activities of the Templars in the Holy Land, and the 1312 AD suppression of the Templars in France and other countries, which culminated in the execution of Jacques de Molay and the continuation of the Knights Templars in England and Scotland; the formation of the society of Knights Templars in London; and the rebuilding of the Temple in 1816. Plus a lengthy intro about the lost Templar fleet and its connections to the ancient North American sea routes.
395 PAGES. 6X9 PAPERBACK. ILLUSTRATED. $16.95. CODE: HKT

ECCENTRIC LIVES AND PECULIAR NOTIONS
by John Michell

The first paperback edition of Michell's fascinating study of the lives and beliefs of over 20 eccentric people. Published in hardback by Thames & Hudson in London, *Eccentric Lives and Peculiar Notions* takes us into the bizarre and often humorous lives of such people as Lady Blount, who was sure that the earth is flat; Cyrus Teed, who believed that the earth is a hollow shell with us on the inside; Edward Hine, who believed that the British are the lost Tribes of Israel; and Baron de Guldenstubbe, who was sure that statues wrote him letters. British writer and housewife Nesta Webster devoted her life to exposing international conspiracies, and Father O'Callaghan devoted his to opposing interest on loans. The extraordinary characters in this book were—and in some cases still are—wholehearted enthusiasts for the various causes and outrageous notions they adopted, and John Michell describes their adventures with spirit and compassion. Some of them prospered and lived happily with their obsessions, while others failed dismally. We read, for example, of the hapless inventor of a giant battleship made of ice who died alone and neglected, and of the London couple who achieved peace and prosperity by drilling holes in their heads. Other chapters on the Last of the Welsh Druids; Congressman Ignacius Donnelly, the Great Heretic and Atlantis; Shakespearean Decoders and the Baconian Treasure Hunt; Early Ufologists; Jerusalem in Scotland; Bibliomaniacs; more.
248 PAGES. 6X9 PAPERBACK. ILLUSTRATED. $14.95. CODE: ELPN

ARKTOS
The Myth of the Pole in Science, Symbolism, and Nazi Survival
by Joscelyn Godwin

A scholarly treatment of catastrophes, ancient myths and the Nazi Occult beliefs. Explored are the many tales of an ancient race said to have lived in the Arctic regions, such as Thule and Hyperborea. Progressing onward, the book looks at modern polar legends including the survival of Hitler, German bases in Antarctica, UFOs, the hollow earth, Agartha and Shambala, more.
220 PAGES. 6X9 PAPERBACK. ILLUSTRATED. $16.95. CODE: ARK

DARK MOON
Apollo and the Whistleblowers
by Mary Bennett and David Percy

•Did you know a second craft was going to the Moon at the same time as Apollo 11?
•Do you know there are serious discrepancies in the account of the Apollo 13 'accident'?
•Did you know that 'live' color TV from the Moon was not actually live at all?
•Did you know that the Lunar Surface Camera had no viewfinder?
•Do you know that lighting was used in the Apollo photographs—yet no lighting equipment was taken to the Moon? All these questions, and more, are discussed in great detail by British researchers Bennett and Percy in *Dark Moon*, the definitive book (nearly 600 pages) on the possible faking of the Apollo Moon missions. Bennett and Percy delve into every possible aspect of this beguiling theory, one that rocks the very foundation of our beliefs concerning NASA and the space program. Tons of NASA photos analyzed for possible deceptions.
568 PAGES. 6X9 PAPERBACK. ILLUSTRATED. BIBLIOGRAPHY. INDEX. $25.00. CODE: DMO

THE DIMENSIONS OF PARADISE
The Proportions & Symbolic Numbers of Ancient Cosmology
by John Michell

The Dimensions of Paradise were known to ancient civilizations as the harmonious numerical standards that underlie the created world. John Michell's quest for these standards provides vital clues for understanding:
•the dimensions and symbolism of Stonehenge
•the plan of Atlantis and reason for its fall
•the numbers behind the sacred names of Christianity
•the form of St. John's vision of the New Jerusalem
•the name of the man with the number 666
•the foundation plan of Glastonbury and other sanctuaries
•and how these symbols suggest a potential for personal, cultural and political regeneration in the 21st century.
220 PAGES. 6X9 PAPERBACK. ILLUSTRATED. BIBLIOGRAPHY. INDEX. $16.95. CODE: DIMP

A HITCHHIKER'S GUIDE TO ARMAGEDDON
by David Hatcher Childress

With wit and humor, popular Lost Cities author David Hatcher Childress takes us around the world and back in his trippy finalé to the Lost Cities series. He sets off on an adventure in search of the apocalypse and end times. Childress hits the road from the fortress of Megiddo, the legendary citadel in northern Israel where Armageddon is prophesied to start. Hitchhiking around the world, Childress takes us from one adventure to another, to ancient cities in the deserts and the legends of worlds before our own. Childress muses on the rise and fall of civilizations, and the forces that have shaped mankind over the millennia, including wars, invasions and cataclysms. He discusses the ancient Armageddons of the past, and chronicles recent Middle East developments and their ominous undertones. In the meantime, he becomes a cargo cult god on a remote island off New Guinea, gets dragged into the Kennedy Assassination by one of the "conspirators," investigates a strange power operating out of the Altai Mountains of Mongolia, and discovers how the Knights Templar and their off shoots have driven the world toward an epic battle centered around Jerusalem and the Middle East.
320 PAGES. 6X9 PAPERBACK. ILLUSTRATED. BIBLIOGRAPHY. INDEX. $16.95. CODE: HGA

CONSPIRACY & HISTORY

LIQUID CONSPIRACY
JFK, LSD, the CIA, Area 51 & UFOs
by George Piccard

Underground author George Piccard on the politics of LSD, mind control, and Kennedy's involvement with Area 51 and UFOs. Reveals JFK's LSD experiences with Mary Pinchot-Meyer. The plot thickens with an ever expanding web of CIA involvement, from underground bases with UFOs seen by JFK and Marilyn Monroe (among others) to a vaster conspiracy that affects every government agency from NASA to the Justice Department. This may have been the reason that Marilyn Monroe and actress-columnist Dorothy Kilgallen were both murdered. Focusing on the bizarre side of history, *Liquid Conspiracy* takes the reader on a psychedelic tour de force. This is your government on drugs!

264 PAGES. 6X9 PAPERBACK. ILLUSTRATED. $14.95. CODE: LIQC

INSIDE THE GEMSTONE FILE
Howard Hughes, Onassis & JFK
by Kenn Thomas & David Hatcher Childress

Steamshovel Press editor Thomas takes on the Gemstone File in this run-up and run-down of the most famous underground document ever circulated. Photocopied and distributed for over 20 years, the Gemstone File is the story of Bruce Roberts, the inventor of the synthetic ruby widely used in laser technology today, and his relationship with the Howard Hughes Company and ultimately with Aristotle Onassis, the Mafia, and the CIA. Hughes kidnapped and held a drugged-up prisoner for 10 years; Onassis and his role in the Kennedy Assassination; how the Mafia ran corporate America in the 1960s; the death of Onassis' son in the crash of a small private plane in Greece; Onassis as Ian Fleming's archvillain Ernst Stavro Blofeld; more.

320 PAGES. 6X9 PAPERBACK. ILLUSTRATED. $16.00. CODE: IGF

THE ARCH CONSPIRATOR
Essays and Actions
by Len Bracken

Veteran conspiracy author Len Bracken's witty essays and articles lead us down the dark corridors of conspiracy, politics, murder and mayhem. In 12 chapters Bracken takes us through a maze of interwoven tales from the Russian Conspiracy (and a few "extra notes" on conspiracies) to his interview with Costa Rican novelist Joaquin Gutierrez and his Psychogeographic Map into the Third Millennium. Other chapters in the book are A General Theory of Civil War; A False Report Exposes the Dirty Truth About South African Intelligence Services; The New-Catiline Conspiracy for the Cancellation of Debt; Anti-Labor Day; 1997 with selected Aphorisms Against Work; Solar Economics; and more. Bracken's work has appeared in such pop-conspiracy publications as *Paranoia*, *Steamshovel Press* and the *Village Voice*. Len Bracken lives in Arlington, Virginia and haunts the dark alleys of Washington D.C., keeping an eye on the predators who run our country. With a gun to his head, he cranks out his rants for fringe publications and is the editor of *Extraphile*, described by *New Yorker Magazine* as "fusion conspiracy theory."

256 PAGES. 6X9 PAPERBACK. ILLUSTRATED. BIBLIOGRAPHY. $14.95. CODE: ACON.

MIND CONTROL, WORLD CONTROL
by Jim Keith

Veteran author and investigator Jim Keith uncovers a surprising amount of information on the technology, experimentation and implementation of mind control. Various chapters in this shocking book are on early CIA experiments such as Project Artichoke and Project R.H.I.C.-EDOM, the methodology and technology of implants, mind control assassins and couriers, various famous Mind Control victims such as Sirhan Sirhan and Candy Jones. Also featured in this book are chapters on how mind control technology may be linked to some UFO activity and "UFO abductions."

256 PAGES. 6X9 PAPERBACK. ILLUSTRATED. FOOTNOTES. $14.95. CODE: MCWC

NASA, NAZIS & JFK:
The Torbitt Document & the JFK Assassination
introduction by Kenn Thomas

This book emphasizes the links between "Operation Paper Clip" Nazi scientists working for NASA, the assassination of JFK, and the secret Nevada air base Area 51. The Torbitt Document also talks about the roles played in the assassination by Division Five of the FBI, the Defense Industrial Security Command (DISC), the Las Vegas mob, and the shadow corporate entities Permindex and Centro-Mondiale Commerciale. The Torbitt Document claims that the same players planned the 1962 assassination attempt on Charles de Gaul, who ultimately pulled out of NATO because he traced the "Assassination Cabal" to Permindex in Switzerland and to NATO headquarters in Brussels. The Torbitt Document paints a dark picture of NASA, the military industrial complex, and the connections to Mercury, Nevada which headquarters the "secret space program."

258 PAGES. 5X8. PAPERBACK. ILLUSTRATED. $16.00. CODE: NNJ

WHO KILLED DIANA?
by Peter Hounam and Derek McAdam

Hounam and McAdam take the reader through a land of unofficial branches of secret services, professional assassins, Psy-Ops, "Feather Men," remote-controlled cars, and ancient clandestine societies protecting the British establishment. They sort through a web of traceless drugs and poisons, inexplicable caches of money, fuzzy photographs, phantom cars of changing color, a large mysterious dog, and rivals in class and ethnic combat to answer the question, Who Killed Diana?! After this book was published, Mohammed El Fayed held an international news conference to announce that evidence showed that a blinding flash of light had contributed to the crash.

218 PAGES. 6X9 PAPERBACK. ILLUSTRATED. $12.95. CODE: WKD

MIND CONTROL, OSWALD & JFK:
Were We Controlled?
introduction by Kenn Thomas

Steamshovel Press editor Kenn Thomas examines the little-known book *Were We Controlled?*, first published in 1968. The book's author, the mysterious Lincoln Lawrence, maintained that Lee Harvey Oswald was a special agent who was a mind control subject, having received an implant in 1960 at a Russian hospital. Thomas examines the evidence for implant technology and the role it could have played in the Kennedy Assassination. Thomas also looks at the mind control aspects of the RFK assassination and details the history of implant technology. Looks at the case that the reporter Damon Runyon, Jr. was murdered because of this book.

256 PAGES. 6X9 PAPERBACK. ILLUSTRATED. NOTES. $16.00. CODE: MCOJ

STRANGE SCIENCE

UNDERGROUND BASES & TUNNELS
What is the Government Trying to Hide?
by Richard Sauder, Ph.D.
Working from government documents and corporate records, Sauder has compiled an impressive book that digs below the surface of the military's super-secret underground! Go behind the scenes into little-known corners of the public record and discover how corporate America has worked hand-in-glove with the Pentagon for decades, dreaming about, planning, and actually constructing, secret underground bases. This book includes chapters on the locations of the bases, the tunneling technology, various military designs for underground bases, nuclear testing & underground bases, abductions, needles & implants, military involvement in "alien" cattle mutilations, more. 50 page photo & map insert.
201 PAGES. 6x9 PAPERBACK. ILLUSTRATED. $15.95. CODE: UGB

UNDERWATER & UNDERGROUND BASES
Surprising Facts the Government Does Not Want You to Know
by Richard Sauder
Dr. Richard Sauder's brand new book *Underwater and Underground Bases* is an explosive, eye-opening sequel to his best-selling, *Underground Bases and Tunnels: What is the Government Trying to Hide?* Dr. Sauder lays out the amazing evidence and government paper trail for the construction of huge, manned bases offsore, in mid-ocean, and deep beneath the sea floor! Bases big enough to secretly dock submarines! Official United States Navy documents, and other hard evidence, raise many questions about what really lies 20,000 leagues beneath the sea. Many UFOs have been seen coming and going from the world's oceans, seas and lakes, implying the existence of secret underwater bases. Hold on to your hats: Jules Verne may not have been so far from the truth, after all! Dr. Sauder also adds to his incredible database of underground bases onshore. New, breakthrough material reveals the existence of additional clandestine underground facilities as well as the surprising location of one of the CIA's own underground bases. Plus, new information on tunneling and cutting-edge, high speed rail magnetic-levitation (MagLev) technology. There are many rumors of secret, underground tunnels with MagLev trains hurtling through them. Is there truth behind the rumors? *Underwater and Underground Bases* carefully examines the evidence and comes to a thought provoking conclusion!
264 PAGES. 6x9 PAPERBACK. ILLUSTRATED. BIBLIOGRAPHY. INDEX. $16.95. CODE: UUB

KUNDALINI TALES
by Richard Sauder, Ph.D.
Underground Bases and Tunnels author Richard Sauder's second book on his personal experiences and provocative research into spontaneous spiritual awakening, out-of-body journeys, encounters with secretive governmental powers, daylight sightings of UFOs, and more. Sauder continues his studies of underground bases with new information on the occult underpinnings of the U.S. space program. The book also contains a breakthrough section that examines actual U.S. patents for devices that manipulate minds and thoughts from a remote distance. Included are chapters on the secret space program and a 130-page appendix of patents and schematic diagrams of secret technology and mind control devices.
296 PAGES. 7x10 PAPERBACK. ILLUSTRATED. BIBLIOGRAPHY. $14.95. CODE: KTAL

QUEST FOR ZERO-POINT ENERGY
Engineering Principles for "Free Energy"
by Moray B. King
King expands, with diagrams, on how free energy and anti-gravity are possible. The theories of zero point energy maintain there are tremendous fluctuations of electrical field energy embedded within the fabric of space. King explains the following topics: Tapping the Zero-Point Energy as an Energy Source; Fundamentals of a Zero-Point Energy Technology; Vacuum Energy Vortices; The Super Tube; Charge Clusters: The Basis of Zero-Point Energy Inventions; Vortex Filaments, Torsion Fields and the Zero-Point Energy; Transforming the Planet with a Zero-Point Energy Experiment; Dual Vortex Forms: The Key to a Large Zero-Point Energy Coherence. Packed with diagrams, patents and photos. With power shortages now a daily reality in many parts of the world, this book offers a fresh approach very rarely mentioned in the mainstream media.
224 PAGES. 6x9 PAPERBACK. ILLUSTRATED. $14.95. CODE: QZPE

MAPS OF THE ANCIENT SEA KINGS
Evidence of Advanced Civilization in the Ice Age
by Charles H. Hapgood
Charles Hapgood's classic 1966 book on ancient maps produces concrete evidence of an advanced worldwide civilization existing many thousands of years before ancient Egypt. He has found the evidence in the Piri Reis Map that shows Antarctica, the Hadji Ahmed map, the Oronteus Finaeus and other amazing maps. Hapgood concluded that these maps were made from more ancient maps from the various ancient archives around the world, now lost. Not only were these unknown people more advanced in mapmaking than any people prior to the 18th century, it appears they mapped all the continents. The Americas were mapped thousands of years before Columbus. Antarctica was mapped when its coasts were free of ice.
316 PAGES. 7x10 PAPERBACK. ILLUSTRATED. BIBLIOGRAPHY & INDEX. $19.95. CODE: MASK

PATH OF THE POLE
Cataclysmic Pole Shift Geology
by Charles Hapgood
Maps of the Ancient Sea Kings author Hapgood's classic book *Path of the Pole* is back in print! Hapgood researched Antarctica, ancient maps and the geological record to conclude that the Earth's crust has slipped in the inner core many times in the past, changing the position of the pole. *Path of the Pole* discusses the various "pole shifts" in Earth's past, giving evidence for each one, and moves on to possible future pole shifts. Packed with illustrations, this is the sourcebook for many other books on cataclysms and pole shifts.
356 PAGES. 6x9 PAPERBACK. ILLUSTRATED. $16.95. CODE: POP.

TESLA TECHNOLOGY

THE FANTASTIC INVENTIONS OF NIKOLA TESLA
Nikola Tesla with additional material by David Hatcher Childress

This book is a readable compendium of patents, diagrams, photos and explanations of the many incredible inventions of the originator of the modern era of electrification. In Tesla's own words are such topics as wireless transmission of power, death rays, and radio-controlled airships. In addition, rare material on German bases in Antarctica and South America, and a secret city built at a remote jungle site in South America by one of Tesla's students, Guglielmo Marconi. Marconi's secret group claims to have built flying saucers in the 1940s and to have gone to Mars in the early 1950s! Incredible photos of these Tesla craft are included. The Ancient Atlantean system of broadcasting energy through a grid system of obelisks and pyramids is discussed, and a fascinating concept comes out of one chapter: that Egyptian engineers had to wear protective metal head-shields while in these power plants, hence the Egyptian Pharoah's head covering as well as the Face on Mars!
•His plan to transmit free electricity into the atmosphere. •How electrical devices would work using only small antennas mounted on them. •Why unlimited power could be utilized anywhere on earth. •How radio and radar technology can be used as death-ray weapons in Star Wars. •Includes an appendix of Supreme Court documents on dismantling his free energy towers. •Tesla's Death Rays, Ozone generators, and more...
342 PAGES. 6x9 PAPERBACK. ILLUSTRATED. BIBLIOGRAPHY AND APPENDIX. $16.95. CODE: FINT

THE TESLA PAPERS
Nikola Tesla on Free Energy & Wireless Transmission of Power
by Nikola Tesla, edited by David Hatcher Childress

In the tradition of *The Fantastic Inventions of Nikola Tesla, The Anti-Gravity Handbook* and *The Free-Energy Device Handbook*, science and UFO author David Hatcher Childress takes us into the incredible world of Nikola Tesla and his amazing inventions. Tesla's rare article "The Problem of Increasing Human Energy with Special Reference to the Harnessing of the Sun's Energy" is included. This lengthy article was originally published in the June 1900 issue of *The Century Illustrated Monthly Magazine* and it was the outline for Tesla's master blueprint for the world. Tesla's fantastic vision of the future, including wireless power, anti-gravity, free energy and highly advanced solar power.
Also included are some of the papers, patents and material collected on Tesla at the Colorado Springs Tesla Symposiums, including papers on:
•The Secret History of Wireless Transmission •Tesla and the Magnifying Transmitter
•Design and Construction of a half-wave Tesla Coil •Electrostatics: A Key to Free Energy
•Progress in Zero-Point Energy Research •Electromagnetic Energy from Antennas to Atoms
•Tesla's Particle Beam Technology •Fundamental Excitatory Modes of the Earth-Ionosphere Cavity
325 PAGES. 8x10 PAPERBACK. ILLUSTRATED. $16.95. CODE: TTP

LOST SCIENCE
by Gerry Vassilatos

Secrets of Cold War Technology author Vassilatos on the remarkable lives, astounding discoveries, and incredible inventions of such famous people as Nikola Tesla, Dr. Royal Rife, T.T. Brown, and T. Henry Moray. Read about the aura research of Baron Karl von Reichenbach, the wireless technology of Antonio Meucci, the controlled fusion devices of Philo Farnsworth, the earth battery of Nathan Stubblefield, and more. What were the twisted intrigues which surrounded the often deliberate attempts to stop this technology? Vassilatos claims that we are living hundreds of years behind our intended level of technology and we must recapture this "lost science."
304 PAGES. 6x9 PAPERBACK. ILLUSTRATED. BIBLIOGRAPHY. $16.95. CODE: LOS

SECRETS OF COLD WAR TECHNOLOGY
Project HAARP and Beyond
by Gerry Vassilatos

Vassilatos reveals that "Death Ray" technology has been secretly researched and developed since the turn of the century. Included are chapters on such inventors and their devices as H.C. Vion, the developer of auroral energy receivers; Dr. Selim Lemstrom's pre-Tesla experiments; the early beam weapons of Grindell-Mathews, Ulivi, Turpain and others; John Hettenger and his early beam power systems. Learn about Project Argus, Project Teak and Project Orange; EMP experiments in the 60s; why the Air Force directed the construction of a huge Ionospheric "backscatter" telemetry system across the Pacific just after WWII; why Raytheon has collected every patent relevant to HAARP over the past few years; more.
250 PAGES. 6x9 PAPERBACK. ILLUSTRATED. $15.95. CODE: SCWT

HAARP
The Ultimate Weapon of the Conspiracy
by Jerry Smith

The HAARP project in Alaska is one of the most controversial projects ever undertaken by the U.S. Government. Jerry Smith gives us the history of the HAARP project and explains how works, in technically correct yet easy to understand language. At best, HAARP is science out-of-control; at worst, HAARP could be the most dangerous device ever created, a futuristic technology that is everything from super-beam weapon to world-wide mind control device. Topics include Over-the-Horizon Radar and HAARP, Mind Control, ELF and HAARP, The Telsa Connection, The Russian Woodpecker, GWEN & HAARP, Earth Penetrating Tomography, Weather Modification, Secret Science of the Conspiracy, more. Includes the complete 1987 Eastlund patent for his pulsed super-weapon that he claims was stolen by the HAARP Project.
256 PAGES. 6x9 PAPERBACK. ILLUSTRATED. $14.95. CODE: HARP

THE TIME TRAVEL HANDBOOK
A Manual of Practical Teleportation & Time Travel
edited by David Hatcher Childress

In the tradition of *The Anti-Gravity Handbook* and *The Free-Energy Device Handbook*, science and UFO author David Hatcher Childress takes us into the weird world of time travel and teleportation. Not just a whacked-out look at science fiction, this book is an authoritative chronicling of real-life time travel experiments, teleportation devices and more. *The Time Travel Handbook* takes the reader beyond the government experiments and deep into the uncharted territory of early time travellers such as Nikola Tesla and Guglielmo Marconi and their alleged time travel experiments, as well as the Wilson Brothers of EMI and their connection to the Philadelphia Experiment—the U.S. Navy's forays into invisibility, time travel, and teleportation. Childress looks into the claims of time travelling individuals, and investigates the unusual claim that the pyramids on Mars were built in the future and sent back in time. A highly visual, large format book, with patents, photos and schematics. Be the first on your block to build your own time travel device!
316 PAGES. 7x10 PAPERBACK. ILLUSTRATED. $16.95. CODE: TTH

ANTI-GRAVITY

THE FREE-ENERGY DEVICE HANDBOOK
A Compilation of Patents and Reports
by David Hatcher Childress

A large-format compilation of various patents, papers, descriptions and diagrams concerning free-energy devices and systems. *The Free-Energy Device Handbook* is a visual tool for experimenters and researchers into magnetic motors and other "over-unity" devices. With chapters on the Adams Motor, the Hans Coler Generator, cold fusion, superconductors, "N" machines, space-energy generators, Nikola Tesla, T. Townsend Brown, and the latest in free-energy devices. Packed with photos, technical diagrams, patents and fascinating information, this book belongs on every science shelf. With energy and profit being a major political reason for fighting various wars, free-energy devices, if ever allowed to be mass distributed to consumers, could change the world! Get your copy now before the Department of Energy bans this book!
292 PAGES. 8X10 PAPERBACK. ILLUSTRATED. BIBLIOGRAPHY. $16.95. CODE: FEH

THE ANTI-GRAVITY HANDBOOK
edited by David Hatcher Childress, with Nikola Tesla, T.B. Paulicki, Bruce Cathie, Albert Einstein and others

The new expanded compilation of material on Anti-Gravity, Free Energy, Flying Saucer Propulsion, UFOs, Suppressed Technology, NASA Cover-ups and more. Highly illustrated with patents, technical illustrations and photos. This revised and expanded edition has more material, including photos of Area 51, Nevada, the government's secret testing facility. This classic on weird science is back in a 90s format!
• **How to build a flying saucer.**
•**Arthur C. Clarke on Anti-Gravity.**
• **Crystals and their role in levitation.**
• **Secret government research and development.**
• **Nikola Tesla on how anti-gravity airships could draw power from the atmosphere.**
• **Bruce Cathie's Anti-Gravity Equation.**
• **NASA, the Moon and Anti-Gravity.**
230 PAGES. 7X10 PAPERBACK. BIBLIOGRAPHY/INDEX/APPENDIX. HIGHLY ILLUSTRATED. $14.95. CODE: AGH

ANTI–GRAVITY & THE WORLD GRID
Is the earth surrounded by an intricate electromagnetic grid network offering free energy? This compilation of material on ley lines and world power points contains chapters on the geography, mathematics, and light harmonics of the earth grid. Learn the purpose of ley lines and ancient megalithic structures located on the grid. Discover how the grid made the Philadelphia Experiment possible. Explore the Coral Castle and many other mysteries, including acoustic levitation, Tesla Shields and scalar wave weaponry. Browse through the section on anti-gravity patents, and research resources.
274 PAGES. 7X10 PAPERBACK. ILLUSTRATED. $14.95. CODE: AGW

ANTI–GRAVITY & THE UNIFIED FIELD
edited by David Hatcher Childress

Is Einstein's Unified Field Theory the answer to all of our energy problems? Explored in this compilation of material is how gravity, electricity and magnetism manifest from a unified field around us. Why artificial gravity is possible; secrets of UFO propulsion; free energy; Nikola Tesla and anti-gravity airships of the 20s and 30s; flying saucers as superconducting whirls of plasma; anti-mass generators; vortex propulsion; suppressed technology; government cover-ups; gravitational pulse drive; spacecraft & more.
240 PAGES. 7X10 PAPERBACK. ILLUSTRATED. $14.95. CODE: AGU

ETHER TECHNOLOGY
A Rational Approach to Gravity Control
by Rho Sigma

This classic book on anti-gravity and free energy is back in print and back in stock. Written by a well-known American scientist under the pseudonym of "Rho Sigma," this book delves into international efforts at gravity control and discoid craft propulsion. Before the Quantum Field, there was "Ether." This small, but informative book has chapters on John Searle and "Searle discs;" T. Townsend Brown and his work on anti-gravity and ether-vortex turbines. Includes a forward by former NASA astronaut Edgar Mitchell.
108 PAGES. 6X9 PAPERBACK. ILLUSTRATED. $12.95. CODE: ETT

TAPPING THE ZERO POINT ENERGY
Free Energy & Anti-Gravity in Today's Physics
by Moray B. King

King explains how free energy and anti-gravity are possible. The theories of the zero point energy maintain there are tremendous fluctuations of electrical field energy imbedded within the fabric of space. This book tells how, in the 1930s, inventor T. Henry Moray could produce a fifty kilowatt "free energy" machine; how an electrified plasma vortex creates anti-gravity; how the Pons/Fleischmann "cold fusion" experiment could produce tremendous heat without fusion; and how certain experiments might produce a gravitational anomaly.
170 PAGES. 5X8 PAPERBACK. ILLUSTRATED. $9.95. CODE: TAP

24 hour credit card orders—call: 815-253-6390 fax: 815-253-6300
email: auphq@frontiernet.net www.adventuresunlimitedpress.com www.wexclub.com

ANTI-GRAVITY

COSMIC MATRIX
Piece for a Jig-Saw, Part Two
by Leonard G. Cramp

Leonard G. Cramp, a British aerospace engineer, wrote his first book *Space Gravity and the Flying Saucer* in 1954. Cosmic Matrix is the long-awaited sequel to his 1966 book *UFOs & Anti-Gravity: Piece for a Jig-Saw*. Cramp has had a long history of examining UFO phenomena and has concluded that UFOs use the highest possible aeronautic science to move in the way they do. Cramp examines anti-gravity effects and theorizes that this super-science used by the craft—described in detail in the book—can lift mankind into a new level of technology, transportation and understanding of the universe. The book takes a close look at gravity control, time travel, and the interlocking web of energy between all planets in our solar system with Leonard's unique technical diagrams. A fantastic voyage into the present and future!
364 PAGES. 6X9 PAPERBACK. ILLUSTRATED. BIBLIOGRAPHY. $16.00. CODE: CMX

UFOS AND ANTI-GRAVITY
Piece For A Jig-Saw
by Leonard G. Cramp

Leonard G. Cramp's 1966 classic book on flying saucer propulsion and suppressed technology is a highly technical look at the UFO phenomena by a trained scientist. Cramp first introduces the idea of 'anti-gravity' and introduces us to the various theories of gravitation. He then examines the technology necessary to build a flying saucer and examines in great detail the technical aspects of such a craft. Cramp's book is a wealth of material and diagrams on flying saucers, anti-gravity, suppressed technology, G-fields and UFOs. Chapters include Crossroads of Aerodymanics, Aerodynamic Saucers, Limitations of Rocketry, Gravitation and the Ether, Gravitational Spaceships, G-Field Lift Effects, The Bi-Field Theory, VTOL and Hovercraft, Analysis of UFO photos, more.
388 PAGES. 6X9 PAPERBACK. ILLUSTRATED. $16.95. CODE: UAG

THE HARMONIC CONQUEST OF SPACE
by Captain Bruce Cathie

Chapters include: Mathematics of the World Grid; the Harmonics of Hiroshima and Nagasaki; Harmonic Transmission and Receiving; the Link Between Human Brain Waves; the Cavity Resonance between the Earth; the Ionosphere and Gravity; Edgar Cayce—the Harmonics of the Subconscious; Stonehenge; the Harmonics of the Moon; the Pyramids of Mars; Nikola Tesla's Electric Car; the Robert Adams Pulsed Electric Motor Generator; Harmonic Clues to the Unified Field; and more. Also included are tables showing the harmonic relations between the earth's magnetic field, the speed of light, and anti-gravity/gravity acceleration at different points on the earth's surface. New chapters in this edition on the giant stone spheres of Costa Rica, Atomic Tests and Volcanic Activity, and a chapter on Ayers Rock analysed with Stone Mountain, Georgia.
248 PAGES. 6X9. PAPERBACK. ILLUSTRATED. BIBLIOGRAPHY. $16.95. CODE: HCS

THE ENERGY GRID
Harmonic 695, The Pulse of the Universe
by Captain Bruce Cathie.

This is the breakthrough book that explores the incredible potential of the Energy Grid and the Earth's Unified Field all around us. Cathie's first book, *Harmonic 33*, was published in 1968 when he was a commercial pilot in New Zealand. Since then, Captain Bruce Cathie has been the premier investigator into the amazing potential of the infinite energy that surrounds our planet every microsecond. Cathie investigates the Harmonics of Light and how the Energy Grid is created. In this amazing book are chapters on UFO Propulsion, Nikola Tesla, Unified Equations, the Mysterious Aerials, Pythagoras & the Grid, Nuclear Detonation and the Grid, Maps of the Ancients, an Australian Stonehenge examined, more.
255 PAGES. 6X9 TRADEPAPER. ILLUSTRATED. $15.95. CODE: TEG

THE BRIDGE TO INFINITY
Harmonic 371244
by Captain Bruce Cathie

Cathie has popularized the concept that the earth is crisscrossed by an electromagnetic grid system that can be used for anti-gravity, free energy, levitation and more. The book includes a new analysis of the harmonic nature of reality, acoustic levitation, pyramid power, harmonic receiver towers and UFO propulsion. It concludes that today's scientists have at their command a fantastic store of knowledge with which to advance the welfare of the human race.
204 PAGES. 6X9 TRADEPAPER. ILLUSTRATED. $14.95. CODE: BTF

MAN-MADE UFOS 1944—1994
Fifty Years of Suppression
by Renato Vesco & David Hatcher Childress

A comprehensive look at the early "flying saucer" technology of Nazi Germany and the genesis of man-made UFOs. This book takes us from the work of captured German scientists to escaped battalions of Germans, secret communities in South America and Antarctica to todays state-of-the-art "Dreamland" flying machines. Heavily illustrated, this astonishing book blows the lid off the "government UFO conspiracy" and explains with technical diagrams the technology involved. Examined in detail are secret underground airfields and factories; German secret weapons; "suction" aircraft; the origin of NASA; gyroscopic stabilizers and engines; the secret Marconi aircraft factory in South America; and more. Introduction by W.A. Harbinson, author of the Dell novels *GENESIS* and *REVELATION*.
318 PAGES. 6X9 PAPERBACK. ILLUSTRATED. INDEX & FOOTNOTES. $18.95. CODE: MMU

FREE ENERGY SYSTEMS

LOST SCIENCE
by Gerry Vassilatos
Rediscover the legendary names of suppressed scientific revolution—remarkable lives, astounding discoveries, and incredible inventions which would have produced a world of wonder. How did the aura research of Baron Karl von Reichenbach prove the vitalistic theory and frighten the greatest minds of Germany? How did the physiophone and wireless of Antonio Meucci predate both Bell and Marconi by decades? How does the earth battery technology of Nathan Stubblefield portend an unsuspected energy revolution? How did the geoaetheric engines of Nikola Tesla threaten the establishment of a fuel-dependent America? The microscopes and virus-destroying ray machines of Dr. Royal Rife provided the solution for every world-threatening disease. Why did the FDA and AMA together condemn this great man to Federal Prison? The static crashes on telephone lines enabled Dr. T. Henry Moray to discover the reality of radiant space energy. Was the mysterious "Swedish stone," the powerful mineral which Dr. Moray discovered, the very first historical instance in which stellar power was recognized and secured on earth? Why did the Air Force initially fund the gravitational warp research and warp-cloaking devices of T. Townsend Brown and then reject it? When the controlled fusion devices of Philo Farnsworth achieved the "break-even" point in 1967 the FUSOR project was abruptly cancelled by ITT.
304 PAGES. 6x9 PAPERBACK. ILLUSTRATED. BIBLIOGRAPHY. $16.95. CODE: LOS

SECRETS OF COLD WAR TECHNOLOGY
Project HAARP and Beyond
by Gerry Vassilatos
Vassilatos reveals that "Death Ray" technology has been secretly researched and developed since the turn of the century. Included are chapters on such inventors and their devices as H.C. Vion, the developer of auroral energy receivers; Dr. Selim Lemstrom's pre-Tesla experiments; the early beam weapons of Grindell-Mathews, Ulivi, Turpain and others; John Hettenger and his early beam power systems. Learn about Project Argus, Project Teak and Project Orange; EMP experiments in the 60s; why the Air Force directed the construction of a huge Ionospheric "backscatter" telemetry system across the Pacific just after WWII; why Raytheon has collected every patent relevant to HAARP over the past few years; more.
250 PAGES. 6x9 PAPERBACK. ILLUSTRATED. $15.95. CODE: SCWT

THE TIME TRAVEL HANDBOOK
A Manual of Practical Teleportation & Time Travel
edited by David Hatcher Childress
In the tradition of *The Anti-Gravity Handbook* and *The Free-Energy Device Handbook*, science and UFO author David Hatcher Childress takes us into the weird world of time travel and teleportation. Not just a whacked-out look at science fiction, this book is an authoritative chronicling of real-life time travel experiments, teleportation devices and more. *The Time Travel Handbook* takes the reader beyond the government experiments and deep into the uncharted territory of early time travellers such as Nikola Tesla and Guglielmo Marconi and their alleged time travel experiments, as well as the Wilson Brothers of EMI and their connection to the Philadelphia Experiment—the U.S. Navy's forays into invisibility, time travel, and teleportation. Childress looks into the claims of time travelling individuals, and investigates the unusual claim that the pyramids on Mars were built in the future and sent back in time. A highly visual, large format book, with patents, photos and schematics. Be the first on your block to build your own time travel device!
316 PAGES. 7x10 PAPERBACK. ILLUSTRATED. $16.95. CODE: TTH

THE TESLA PAPERS
Nikola Tesla on Free Energy & Wireless Transmission of Power
by Nikola Tesla, edited by David Hatcher Childress
David Hatcher Childress takes us into the incredible world of Nikola Tesla and his amazing inventions. Tesla's rare article "The Problem of Increasing Human Energy with Special Reference to the Harnessing of the Sun's Energy" is included. This lengthy article was originally published in the June 1900 issue of *The Century Illustrated Monthly Magazine* and it was the outline for Tesla's master blueprint for the world. Tesla's fantastic vision of the future, including wireless power, anti-gravity, free energy and highly advanced solar power. Also included are some of the papers, patents and material collected on Tesla at the Colorado Springs Tesla Symposiums, including papers on: •The Secret History of Wireless Transmission •Tesla and the Magnifying Transmitter •Design and Construction of a Half-Wave Tesla Coil •Electrostatics: A Key to Free Energy •Progress in Zero-Point Energy Research •Electromagnetic Energy from Antennas to Atoms •Tesla's Particle Beam Technology •Fundamental Excitatory Modes of the Earth-Ionosphere Cavity
325 PAGES. 8x10 PAPERBACK. ILLUSTRATED. $16.95. CODE: TTP

THE FANTASTIC INVENTIONS OF NIKOLA TESLA
by Nikola Tesla with additional material by David Hatcher Childress
This book is a readable compendium of patents, diagrams, photos and explanations of the many incredible inventions of the originator of the modern era of electrification. In Tesla's own words are such topics as wireless transmission of power, death rays, and radio-controlled airships. In addition, rare material on German bases in Antarctica and South America, and a secret city built at a remote jungle site in South America by one of Tesla's students, Guglielmo Marconi. Marconi's secret group claims to have built flying saucers in the 1940s and to have gone to Mars in the early 1950s! Incredible photos of these Tesla craft are included. The Ancient Atlantean system of broadcasting energy through a grid system of obelisks and pyramids is discussed, and a fascinating concept comes out of one chapter: that Egyptian engineers had to wear protective metal head-shields while in these power plants, hence the Egyptian Pharoah's head covering as well as the Face on Mars! •His plan to transmit free electricity into the atmosphere. •How electrical devices would work using only small antennas. •Why unlimited power could be utilized anywhere on earth. •How radio and radar technology can be used as death-ray weapons in Star Wars.
342 PAGES. 6x9 PAPERBACK. ILLUSTRATED. $16.95. CODE: FINT

LOST CITIES

LOST CITIES OF ATLANTIS, ANCIENT EUROPE & THE MEDITERRANEAN
by David Hatcher Childress
Atlantis! The legendary lost continent comes under the close scrutiny of maverick archaeologist David Hatcher Childress in this sixth book in the internationally popular *Lost Cities* series. Childress takes the reader in search of sunken cities in the Mediterranean; across the Atlas Mountains in search of Atlantean ruins; to remote islands in search of megalithic ruins; to meet living legends and secret societies. From Ireland to Turkey, Morocco to Eastern Europe, and around the remote islands of the Mediterranean and Atlantic, Childress takes the reader on an astonishing quest for mankind's past. Ancient technology, cataclysms, megalithic construction, lost civilizations and devastating wars of the past are all explored in this book. Childress challenges the skeptics and proves that great civilizations not only existed in the past, but the modern world and its problems are reflections of the ancient world of Atlantis.
524 PAGES. 6X9 PAPERBACK. ILLUSTRATED WITH 100S OF MAPS, PHOTOS AND DIAGRAMS. BIBLIOGRAPHY & INDEX. $16.95. CODE: MED

LOST CITIES OF CHINA, CENTRAL INDIA & ASIA
by David Hatcher Childress
Like a real life "Indiana Jones," maverick archaeologist David Childress takes the reader on an incredible adventure across some of the world's oldest and most remote countries in search of lost cities and ancient mysteries. Discover ancient cities in the Gobi Desert; hear fantastic tales of lost continents, vanished civilizations and secret societies bent on ruling the world; visit forgotten monasteries in forbidding snow-capped mountains with strange tunnels to mysterious subterranean cities! A unique combination of far-out exploration and practical travel advice, it will astound and delight the experienced traveler or the armchair voyager.
429 PAGES. 6X9 PAPERBACK. ILLUSTRATED. FOOTNOTES & BIBLIOGRAPHY. $14.95. CODE: CHI

LOST CITIES OF ANCIENT LEMURIA & THE PACIFIC
by David Hatcher Childress
Was there once a continent in the Pacific? Called Lemuria or Pacifica by geologists, Mu or Pan by the mystics, there is now ample mythological, geological and archaeological evidence to "prove" that an advanced and ancient civilization once lived in the central Pacific. Maverick archaeologist and explorer David Hatcher Childress combs the Indian Ocean, Australia and the Pacific in search of the surprising truth about mankind's past. Contains photos of the underwater city on Pohnpei; explanations on how the statues were levitated around Easter Island in a clockwise vortex movement; tales of disappearing islands; Egyptians in Australia; and more.
379 PAGES. 6X9 PAPERBACK. ILLUSTRATED. FOOTNOTES & BIBLIOGRAPHY. $14.95. CODE: LEM

ANCIENT TONGA
& the Lost City of Mu'a
by David Hatcher Childress
Lost Cities series author Childress takes us to the south sea islands of Tonga, Rarotonga, Samoa and Fiji to investigate the megalithic ruins on these beautiful islands. The great empire of the Polynesians, centered on Tonga and the ancient city of Mu'a, is revealed with old photos, drawings and maps. Chapters in this book are on the Lost City of Mu'a and its many megalithic pyramids, the Ha'amonga Trilithon and ancient Polynesian astronomy, Samoa and the search for the lost land of Havai'iki, Fiji and its wars with Tonga, Rarotonga's megalithic road, and Polynesian cosmology. Material on Egyptians in the Pacific, earth changes, the fortified moat around Mu'a, lost roads, more.
218 PAGES. 6X9 PAPERBACK. ILLUSTRATED. COLOR PHOTOS. BIBLIOGRAPHY. $15.95. CODE: TONG

ANCIENT MICRONESIA
& the Lost City of Nan Madol
by David Hatcher Childress
Micronesia, a vast archipelago of islands west of Hawaii and south of Japan, contains some of the most amazing megalithic ruins in the world. Part of our *Lost Cities* series, this volume explores the incredible conformations on various Micronesian islands, especially the fantastic and little-known ruins of Nan Madol on Pohnpei Island. The huge canal city of Nan Madol contains over 250 million tons of basalt columns over an 11 square-mile area of artificial islands. Much of the huge city is submerged, and underwater structures can be found to an estimated 80 feet. Islanders' legends claim that the basalt rocks, weighing up to 50 tons, were magically levitated into place by the powerful forefathers. Other ruins in Micronesia that are profiled include the Latte Stones of the Marianas, the menhirs of Palau, the megalithic canal city on Kosrae Island, megaliths on Guam, and more.
256 PAGES. 6X9 PAPERBACK. ILLUSTRATED. COLOR PHOTOS. BIBLIOGRAPHY. $16.95. CODE: AMIC

LOST CITIES

TECHNOLOGY OF THE GODS
The Incredible Sciences of the Ancients
by David Hatcher Childress
Popular *Lost Cities* author David Hatcher Childress takes us into the amazing world of ancient technology, from computers in antiquity to the "flying machines of the gods." Childress looks at the technology that was allegedly used in Atlantis and the theory that the Great Pyramid of Egypt was originally a gigantic power station. He examines tales of ancient flight and the technology that it involved; how the ancients used electricity; megalithic building techniques; the use of crystal lenses and the fire from the gods; evidence of various high tech weapons in the past, including atomic weapons; ancient metallurgy and heavy machinery; the role of modern inventors such as Nikola Tesla in bringing ancient technology back into modern use; impossible artifacts; and more.

356 PAGES. 6x9 PAPERBACK. ILLUSTRATED. BIBLIOGRAPHY. $16.95. CODE: TGOD

VIMANA AIRCRAFT OF ANCIENT INDIA & ATLANTIS
by David Hatcher Childress, introduction by Ivan T. Sanderson
Did the ancients have the technology of flight? In this incredible volume on ancient India, authentic Indian texts such as the *Ramayana* and the *Mahabharata* are used to prove that ancient aircraft were in use more than four thousand years ago. Included in this book is the entire Fourth Century BC manuscript *Vimaanika Shastra* by the ancient author Maharishi Bharadwaaja, translated into English by the Mysore Sanskrit professor G.R. Josyer. Also included are chapters on Atlantean technology, the incredible Rama Empire of India and the devastating wars that destroyed it. Also an entire chapter on mercury vortex propulsion and mercury gyros, the power source described in the ancient Indian texts. Not to be missed by those interested in ancient civilizations or the UFO enigma.

334 PAGES. 6x9 PAPERBACK. ILLUSTRATED. $15.95. CODE: VAA

LOST CONTINENTS & THE HOLLOW EARTH
I Remember Lemuria and the Shaver Mystery
by David Hatcher Childress & Richard Shaver
Lost Continents & the Hollow Earth is Childress' thorough examination of the early hollow earth stories of Richard Shaver and the fascination that fringe fantasy subjects such as lost continents and the hollow earth have had for the American public. Shaver's rare 1948 book *I Remember Lemuria* is reprinted in its entirety, and the book is packed with illustrations from Ray Palmer's *Amazing Stories* magazine of the 1940s. Palmer and Shaver told of tunnels running through the earth—tunnels inhabited by the Deros and Teros, humanoids from an ancient spacefaring race that had inhabited the earth, eventually going underground, hundreds of thousands of years ago. Childress discusses the famous hollow earth books and delves deep into whatever reality may be behind the stories of tunnels in the earth. Operation High Jump to Antarctica in 1947 and Admiral Byrd's bizarre statements, tunnel systems in South America and Tibet, the underground world of Agartha, the belief of UFOs coming from the South Pole, more.

344 PAGES. 6x9 PAPERBACK. ILLUSTRATED. $16.95. CODE: LCHE

LOST CITIES OF NORTH & CENTRAL AMERICA
by David Hatcher Childress
Down the back roads from coast to coast, maverick archaeologist and adventurer David Hatcher Childress goes deep into unknown America. With this incredible book, you will search for lost Mayan cities and books of gold, discover an ancient canal system in Arizona, climb gigantic pyramids in the Midwest, explore megalithic monuments in New England, and join the astonishing quest for lost cities throughout North America. From the war-torn jungles of Guatemala, Nicaragua and Honduras to the deserts, mountains and fields of Mexico, Canada, and the U.S.A., Childress takes the reader in search of sunken ruins, Viking forts, strange tunnel systems, living dinosaurs, early Chinese explorers, and fantastic lost treasure. Packed with both early and current maps, photos and illustrations.

590 PAGES. 6x9 PAPERBACK. ILLUSTRATED. FOOTNOTES & BIBLIOGRAPHY. $16.95. CODE: NCA

LOST CITIES & ANCIENT MYSTERIES OF SOUTH AMERICA
by David Hatcher Childress
Rogue adventurer and maverick archaeologist David Hatcher Childress takes the reader on unforgettable journeys deep into deadly jungles, high up on windswept mountains and across scorching deserts in search of lost civilizations and ancient mysteries. Travel with David and explore stone cities high in mountain forests and hear fantastic tales of Inca treasure, living dinosaurs, and a mysterious tunnel system. Whether he is hopping freight trains, searching for secret cities, or just dealing with the daily problems of food, money, and romance, the author keeps the reader spellbound. Includes both early and current maps, photos, and illustrations, and plenty of advice for the explorer planning his or her own journey of discovery.

381 PAGES. 6x9 PAPERBACK. ILLUSTRATED. FOOTNOTES. BIBLIOGRAPHY. $14.95. CODE: SAM

LOST CITIES & ANCIENT MYSTERIES OF AFRICA & ARABIA
by David Hatcher Childress
Across ancient deserts, dusty plains and steaming jungles, maverick archaeologist David Childress continues his world-wide quest for lost cities and ancient mysteries. Join him as he discovers forbidden cities in the Empty Quarter of Arabia; "Atlantean" ruins in Egypt and the Kalahari desert; a mysterious, ancient empire in the Sahara; and more. This is the tale of an extraordinary life on the road: across war-torn countries, Childress searches for King Solomon's Mines, living dinosaurs, the Ark of the Covenant and the solutions to some of the fantastic mysteries of the past.

423 PAGES. 6x9 PAPERBACK. ILLUSTRATED. FOOTNOTES & BIBLIOGRAPHY. $14.95. CODE: AFA

THE MYSTERY OF EASTER ISLAND
by Katherine Routledge
The reprint of Katherine Routledge's classic archaeology book which was first published in London in 1919. The book details her journey by yacht from England to South America, around Patagonia to Chile and on to Easter Island. Routledge explored the amazing island and produced one of the first-ever accounts of the life, history and legends of this strange and remote place. Routledge discusses the statues, pyramid-platforms, Rongo Rongo script, the Bird Cult, the war between the Short Ears and the Long Ears, the secret caves, ancient roads on the island, and more. This rare book serves as a sourcebook on the early discoveries and theories on Easter Island.
432 PAGES. 6X9 PAPERBACK. ILLUSTRATED. $16.95. CODE: MEI

MYSTERY CITIES OF THE MAYA
Exploration and Adventure in Lubaantun & Belize
by Thomas Gann
First published in 1925, *Mystery Cities of the Maya* is a classic in Central American archaeology-adventure. Gann was close friends with Mike Mitchell-Hedges, the British adventurer who discovered the famous crystal skull with his adopted daughter Sammy and Lady Richmond Brown, their benefactress. Gann battles pirates along Belize's coast and goes upriver with Mitchell-Hedges to the site of Lubaantun where they excavate a strange lost city where the crystal skull was discovered. Lubaantun is a unique city in the Mayan world as it is built out of precisely carved blocks of stone without the usual plaster-cement facing. Lubaantun contained several large pyramids partially destroyed by earthquakes and a large amount of artifacts. Gann shared Mitchell-Hedges belief in Atlantis and lost civilizations (pre-Mayan) in Central America and the Caribbean. Lots of good photos, maps and diagrams.
252 PAGES. 6X9 PAPERBACK. ILLUSTRATED. $16.95. CODE: MCOM

IN SECRET TIBET
by Theodore Illion
Reprint of a rare 30s adventure travel book. Illion was a German wayfarer who not only spoke fluent Tibetan, but travelled in disguise as a native through forbidden Tibet when it was off-limits to all outsiders. His incredible adventures make this one of the most exciting travel books ever published. Includes illustrations of Tibetan monks levitating stones by acoustics.
210 PAGES. 6X9 PAPERBACK. ILLUSTRATED. $15.95. CODE: IST

DARKNESS OVER TIBET
by Theodore Illion
In this second reprint of Illion's rare books, the German traveller continues his journey through Tibet and is given directions to a strange underground city. As the original publisher's remarks said, "this is a rare account of an underground city in Tibet by the only Westerner ever to enter it and escape alive!"
210 PAGES. 6X9 PAPERBACK. ILLUSTRATED. $15.95. CODE: DOT

IN SECRET MONGOLIA
by Henning Haslund
First published by Kegan Paul of London in 1934, Haslund takes us into the barely known world of Mongolia of 1921, a land of god-kings, bandits, vast mountain wilderness and a Russian army running amok. Starting in Peking, Haslund journeys to Mongolia as part of the Krebs Expedition—a mission to establish a Danish butter farm in a remote corner of northern Mongolia. Along the way, he smuggles guns and nitroglycerin, is thrown into a prison by the new Communist regime, battles the Robber Princess and more. With Haslund we meet the "Mad Baron" Ungern-Sternberg and his renegade Russian army, the many characters of Urga's fledgling foreign community, and the last god-king of Mongolia, Seng Chen Gegen, the fifth reincarnation of the Tiger god and the "ruler of all Torguts." Aside from the esoteric and mystical material, there is plenty of just plain adventure: Haslund encounters a Mongolian werewolf; is ambushed along the trail; escapes from prison and fights terrifying blizzards; more.
374 PAGES. 6X9 PAPERBACK. ILLUSTRATED. BIB. & INDEX. $16.95. CODE: ISM

MEN & GODS IN MONGOLIA
by Henning Haslund
First published in 1935 by Kegan Paul of London, Haslund takes us to the lost city of Karakota in the Gobi desert. We meet the Bodgo Gegen, a god-king in Mongolia similar to the Dalai Lama of Tibet. We meet Dambin Jansang, the dreaded warlord of the "Black Gobi." There is even material in this incredible book on the Hi-mori, an "airhorse" that flies through the sky (similar to a Vimana) and carries with it the sacred stone of Chintamani. Aside from the esoteric and mystical material, there is plenty of just plain adventure: Haslund and companions journey across the Gobi desert by camel caravan; are kidnapped and held for ransom; witness initiation into Shamanic societies; meet reincarnated warlords; and experience the violent birth of "modern" Mongolia.
358 PAGES. 6X9 PAPERBACK. ILLUSTRATED. INDEX. $15.95. CODE: MGM

ATLANTIS REPRINT SERIES

ATLANTIS: MOTHER OF EMPIRES
Atlantis Reprint Series
by Robert Stacy-Judd
Robert Stacy-Judd's classic 1939 book on Atlantis is back in print in this large-format paperback edition. Stacy-Judd was a California architect and an expert on the Mayas and their relationship to Atlantis. He was an excellent artist and his work is lavishly illustrated. The eighteen comprehensive chapters in the book are: The Mayas and the Lost Atlantis; Conjectures and Opinions; The Atlantean Theory; Cro-Magnon Man; East is West; And West is East; The Mormons and the Mayas; Astrology in Two Hemispheres; The Language of Architecture; The American Indian; Pre-Panamanians and Pre-Incas; Columns and City Planning; Comparisons and Mayan Art; The Iberian Link; The Maya Tongue; Quetzalcoatl; Summing Up the Evidence; The Mayas in Yucatan.
340 PAGES. 8X11 PAPERBACK. ILLUSTRATED. INDEX. $19.95. CODE: AMOE

MYSTERIES OF ANCIENT SOUTH AMERICA
Atlantis Reprint Series
by Harold T. Wilkins
The reprint of Wilkins's classic book on the megaliths and mysteries of South America. This book predates Wilkin's book *Secret Cities of Old South America* published in 1952. *Mysteries of Ancient South America* was first published in 1947 and is considered a classic book of its kind. With diagrams, photos and maps, Wilkins digs into old manuscripts and books to bring us some truly amazing stories of South America: a bizarre subterranean tunnel system; lost cities in the remote border jungles of Brazil; legends of Atlantis in South America; cataclysmic changes that shaped South America; and other strange stories from one of the world's great researchers. Chapters include: Our Earth's Greatest Disaster, Dead Cities of Ancient Brazil, The Jungle Light that Shines by Itself, The Missionary Men in Black: Forerunners of the Great Catastrophe, The Sign of the Sun: The World's Oldest Alphabet, Sign-Posts to the Shadow of Atlantis, The Atlanean "Subterraneans" of the Incas, Tiahuanacu and the Giants, more.
236 PAGES. 6X9 PAPERBACK. ILLUSTRATED. INDEX. $14.95. CODE: MASA

SECRET CITIES OF OLD SOUTH AMERICA
Atlantis Reprint Series
by Harold T. Wilkins
The reprint of Wilkins' classic book, first published in 1952, claiming that South America was Atlantis. Chapters include Mysteries of a Lost World; Atlantis Unveiled; Red Riddles on the Rocks; South America's Amazons Existed!; The Mystery of El Dorado and Gran Payatiti—the Final Refuge of the Incas; Monstrous Beasts of the Unexplored Swamps & Wilds; Weird Denizens of Antediluvian Forests; New Light on Atlantis from the World's Oldest Book; The Mystery of Old Man Noah and the Arks; and more.
438 PAGES. 6X9 PAPERBACK. ILLUSTRATED. BIBLIOGRAPHY & INDEX. $16.95. CODE: SCOS

THE SHADOW OF ATLANTIS
The Echoes of Atlantean Civilization Tracked through Space & Time
by Colonel Alexander Braghine
First published in 1940, *The Shadow of Atlantis* is one of the great classics of Atlantis research. The book amasses a great deal of archaeological, anthropological, historical and scientific evidence in support of a lost continent in the Atlantic Ocean. Braghine covers such diverse topics as Egyptians in Central America, the myth of Quetzalcoatl, the Basque language and its connection with Atlantis, the connections with the ancient pyramids of Mexico, Egypt and Atlantis, the sudden demise of mammoths, legends of giants and much more. Braghine was a linguist and spends part of the book tracing ancient languages to Atlantis and studying little-known inscriptions in Brazil, deluge myths and the connections between ancient languages. Braghine takes us on a fascinating journey through space and time in search of the lost continent.
288 PAGES. 6X9 PAPERBACK. ILLUSTRATED. $16.95. CODE: SOA

THE SHADOW OF ATLANTIS

ALEXANDER BRAGHINE

THIS 1940 CLASSIC ON ATLANTIS, MEXICO AND ANCIENT EGYPT IS BACK IN PRINT

ATLANTIS REPRINT SERIES

THE HISTORY OF ATLANTIS
by Lewis Spence
Lewis Spence's classic book on Atlantis is now back in print! Spence was a Scottish historian (1874-1955) who is best known for his volumes on world mythology and his five Atlantis books. *The History of Atlantis* (1926) is considered his finest. Spence does his scholarly best in chapters on the Sources of Atlantean History, the Geography of Atlantis, the Races of Atlantis, the Kings of Atlantis, the Religion of Atlantis, the Colonies of Atlantis, more. Sixteen chapters in all.
240 PAGES. 6X9 PAPERBACK. ILLUSTRATED WITH MAPS, PHOTOS & DIAGRAMS. $16.95. CODE: HOA

ATLANTIS IN SPAIN
A Study of the Ancient Sun Kingdoms of Spain
by E.M. Whishaw
First published by Rider & Co. of London in 1928, this classic book is a study of the megaliths of Spain, ancient writing, cyclopean walls, sun worshipping empires, hydraulic engineering, and sunken cities. An extremely rare book, it was out of print for 60 years. Learn about the Biblical Tartessus; an Atlantean city at Niebla; the Temple of Hercules and the Sun Temple of Seville; Libyans and the Copper Age; more. Profusely illustrated with photos, maps and drawings.
284 PAGES. 6X9 PAPERBACK. ILLUSTRATED. $15.95. CODE: AIS

YOU ARE INVITED!

Come visit the Kempton bookstore café,

World Headquarters of **ADVENTURES UNLIMITED!**
One Adventure Place, Kempton, ILLINOIS 60946 USA
Phone: 815-253-6390 •Fax: 815-253-6300
E-Mail: auphq@frontiernet.net

Our bookstore cafés are unique!
We have locations in Auckland,
Kathmandu and Amsterdam.
Our Kempton bookstore is an exciting
blend of adventure, science and history.
Open regular business hours
Monday through Saturday.
Sundays by appointment.
Call us to let us know
you are coming!

SGT. PEPPER'S BAR & GRILL

With Pool Table, Dart Boards,
Other Games, Great Jukebox,
and more! Lunch Every Day!
Try our Beatle Burger!
Dinners on Fridays and Saturdays!
Phone 815-253-6407

Members can visit the World Explorers Club
World HQ at 403 Kemp Street in Kempton.
Join the club—read the magazine.
Membership has its privileges!
Phone: 815-253-9000 Fax: 815-253-6300

One Adventure Place
P.O. Box 74
Kempton, Illinois 60946
United States of America
Tel.: 815-253-6390 • Fax: 815-253-6300
Email: auphq@frontiernet.net
http://www.adventuresunlimitedpress.com
or www.wexclub.com/aup

ORDERING INSTRUCTIONS

✓ Remit by USD$ Check, Money Order or Credit Card
✓ Visa, Master Card, Discover & AmEx Accepted
✓ Prices May Change Without Notice
✓ 10% Discount for 3 or more Items

SHIPPING CHARGES

United States

✓ Postal Book Rate { $3.00 First Item
 50¢ Each Additional Item
✓ Priority Mail { $4.00 First Item
 $2.00 Each Additional Item
✓ UPS { $5.00 First Item
 $1.50 Each Additional Item

NOTE: UPS Delivery Available to Mainland USA Only

Canada

✓ Postal Book Rate { $6.00 First Item
 $2.00 Each Additional Item
✓ Postal Air Mail { $8.00 First Item
 $2.50 Each Additional Item
✓ Personal Checks or Bank Drafts MUST BE
USD$ and Drawn on a US Bank
✓ Canadian Postal Money Orders OK
✓ Payment MUST BE USD$

All Other Countries

✓ Surface Delivery { $10.00 First Item
 $4.00 Each Additional Item
✓ Postal Air Mail { $14.00 First Item
 $5.00 Each Additional Item
✓ Payment MUST BE USD$
✓ Checks and Money Orders MUST BE USD$
 and Drawn on a US Bank or branch.
✓ Add $5.00 for Air Mail Subscription to
 Future *Adventures Unlimited* Catalogs

SPECIAL NOTES

✓ RETAILERS: Standard Discounts Available
✓ BACKORDERS: We Backorder all Out-of-
 Stock Items Unless Otherwise Requested
✓ PRO FORMA INVOICES: Available on Request
✓ VIDEOS: NTSC Mode Only. Replacement only.
✓ For PAL mode videos contact our other offices:

European Office:
Adventures Unlimited, Pannewal 22,
Enkhuizen, 1602 KS, The Netherlands
http: www.adventuresunlimited.nl
Check Us Out Online at:
www.adventuresunlimitedpress.com

Please check: ☑

| ☐ This is my first order | ☐ I have ordered before | ☐ This is a new address |

| Name |
| Address |
| City |
| State/Province | Postal Code |
| Country |
| Phone day | Evening |
| Fax |

Item Code	Item Description	Price	Qty	Total

Please check: ☑

☐ Postal-Surface
☐ Postal-Air Mail
(Priority in USA)
☐ UPS
(Mainland USA only)

Subtotal ⟹	
Less Discount-10% for 3 or more items ⟹	
Balance ⟹	
Illinois Residents 6.25% Sales Tax ⟹	
Previous Credit ⟹	
Shipping ⟹	
Total (check/MO in USD$ only) ⟹	

☐ Visa/MasterCard/Discover/Amex

Card Number

Expiration Date

10% Discount When You Order 3 or More Items!

Comments & Suggestions	Share Our Catalog with a Friend